WOMEN'S WAGES, WOMEN'S WORTH

Politics, Religion, and Equity

Fredelle Zaiman Spiegel

Continuum • New York

1994
The Continuum Publishing Company
370 Lexington Avenue, New York, NY 10017

Printed in the United States of America

Library of Congress Cataloging-in-Publication Data

Spiegel, Fredelle Zaiman.
 Women's wages, women's worth : politics, religion, and equity / Fredelle Zaiman Spiegel.
 p. cm.
 Includes bibliographical references.
 ISBN 0-8264-0656-4 (acid-free paper)
 1. Pay equity—Religious aspects. 2. Wages—Women—United States. 3. Sex discrimination in employment—United States. 4. Sexual division of labor—United States. 5. Women and religion—United States. 6. Religion and politics—United States.
 HD6061.2.U6S7 1993 93-44437
 331.4'2153'0973—dc20 CIP
 r94

To Steven
and our children
Mira, Nina, Avi

"How can I repay God for all I have been given?"
Ps. 116:12

CONTENTS

Acknowledgments

This volume is dedicated to my husband and children without whom there would have been no book. Not only were they exceptionally supportive of the endeavor, they also provided the life circumstances out of which the project developed. As women (and even some men) know, it is not easy to raise children and enjoy a professional career. Had I not struggled with this challenge myself, I would probably never have become interested in the complex question of comparable worth. I hope that my work will help others who are embarked on similar paths. I believe strongly that ways must be found in our society to accommodate both motherhood and women's equality.

I feel fortunate that there are so many people who contributed to this publication. The faculty of the School of Religion at the University of Southern California provided a stimulating and supportive environment for learning classic texts and creating new work. My dissertation committee chaired by William May with Donald Miller and David Ellenson was especially helpful. My fellow students, Elizabeth Say, Mark Kowaleski, Lois Lorentzen, Bron Taylor and Robert Pearson, helped to keep the project on track when the inevitable strains of graduate school seemed overwhelming. I am delighted to be able to honor our pledge to each other that we publish our manuscripts.

My colleagues in the Department of Religious Studies at California State University, Northridge continue to provoke lively conversation about religion, politics, and women. I am especially grateful to the chair, James Goss, who has managed, in very trying circumstances, to provide me with a teaching schedule which allowed me the time I needed to complete this volume.

Cynthia Eller is more than one could hope for as an editor. She inspired and nurtured a better manuscript. Having a first rate scholar in the field edit the volume did much to enhance its quality. I thank her for her help and appreciate Continuum's wisdom in allowing her to do this work.

Calvin Goldscheider insisted that I revise the manuscript for publication when I had lost enthusiasm for the enterprise. I am grateful for his continuing encouragement as well as his good advice.

Harry Brickman helped me when I most needed it. There would not have been a book without him. I thank him for being there. Naomi and Bob Brofman, Heidi Singh, Jim Doherty and Murray Tenenbaum have been an important part of this endeavor for many years. I thank them for their

support and their good company. I appreciate Concetta Alfano's insistence that I was writing a book whenever I needed to be reminded. I am also grateful to David Pervin who saved me many hours by his gracious offer to check sources and retrieve lost volumes.

I am sorry that neither of my parents lived long enough to see the publication of this book. I think that they would be able to find their influence in these pages. They encouraged, perhaps demanded, intellectual pursuits, yet insisted on the importance of family. This volume is testimony to the power of their message.

Joel Zaiman's continuing encouragement of my writing has meant a great deal to me. His phone calls always stimulate and nourish. Ann Zaiman's willingness to design the jacket for this volume was a special gift for which I am very grateful. Her work has enhanced my most important endeavors. I am especially glad that it covers this book.

Gail Zaiman Dorph lived down the block during the entire gestation of this work and shared many moments of joy and despair. She moved just as the book was completed. I'm sorry she wasn't able to stay longer.

Claire Spiegel raised the perfect husband and I thank her for that. Her struggle to raise three children as a widow earning a woman's wage made those children (and their spouses) acutely aware of the implications of the wage differential. Her impact can be seen in this publication.

There is no adequate way to thank Steve. He painstakingly read far too many versions than any author can expect to have read. He offered me words when I could find none. Most important, he has been unfaltering in his support. His encouragement and his love are essential ingredients in this work.

Without Mira, Nina, and Avi my life would have been unbearably diminished. They have been a constant challenge, but also a continuing joy. Seeing them grow has given me more pleasure than I ever expected. I thank them for their patience with me. It is my wish that they be blessed with all the good that life can offer. I am especially delighted to be able to dedicate this book to them because they have become my intellectual companions and conversation partners.

I hope the reader will be persuaded by the pages that follow to consider the relationship between the religious and secular components of the comparable worth debate. The resolution of the conflict between family and equality will determine the quality of our lives and our children's lives in future decades.

Los Angeles, California
March 1994

1

Religion, Politics, and Women's Wages

The press and media are filled with commentaries that highlight women's issues, women's gains, and gender as a major concern in society. From Anita Hill to Murphy Brown, in fact and in fiction, an uncritical observer of the American scene might easily conclude that women are making gains. Their independence is becoming more acceptable, their views more important, and their prominence more pervasive. Yet the glitz and glory reflect appearance, not reality. When it comes to the bottom line—the workplace—women are still far behind their male counterparts. When it comes to women's equality, the business of America is still business as usual.

In a recently published study of the plight of women in America, Sylvia Ann Hewlett offers the following information about women's wages.

> In 1939, when Franklin D. Roosevelt was president, *Gone With the Wind* was awarded the Academy Award as best picture, and Joe DiMaggio won the batting title, women earned sixty-three cents to a man's dollar. . . . Today women earn sixty-four cents to a man's dollar. . . . We have women astronauts and women vice-presidential candidates—indeed fully 45 percent of the U.S. labor force is now female—but despite all these changes, the gap between male and female earnings is as wide as it was half a century ago. . . . In 1984 the median earnings of women who worked full time year-round was $14,479, while similarly employed men earned $23,218. A woman with four years of college still earns less than a male high school dropout.[1]

Much has been written about the disparity between women's and men's wages in the United States. Many economists and social scientists have tried

to account for the wage gap, offering theories about work as well as about women. There has been legislation and adjudication on the question of employment discrimination against women, and efforts have been made to narrow the difference in men's and women's earnings. Comparable worth, the effort to offer wages in job categories dominated by women comparable to wages in job categories dominated by men, is the central policy approach seeking to close the gap.

Despite massive changes in the number of women in the work force, and significant changes in the positions available to some women, the discrepancy persists. In 1985 women still earned, on average, only 64 cents compared to every dollar earned by a man.[2] By 1990, women earned 71 cents to each man's dollar.[3] Although the difference in pay between women and men appears to be narrowing slightly, the gap still remains significant. Moreover, the wages of women of color are considerably lower than those of white women. When non-white women's wages are compared to those of white men, the ratio between women's and men's wages is even starker. In 1990 white women earned 69.4 percent of a white man's wage. African-American women earned only 62.5 percent of that wage. Hispanic women earned 54.3 percent as much as white men. If non-white men's wages are compared to women's wages, the numbers change again. Although men of color earn less than white men, white women earn less than white men or black men. For example, in 1990 black men earned 73.1 percent of the white male's dollar whereas white women earned only 69.4 percent of it. Only men of Hispanic origin earn less than white women, and they earn more than either black or Hispanic women. Although race is clearly a relevant factor in the wage differential, in the area of earnings it is gender, not race, which is the more salient category.[4] Women of color are doubly jeopardized, limited in their earnings by both their gender and their race.

One of the reasons that the wage gap has proved so difficult to close is that it rests on unresolved dilemmas that have little to do with salaries or money. Questions about such fundamental human concerns as the place of women in society, differences between women and men, and even the intrinsic value of women and men underlie discussions of women's wages. Until these questions are resolved, the wage gap will persist.

Until the important role that religious voices are playing in this policy debate is identified, these discussions will be incomplete. It may seem odd, even illogical, to consider religion and the technical issues of women's wages in the same breath. Yet that is precisely the point of this volume. Because questions of women's worth are ultimately reflections of differences in people's values, the religious dimension must be considered.

This book asserts that the study of comparable worth policies must give attention to the role of religion. At the same time, it posits that assessing the place of religion in the comparable worth debate can shed new light on the religious function in American public policy.

WOMEN'S WAGES, WOMEN'S WORTH

The very term *comparable worth* raises questions of value. How is one's worth to be determined? By what standards is worth assessed? What are the components of worth—beauty, fortune, fame, goodness to other human beings, public service, altruism? Although technically referring to the notion of the monetary worth of any particular job, the term "comparable worth" gives evidence of the importance of wages in determining a person's deeper "worth" in contemporary American society. It speaks to questions about the comparative value of the two genders. Considerations of the worth of the different genders or of a person's value to society are implicated in wage differentials.

In a capitalist and materialist society in which women are paid less than men, women are seen to be worth less than men, not only in the job market but in other arenas of life as well. In our society, wages are all too frequently used not only as a means of acquiring objects but also as a means of acquiring intangibles such as status or power. Michael Walzer, in *Spheres of Justice*, proposes a system of "complex equality" where "no citizen's standing in one sphere or with regard to one social good can be undercut by his standing in some other sphere, with regard to some other good."[5] He quotes Pascal's *Pensees*: "Tyranny is the wish to obtain by one means what can only be had by another. We owe different duties to different qualities: love is the proper response to charm, fear to strength, and belief to learning."[6]

Yet Walzer acknowledges, as do others, that distributive spheres are not always kept separate. Money frequently buys non-material goods. He quotes Marx's comments on money: "What I am and can do is not at all determined by my individuality. I am ugly, but I can buy the most beautiful women for myself. Consequently, I am not ugly . . . I am stupid, but since money is the real mind of all things, how should its possessor be stupid?"[7] The problem of comparable worth is more significant than the question of equal wages alone implies, because money buys more than objects.

The question of comparable worth also relates to the issue of work itself, not only to the issue of wages. In the religious tradition, the notion of a calling, or vocation, is used not only to help one's self-definition but also to help one feel secure and significant in one's work. Even in the secular tradition, this notion of the importance of work or vocation has not disappeared. Freud, for example, argued that the hallmark of a healthy adult is

the ability to love and to work. If women are limited in their ability to work in the arena they prefer, and limited in their ability to receive a reward appropriate to that arena, their essential human rights are diminished.

Recent studies have also discussed the relationship between work and personality and lead to the conclusion that women are harmed by their relegation to female-dominated job ghettoes. For example, Kai Erikson finds that "the more autonomous and self-directed a person's work, the more positive its effects on personality; and the more routinized and closely supervised the work, the more negative its effects." [8] Women who are confined to low-paying jobs, where they lack autonomy, suffer these negative effects.

Women's lower wages also have measurable effects on women and society. Women living in poverty far outnumber men. Families headed by women are four times as likely to be living in poverty than families with two spouses. Almost 30 percent of white female-headed households, and over 50 percent of black and Hispanic female-headed households, live in poverty. Almost 67 percent of all children living in a female-headed household are impoverished.[9] An obvious explanation for the prevalence of female poverty is that women's depressed wages make it harder for them to support their families.

At the same time, wage earning married women and men also suffer from the effects of women's lower wages. For example, egalitarian marriages where both husband and wife attempt to share household tasks (and if relevant, child rearing), are strained by a situation wherein one member of the couple earns significantly less than the other. It is difficult to maintain the parity of domestic chores, and especially child rearing responsibilities, when the loss of one partner's salary or one day's wages (should that partner need to take time off of work) is clearly greater than the loss of the other's.

The impact of women's wages is both practical and far reaching. It is about money—who has it and who does not, who can get it and who cannot. But it also goes beyond the question of money. It is about women's value, both to themselves and to society. It is a moral and religious as well as a political problem.

THE WAGE GAP

The question of pay equity between women and men has been debated as a public policy question at least since 1963 when the Equal Pay Act (EPA) was passed. In 1964 Title VII of the Civil Rights Act augmented this legislation. Both of these measures were instituted in order to attempt to close the wage gap, although Title VII was directed more toward racial than gender discrimination. (In fact, many commentators assert that adding gender as a

category under Title VII was meant to show the absurdity of the proposal for equality, not to help advance women's equality. Wendy Kaminer notes that "the word *sex* was added to the law by a white Southern Democrat in an attempt to retard its passage or, according to some observers, as a joke.")[10] Both of these acts require that some measure of unequal, or discriminatory, behavior be demonstrated in order for a woman to claim that she is being paid unfairly. The Equal Pay Act was amended to the Fair Labor Standards Act and provides for "equal pay for equal work on jobs the performance of which requires equal skill, effort and responsibility and which are performed under similar working conditions."[11] Title VII prohibits discrimination based on race, sex, religion or national origin. The Bennett Amendment added to Title VII reiterates that certain factors mentioned in the EPA such as differences in seniority, merit, and productivity are legitimate reasons for pay differences.

Closing the gender wage gap by legislation, however, is extremely difficult. For one thing, there is little agreement on what factors are the most important contributors to the significant differences in pay between women and men. There are at least three general explanations for the wage differential: women are concentrated in jobs that require less education or skill than men, women might receive lower pay than men for identical work, or women might be doing different work than men, but work that is comparable in terms of the training required and the complexity of the task, and receiving lower pay for this work. Studies indicate that all three of these general explanations account in part for the wage differential.

Comparable worth legislation or litigation provides one path toward addressing the wage differential. It addresses the third category—jobs which are similar in measurable standards but are receiving different wages. It seeks to close the wage gap between women and men who receive different wages for work that is alike, but not identical. Civil rights legislation deals with the second category—it is illegal for women and men to receive different pay for the exact same job. If such a situation persists, it is a question of enforcement rather than legislation. The first factor, women's lower expectations or more limited education and training, cannot be resolved by wage policies. Cultural shifts are needed to bring about change at this level.

The question of comparable worth becomes especially relevant because most jobs in America are segregated by sex. According to the 1970 census, more than 50 percent of the 553 listed occupations were occupied 80 percent by males; 9 percent of the occupations were filled by more than 80 percent females. Even more striking is that "70 percent of the men and 54 percent of the women in the labor force [were] concentrated in occupations

dominated by their own sex."[12] The 1985 statistics offer similar numbers. Seventy percent of women working full time were in occupations with over 75 percent female employees.[13] In 1990, 59 percent of all working women still remained in only three broad job categories: sales, services, and clerical.[14] Women working part time were even more likely to be in female-dominated occupations.

If one desired to integrate these occupational categories by gender in order to end job segregation by sex, massive rearrangements of the marketplace would have to occur. Treiman and Hartmann calculated that based on the 1970 census figures, 44 percent of the white women in the work force would have to change occupational categories.[15] Although by 1990 there were larger numbers of women in what had been male-dominated job categories, men had not entered the traditional women's jobs.[16] Therefore, there would be only small differences in a calculation of job shifts necessary to significantly alter the sex-segregated nature of the American workplace based on the 1990 census data.

Of course, if these sex-segregated categories offered similar wages, the question of comparable worth would not arise. However, "not only do women do different work than men, but . . . the work women do is paid less, and the more an occupation is dominated by women, the less it pays."[17] A study conducted by the U.S. Bureau of Labor Statistics shows the correlation between the hourly wage and the percentage of females employed in various industries: "A ranking of 52 industries in July 1982 shows that the apparel and textile products industry had the highest percentage of women workers (81.9 percent), and ranked 50th in average hourly earnings. The bituminous coal and lignite mining industry, on the other hand, ranked 52nd in percentage of women employees (5.1 percent) and first in average hourly earnings."[18]

This inverse relationship between wages and percentages of women employed in any given occupational category can be seen almost across the board. For example, in 1985 a secretary/typist, working in an occupation that was 97.7 percent female dominated, was paid on average $276 per week. A truck driver, working in an occupation that was dominated by men, having only 2.1 percent females in its category, was paid an average wage of $363.[19] It would be difficult to argue that the education, training or skills necessary for truck driving are significantly greater than those required for secretaries.

Women not only earn less than men when they are doing "women's work." They also earn, on average, less than men when they are working in the same occupational classifications. Women's jobs tend to be paid at the lower end of the spectrum. For example, "in 1982, 16.2 percent of women

managers and administrators earned less than $200 per week, compared with only 3.2 percent of men." [20] As Catharine MacKinnon notes, prostitution and modeling are the only fields in which women as a group earn more than men.[21]

EQUALITY AND COMPARABLE WORTH

The concept of comparable worth ultimately rests on the principle of equality. Jobs that are in some way equal, or comparable, to one another are to be paid equally. According to Evans and Nelson, for strategic purposes, pay equity has become the favored phrase for those who wish to convey "the *goal* of eliminating wage discrimination rather than the *process*. In the eyes of many proponents, 'pay equity' captures rhetorically their deeper and less technocratic intentions and it claims for their 'side' the fundamental value of fairness." [22] However, the term comparable worth is used in most scholarly literature to convey the policy itself, rather than the goals it seeks.[23]

The notion of pay equity is based on the broad principle of justice that like cases be treated alike. Advocates of comparable worth turn to this fundamental principle. Yet, discussions of comparable worth become confused because the question of equality is complex. Most Americans agree that like cases should be treated alike, and even assume that equality of treatment is crucial to the American polity and culture. However, there is vast disagreement about what, in fact, constitutes a like case. As recent discussion about civil rights issues (especially those involving race) indicate, there is considerable dispute about the factors that are relevant in assessing equality. It is impossible to either compare or assess equality until there is agreement about what factors should be studied for either similarities or dissimilarities.

Because of this problem, legal theorist Peter Westen asserts that the very idea of equality is an empty concept.[24] He contends that the difficulty of deciding which factors are relevant to the discussion of formal justice undermines the notion of equality itself. Janet Rifkin and Diane Polan similarly question the feasibility of the concept. Offering a feminist legal perspective, they wonder whether the concept is too imbedded within the patriarchal legal tradition to be used meaningfully.[25] The notion of equality is particularly difficult in discussion of comparable worth because the choice among relevant factors to be compared includes not only questions about specific jobs but also questions about the similarity or dissimilarity of the genders.

As Michael Rubenstein notes, "women are paid less than men partly because of the attributes they bring to the job, partly because of the jobs they are in and partly because they are women." [26] In other words, arguments about human capital differences, about the nature of job segregation by sex,

and about the intrinsic value of women are all brought to bear on the discussion of comparable worth. The debate about the issue is complicated because advocates and opponents of comparable worth disagree in their assessments of the importance of education, experience, and technical skill and in their judgment of women's intrinsic nature.

A final—and crucial—complication is that advocates and opponents of comparable worth disagree about the role of the free market. It is clear that there is wide variation in wages, not only between, but also within job categories. Since salaries are offered by particular firms or businesses, there is little control over wage setting by government agencies or legislative devices. There is also little agreement about the desirability of government controls.

Both proponents and opponents of comparable worth agree, however, that in the work world principles of merit reign. Discussions of comparable worth inherently accept that salaries and wages are based on some principle of merit, rather than on need or on charity. Few Americans assume that everyone, no matter what job they are doing, should receive the same salary or that wages should be set solely on need. Some jobs are rewarded with higher pay than others because they are seen to be able to command more on the open market. For example, physicians receive higher wages than sanitation engineers; lawyers receive higher pay than school teachers.

Yet, there is little agreement about how these different occupational categories actually come to be valued. Much as devotees of the free market might wish it otherwise, principles of supply and demand do not account for all differences of valuation. Nurses, for example, have long been used as an example of a profession which is undersupplied relative to its demand. Yet nurses' wages do not reflect this condition. It is difficult to assess precisely why work dominated by women is paid so much less than work dominated by men. Differences in the value of women's and men's work could be explained as part of the large numbers of variations in wages between job categories or as a reflection of the unequal social value of women and men.

Because of the difficulty posed by these distinctions in wages between job categories, advocates and opponents also tend to favor different definitions of equality in assessing comparable worth. Opponents tend to focus on the concept of equality of opportunity. They assert that if women have the same opportunity as men to compete for jobs, then the principles of equality are being respected. Advocates of comparable worth, in contrast, assert that it is not equal opportunity that is necessary, but rather equal results. One should not compare the number of women who apply for a particular job with the number of male applicants, but rather the number of women and men hired.

SYMMETRY V. ASYMMETRY

This already complicated picture is given a further twist by historic and legal disagreement about the intrinsic or essential nature of women and men. This disparity is present even among those seeking to advance women's rights. Equal rights feminists have rested their case on claims that women and men are essentially alike. In contrast, protectionist feminists are more likely to assert gender difference. Because of the confusion inherent in the labels given to these two strands of thought in the history of American feminism, all of whose members were, after all, campaigning for women's rights, Christine Littleton proposes the terms "symmetry" and "asymmetry." For Littleton, the more commonly used terminology not only "make[s] it harder to think clearly about the issues raised by the equality debate, it also places the focus on how 'women' should be treated rather than on the more fundamental question of whether and how the existence of two sexes should shape law and society." [27]

The symmetrical approach takes its cues from civil rights principles; hence the label "equal rights feminists." Gender as a category is seen as similar to race. This approach asserts that there are no significant differences between women and men, just as there are no significant distinctions between black or white people. In fact, symmetrical thinkers assume, as in the case of most recent court decisions that have ruled in favor of women's equality, that "women, given the chance, really are, or could be just like men." [28] Many of the earliest feminists are in this category. For example, "the first women's rights advocates of the mid-1800's drew from John Mill and Mary Wollstonecraft a belief in the natural equality of all human beings and sought to extend the natural rights of men to women. They stressed what the sexes shared—the capacity to reason and the right to determine their own destinies, instead of how they differed biologically." [29] Symmetrical principles are often favored by the American legal system which rests on the principle of like cases being treated alike. This approach is used in the comparable worth debate most frequently by liberal feminists. According to Littleton, symmetry is also appealing to many liberal men, who are offered "a share in the feminist enterprise.... Ending this form of sexual inequality could free men to express their 'feminine' side, just as it frees women to express their 'masculine' side." [30]

Asymmetrical theorists, on the other hand, assume that women and men are indeed different, and that these differences should not be ignored. Perhaps they even need to be highlighted. This group, often called "protectionist" or "social" feminists, is historically responsible for protectionist labor legislation. These feminists pressed for laws that limited hours and

demanded safety, especially for women and children. They were also active in the early feminist movement, especially in the drive for women's suffrage, arguing that it was because of women's differences from men that their vote was necessary. Women's domesticating influence would benefit the country. This same type of argument today is used to assert that women are less likely to wage war than men and that women are less likely to spend resources on defense and more likely to spend them on social welfare. Of course, as social critic Wendy Kaminer notes: "women's virtues—moral and emotional sensitivity—were inextricably linked to her most crippling vulnerabilities—physical and intellectual weakness. These were the qualities associated with motherhood and domesticity, which may have won women the vote and lost them the battle for full equality. As mothers, women were protected instead of empowered." [31]

This asymmetrical approach is seen on both sides of the comparable worth debate. Opponents of comparable worth often assert that the differences between women and men explain why women are not, and should not, be paid the same wages as men. On the other hand, some advocates argue that it is the lack of respect for these differences that unfairly penalizes women in the work world.

THE PROBLEM OF COMPARABILITY

If assessing equality raises problems, asserting comparability is even more complex. Both sides of the comparable worth debate agree that this task of comparing jobs across large occupational categories is difficult. Yet the concept and implementation of comparable worth depends on the possibility of comparison.

At the beginning of the 1980s both the Equal Employment Opportunity Commission (EEOC), then generally favorable to the concept of comparable worth, and the Business Roundtable, an organization that both represents and symbolizes the power of America's largest corporations and is generally opposed to comparable worth, sponsored conferences and studies on the question of comparing jobs. Robert Livernash, the editor of the Business Roundtable's proceedings, concluded, "There is simply no known technique by which job 'worth' in any intrinsic sense can be measured." [32] The editors of the EEOC-commissioned study, Donald Treiman and Heidi Hartmann, conclude that "acceptance of a comparable worth approach . . . does not require an absolute standard by which the value or worth of *all* jobs can be measured. In the judgment of the committee, no such standard exists nor, in our society, is likely to exist." [33]

The history of several recent court decisions based on Title VII gives

evidence of the nature of the problem, both by offering some examples of discrimination and by indicating the difficulty of the concept of comparability. The following brief review also shows some of the steps taken toward ameliorating the wage differences between the sexes.

Several cases from the late 1970s and 1980s—*County of Washington v. Gunther, IUE v. Westinghouse Corporation*; and *AFSCME v. the State of Washington*—set the stage for comparable worth discussion. These cases are often used as legal precedents for the operationalizing of comparable worth. They also suggest several different ways of trying to assess comparability.

The *1981 Gunther* decision settled the suit brought by Alberta Gunther and three of her co-workers. Gunther was a guard in an Oregon county jail who claimed in the 1970s that women guards were paid less than their male counterparts for doing essentially the same job. The female guards, however, had fewer prisoners under their charge and, unlike the male guards, performed some clerical tasks. Because of these differences the federal district court concluded that the male and female jobs were not "substantially equal" and that the women were therefore not entitled to equal pay. On appeal, however, the Ninth Circuit Court of Appeals reversed the decision and held that the women were entitled to sue under Title VII based on evidence they had presented that "a portion of the discrepancy between their salaries and those of the male guards could be ascribed only to sex discrimination." [34] The Supreme Court upheld the Court of Appeals' decision.

The *Gunther* case dealt with men and women doing substantially the same job. Moreover, the women guards were able to demonstrate that the county itself knew that these jobs were almost equivalent and "intentionally" discriminated against them. The women guards brought evidence that the County of Washington had "conducted its own survey of outside markets and the worth of the guard jobs; that the county survey indicated that the women should be paid approximately 95 percent as much as the male guards; that it paid them only 70 percent as much, while paying the male guards the full evaluated worth of their jobs; and that the failure to pay the women the full evaluated worth of their jobs was attributable to intentional sex discrimination." [35]

The 1974 suit of the *International Union of Electricians (IUE) v. Westinghouse Electric* dealt with jobs that were not as similar as those of the male and female guards in the *Gunther* case. Yet the plaintiff was able to prove, as in *Gunther*, that there was intentional underpayment of the women employees. The union pointed to a job evaluation analysis undertaken by the company itself in the 1930s that was used as a basis for setting wages, and claimed that all subsequent wages were based on this original scale. In this 1930s

analysis the Westinghouse Corporation had assigned points to various jobs based on a "gender-neutral rating system." However, it then "deliberately set lower wage rates for jobs occupied by women than for those with equal ratings held by men." [36] According to company records, women were paid less than men because "of the more transient character of the service of the former, the relative shortness of their activity in industry, the differences in environment required, the extra services that must be provided, overtime limitations, extra help needed for the occasional heavy work, and the general sociological factors not requiring discussion herein." [37]

In the 1981 case raised by the American Federation of State, County, and Municipal Employees (AFSCME) against the State of Washington, there was a study done by the employer that the federal district court used in deciding the case in favor of the union. The state's own study (commissioned only after the union had requested it) had shown that female-dominated job categories paid, on the average, 20 percent less than male-dominated categories. The study utilized a point system that assessed "knowledge and skills, mental demands, accountability, and working conditions" [38] for various jobs, and it pointed to numerous examples of jobs with equal points receiving different wages. For example, "a Food Service Worker I, at 93 points, earned an average salary of $472 per month, while a Delivery Truck Driver I, at 94 points, earned $792; a Clerical Supervisor III, at 305 points, earned an average of $794. A Nurse Practitioner II at 385 points had average earnings of $832, the same as those of a Boiler Operator with only 144 points. A Homemaker I, with 198 points and an average salary of $462, had the lowest earnings of all evaluated jobs." [39]

These three early comparable worth cases all showed that the employers discriminated within their own companies or agencies. Because these employers had information that indicated that the female-categorized positions should have been paid more according to the company's own standard, the court found evidence of discrimination. Although the 1983 decision in *AFSCME v. the State of Washington* (which awarded employees almost $1 billion in back pay) was later reversed, the acceptance of the idea of comparable worth was already sufficiently entrenched in the state that comparable worth policies were implemented without the court order.

In numerous cities and local jurisdictions, including San Jose and Contra Costa County, California, administrative decisions based on the same principles as the successful court cases have led to increased pay equity for women. [40] In fact, the instigation for comparable worth policies has grown steadily in the public sector since the AFSCME case against the State of

Washington. The successful attempts have followed the pattern delineated in the court cases that favored comparable worth.

Other recent cases which have involved legislation, rather than administrative or court decisions, have also used the same tactics. The recent institution of pay equity in the state of Minnesota as well as in its counties and local governments confirms the importance of proving discrepancies in pay between similarly rated male- and female-dominated occupational categories. In Minnesota, an independent study indicating vast differences in wages between women and men predated the legislative efforts to establish pay equity. This evaluation found that "women's jobs routinely paid around 20% less than men's jobs at the same Hay-point level."[41]

> In 1982, the highest monthly pay of the Delivery Van Driver position, a male-dominated class receiving 117 Hay points, was $1,382. The highest monthly salary for the Clerk Typist position, a female-dominated class with 117 Hay points, was $1,115. At the highest end of the pay range, the Delivery Van Driver position made $267 (23.9%) more per month than the Clerk Typist position. The findings repeated themselves at every level of Hay points.[42]

The cases that have been unsuccessful in implementing comparable worth show the difficulty of proving job comparability in the absence of an acceptable, and most often, previously undertaken, internal comparison. In these cases, the courts have been reluctant to rule in favor of equalizing wages. Without an internal job evaluation process that has demonstrated specific evidence of discrimination against women, the courts have more often ruled against the plaintiffs.

Court decisions such as *Lemons v. the City and County of Denver* and *Equal Employment Opportunity Commission v. Sears* are used as precedent by those opposed to comparable worth. They offer different means of assessing comparability. In the 1978 case of *Lemons v. the City and County of Denver*, a group of nurses claimed that their jobs were underpaid. They noted that "their jobs required greater training and skill than many other male-dominated jobs—for example, tree trimmers, sign painters, and real estate appraisers — that were compensated at a higher rate."[43] The city, however, claimed that its wage structure was set on the basis of wages in the private sector. Since the nurses were being paid at a rate comparable to nurses in the private sector, they maintained that there was no discrimination against the nurses. The court agreed.

One of the more publicized comparable worth cases was the mid-1980s *Equal Employment Opportunity Commission v. Sears* suit. The EEOC charged

Sears with discriminating against women because they had traditionally been kept in sales positions where commissions were likely to be limited. Women were not found in areas such as durable goods where commissions were higher. Two well-known historians offered conflicting testimony in the case. Alice Kessler-Harris testified that women's greater presence in lower paying positions was evidence of discrimination against women. Rosalind Rosenberg argued that women's dominance in these positions was merely a reflection of women's choice, not evidence of discrimination. The court agreed with Rosenberg.[44]

BEYOND THE TECHNICAL DEBATE

The complexities of these cases and the frequent controversies which surround them illustrate the problems inherent in the comparable worth debate. It is not surprising that the difficulty of assessing the reasons that women's wages are so persistently and significantly lower than men's, let alone of finding a way to lessen the gap between them, has intrigued and puzzled a wide variety of authors. The policy issue of comparable worth in particular is often discussed in highly technical terms because it rests on the necessity of comparing jobs that are in some ways equivalent but are not precisely identical. Yet comparable worth is more than a legal, economic, or technical problem. It is a moral issue as well.

This book does not involve itself with the technicalities of either an economic or a legal solution to the problem of comparable worth. Rather, it sees the issue of the wage gap as a moral problem and tries to offer a moral solution. It notes that underlying much of the discussion about the free market, or the evidence of discrimination against women, or the difficulties of actually comparing different jobs that are in some ways similar, is the disagreement about whether women are the same as or different from men. Ultimately, it is a question of women's value. The debate on comparable worth attempts to identify the proper place of women in society and it will not be resolved until these underlying questions are addressed.

Most significantly, the problem of women's lower wages has proven intractable at least in part because it uncovers a fundamental conflict between the value of equality—on which fairness in the world of work is supposed to rest—and the value of family—a realm which has traditionally been seen as outside the world of work and the values of equality. When women enter the work world it raises the question of whether they are to be treated by the standard of that world—namely equality—or by the standard with which the family is associated—namely inequality. At this point, a clash between these two values becomes inevitable.

By studying the problem of women's wages as a conflict of values, this book tries to find ways of ameliorating the tension between the values of equality and family in order to help close the gap between women's and men's wages. It aims to find a solution to the dilemma posed by comparable worth not by studying the marketplace directly but by studying the fundamental social values that are in conflict. In so doing, it presents the possibility of a society in which women will be as respected as men, while not having to be identical to them.

2

Family Versus Equality

The conflict between family and equality is deeply imbedded within the comparable worth debate. While advocates stress the necessity for pay equity in the marketplace, opponents discuss the importance of the family. The roots of the dispute are buried in these contrasting fundamental priorities.

ROLE EQUITY, ROLE CHANGE

These conflicting values can be seen to reflect a typology offered by Joyce Gelb and Marion Lief Palley in *Women and Public Policies*. Gelb and Palley note that most public policy issues relating to women can be divided into two types: those that address perceived role equity and those that deal with perceived role change. Issues that concentrate on role equity are seen as less threatening to established social patterns than those that appear to deal with role change, a "change in the dependent female role of wife, mother, and homemaker, holding the potential of greater sexual freedom and independence in a variety of contexts."[1]

In this classification, advocates of comparable worth try to present the issue as one of role equity, that is, as simply extending to women equally the rights now available to men. Opponents of comparable worth, on the other hand, present the case in terms of role change, and see equality in the workplace as a threat to the family.

Advocates of comparable worth do not stress a relationship between comparable worth and maintaining the family. On the contrary, they note

the limited number of families that embody the traditional patriarchal prototype of a wage-earning father and a non-wage earning mother and question why comparable worth opponents are trying to protect a form of the family that is no longer prevalent in American society. The concern of advocates of comparable worth is with the workplace itself. They claim that the free market reflects the discrimination that is inherent in society.

Sharon Toffey Shepala and Ann T. Viviano, for example, claim that "women's work—in fact, virtually anything done by women—is characterized as less valuable. In addition, the characteristics attributed to women are those our society values less." [2] They hypothesize that "it may be that 'female' characteristics are valued less precisely because they are considered female. The same may be said of the lower value placed on female activities." [3] They refer to Margaret Mead's studies which indicate that "in all cultures, without any known exception, male activity is seen as achievement." [4] These two researchers conclude that "women are culturally devalued and their work is devalued as a result." [5] In fact, many advocates of comparable worth point to a recent study by the Bureau of the Census that indicated that "even if women's education, experience, and [career] interruptions were the same as men's, the earnings gap would be reduced by only about five percentage points." [6] Advocates of comparable worth seek to end what they see as discrimination in the workplace.

Opponents of comparable worth, on the other hand, tend to stress the importance of women remaining wives and mothers. For some, such as George Gilder, the very continuation of society would seem to depend on encouraging the wage differential between men and women. Gilder assumes that this wage gap enables a man to support a wife and children, and discourages women from leaving their important labor at home in order to enter the marketplace. For Gilder, maintaining the family is crucial because "civilization is essentially based on men subduing their short term compulsions, their impulses to violence and fighting and short term sexual experience, to the long-term horizons which women bear in their very wombs. The woman's body tells her that she participates in the ongoing future. The man doesn't learn this meaning in general, except through marriage." [7] It is only through marriage that "men gain a future as significant as is embodied in women." [8] Without marriage, civilization itself is imperiled. In these terms, the institution of comparable worth policies would threaten civilization.

One camp in the comparable worth debate is trying to present its case by focusing on extending rights and either denying or avoiding the question of whether this enhanced equality will, in fact, also lead to role change. The other faction is avoiding the question of equality and focusing on the

threat of change. Neither group has spoken against the claims of its adversaries. Each side simply maintains its own position of either advocating role equity or fearing role change. The question of whether equality for women inevitably leads to dangerous social instability is never even addressed.

Because neither side has been willing or able to counter the arguments or the stance of its opponents, they have both left open the question of whether equal wages for women are more appropriately seen as role equity or role change. Neither side has tried to resolve the tension between family and equality. Rather, discussions of comparable worth seem to be based on an implicit acceptance of the evaluation of Charlotte Perkins Gilman, one of America's early feminists. She noted the difficulties of combining the values of equality and family in her own life:

> We have so arranged life that a man may have a home, a family, love, companionship, domesticity and fatherhood, yet remain an active citizen of age and country. We have so arranged life, on the other hand, that a woman must "choose"; must either live alone, unloved, unaccompanied, uncared for, homeless, childless, with her work in the world for sole consolation; or give up all world service for the joys of love, motherhood, and domestic service.[9]

Contemporary discussion of women's wages all too frequently still asks women to make a choice between the desire for equality in the public arena and the desire for a family. Women today still feel the need to choose between career and motherhood. That this decision is still being required should not be surprising. The conflict between equality and family is ingrained in both the theological and secular traditions of the Western world.

FAMILY AND EQUALITY: THE THEOLOGICAL TRADITION

The tension between family and equality for women has a long history in the Western religious tradition. The cosmology on which Western religious thought rests offers conflicting views. The Bible itself offers evidence of tension about the proper place of women in society. Genesis 1:27 states that women and men were both created simultaneously, and in God's image. Genesis 2:22 offers a story of Adam's creation preceding Eve's.

Many in the religious tradition read the cosmogonic verses as evidence that women are not equal to men by virtue of their later creation. The desire to establish equality between the sexes would therefore be inappropriate. Genesis 3, the story of Adam and Eve's expulsion from the Garden of Eden, known in the Christian tradition as "the fall," can be viewed as the justification for the public/private split and for job segregation by sex. Adam's punishment is to toil and earn his bread by the sweat of his brow. Eve's pun-

ishment, on the other hand, is to have her husband rule over her and to bear children in pain. According to this story, women and men are ordained by God to have different functions in life. Man is to work in what we now call the public arena; woman's work is confined to the family.

This cosmology permeates the entire Western religious tradition. Religious opponents of the idea of comparable worth refer to this story as proof of the correctness of their position. According to Mary Daly, the stories of creation and the expulsion from the Garden of Eden have "projected a malignant image of the male-female relationship and of the 'nature' of women that is deeply imbedded in the modern psyche." [10] Religious advocates of women's equality, on the other hand, must still explain its meaning even while interpreting the story differently from their adversaries. Thus theologians have long debated the significance both of the creation stories and of the expulsion from paradise. These are the stories that form the base for theological discussion of the nature of women and men and of the appropriate relationship between the two genders. These are also the texts that underlie discussions of the nature of sin, of humanity's relationship to God, and of redemption.

In the Jewish tradition, these stories are used to explain that marriage is positive and, indeed, necessary. After all, Genesis 2 states that man is to leave his mother and father and to "cleave unto his wife." Moreover, the first biblical commandment is to "be fruitful and multiply" (Gen. 1:28). According to this tradition, marriage, not celibacy, is the higher good. It is fitting that women be wives and mothers for that is what they were commanded to be in Genesis 3. A woman's desire is for her husband, and she will bear children in pain. As in all traditions stemming from the Bible, the stories of cosmology are not the only ones used to explain or order the world. They are primary, however, for understanding the relationship between the genders.

The Christian tradition is replete with discussions of such questions as the relative good of marriage versus celibacy, the inherent good or evil in sexual relationships, and the role of women in bringing sin into the world. The church fathers discussed these subjects at great length, generally agreeing that sex, especially sexual desire, must be viewed, at least since the fall, as evil. Celibacy was seen as a more admirable state than indulging one's sexual passions. While marriage was the only appropriate place to act upon these desires, it was still viewed as less positive than celibacy. Sexual desire was seen as part of the punishment for sin. While the church fathers debated whether there would have been sexual relationships at all in the Garden of Eden, they agreed that if they had taken place, they would have been without the concupiscence of subsequent time.

Women were viewed as intrinsically connected with sin, since Eve was the person who first ate of the forbidden fruit and who then tempted Adam. Because of this first sin, the church fathers (and the Catholic Church, as well as many Protestant denominations) assume that all people are now born into a state of original sin.

Martin Luther, and the Reformation, added another religious perspective on these topics. Luther did not agree with the church fathers that celibacy was a better condition than marriage. Rather, he viewed marriage as the highest estate for women and men. Marriage, for Luther, was part of God's plan. Of course, sexual relationships were still to take place only within marriage, and then, as with his forbears, only for purposes of procreation. Women's primary purpose was to bear children and they were still seen as connected with bringing sin into the world.

The relationship between sin and sexuality, and the tradition of gender inequality, appear in the modern era as the tension between equality and family. It is still commonly assumed that women's role as childbearer leaves her unable to be treated as man's equal.

This belief is so deeply ingrained that many who attempted to encourage women's equality developed alternatives to the patriarchal family and to women's childbearing. For example, Ann Lee, the founder of the Shaker community, recognized the question of the relationship between the genders as basic to society. Lee clearly saw a tension between equality and family. She thought that in order for women to gain the equality with men to which they were entitled they had to avoid sexual relationships. For Ann Lee, sex was at the heart of sin and therefore must be abjured. Women should be married to Jesus. Ann Lee's version of redemption included an understanding of a sexless Kingdom of God: "The power thus to live, in virgin purity and innocence, is found in the conviction that a spotless, virgin, angelic life is the order of the kingdom of Christ, and is higher, better, happier than a sensual, worldly life. . . . Shakers . . . do not condemn marriage, nor orderly generation, *as worldly institutions*, but claim these have no place in Christ's kingdom; therefore, *relegate them to the world, where alone they belong*." [11]

Many utopian communities, popular in late 19th-century America, also wrestled with the question of women's equality. Most concluded that if women were to be men's equals radical changes in the family were necessary. John Noyes, the founder of the Oneida community, thought that in order to alter the fundamental nature of society he would have to change the nature of sexual relationships between women and men. In order to free women from the overwhelming burdens of childbearing and child rearing, he proposed radical sexual practices. Complex marriage, a system in which all

believers are married to one another, no longer limited sexual relationships to one partner. His theological justification was based on his interpretations of the Christian concepts of love and redemption. As Noyes explained in proposition nine of *Bible Communism*:

> The abolishment of sexual exclusiveness is involved in the love-relation required between all believers by the express injunction of Christ and the apostles, and by the whole tenor of the New Testament. "The new commandment is, that we love one another," and that, not by pairs, as in the world, but *en masse*. We are required to love one another *fervently* (1 Pet. 1:22), or, as the original might be rendered, *burningly*. The fashion of the world forbids a man and woman who are otherwise appropriated, to love one another burningly—to flow into each other's hearts. But if they obey Christ they must do this. . . .[12]

The influence of the Genesis stories can be seen in the entire Western religious tradition. The basis of society in these religions stems from God's creation and from the relationship of women and men that comes from this creation. Even when, in the modern era, women's equality is desired, it does not seem possible to achieve it without fundamentally changing the relationship between women and men and indeed, the entire social structure. Women's traditional role in the family is in tension with women's ability to be men's equals in society. The question both Judaism and Christianity still confront is whether it is possible to resolve this tension without resorting to radical or utopian alternatives like the Shaker and Oneida communities.

FAMILY AND EQUALITY: THE SECULAR TRADITION

A similar tension between equality and family can be seen in the non-religious inheritance of the Western tradition. Even a cursory glance at political theories indicates the conflict between these two values for which there are several practical and theoretical explanations.

As many observers have pointed out, the family perpetuates inequalities in society. Plato was perhaps the first Western philosopher to note that if one desired true equality in society the institution of the family would have to be abolished. The guardian class in Plato's *Republic* was to be made up of equal individuals, both women and men, whose children were to be raised not in individual families, but in common.

Centuries later, John Rawls noticed the same tension between equality and family. In his important work, *A Theory of Justice*, Rawls claims:

> The principle of fair opportunity can be only imperfectly carried out, at least as long as the institution of the family exists. The extent to which natural capacities develop and reach fruition is affected by all kinds of so-

cial conditions and class attitudes. Even the willingness to make an effort, to try, and so to be deserving in the ordinary sense is itself dependent upon happy family and social circumstances. It is impossible in practice to secure equal chances of achievement and culture for those similarly endowed and therefore we may want to adopt a principle which recognizes this fact and also mitigates the arbitrary effects of the natural lottery itself.[13]

Michael Walzer agrees that the family is a breeding ground for inequality. "Here is a world of passion and jealousy," he writes, and a "perennial source of inequality."[14] The family offers not only unequal economic benefits but also "functions as an emotional unit within which love is hoarded and passed on."[15] Thus, "favoritism begins in the family—as when Joseph is singled out from his brothers—and is only then extended into politics and religion, into schools, markets, and workplaces."[16] According to Walzer, it is then not surprising that "the most radical egalitarian proposal, . . . the simplest way to simple equality, is the abolition of the family."[17] Yet Walzer does not advocate this simple solution for he believes that "the family is a sphere of special relationship."[18] Thus, "the strength of the family lies . . . in the guarantee of love. The guarantee isn't always effective; but for children, at least, no one has yet produced a substitute."[19]

These inherent conflicts between equality and family are heightened in the modern era. With modernity, society has become increasingly complex, and, as Talcott Parsons has noted, ascriptive attributes such as family status have tended to be replaced by more achievement-oriented concerns in the public arena. At the same time, individual characteristics such as intelligence or skill that can in some way be measured have become more important than one's standing in the community. Of course, as Jesse Bernard has observed, while Parsons' archetype of modern society may be descriptive of the world of men, his premodern archetype describes not only preliterate societies but is also apt for contemporary women within the sphere of the family.[20]

With modernity, the differences between the world of work and the world of the family have actually intensified. Equality of treatment in the workplace has become the accepted standard, but ascriptive characteristics are still dominant in the family. Today the family is based more on personal choices than in the past, and therefore the conflict of value between the work world and the domain of the family is greater than in previous eras. As Walzer points out, in premodern times families were often formed on the basis of status and power, as in arranged marriages between monarchs. It is only in modernity that people are expected to marry for love, an emotion that simply does not, or is at least not supposed to, oper-

ate in the work arena. The differences between these two arenas of work and family, and the conflict in the principles by which they are seen to operate, has increased.

There are other reasons as well why this tension between family and equality persists. For example, a concept such as love cannot be explained by the more rational characteristics that modernity values. As Max Weber wrote at the beginning of the contemporary era, a long marriage "up to the pianissimo of old age"[21] characterized by love and a feeling of mutual responsibility is not only rare, but must be viewed as a gift of grace, not as a reward for one's merit. Marriage and family based on love, then, cannot be accounted for by the rational principles of modernity. They are seen to operate outside the realm of the rational.

Families are also hard to place in liberal theory since liberalism is based on the concept of individualism. From either the utilitarian perspective of each person counting for one in a calculation designed to predict the outcomes of actions, or the Kantian perspective of each person being valued as an end in him or herself, the liberal tradition rests on the individual, not the group. In the social contract model, people voluntarily agree to come together to form a society; the individual precedes the group. Further, in modernity personal merit was to replace characteristics based on group membership as the criterion for social reward. Yet families are, in fact, groups and operate as such.

Although American society at least theoretically values the family and seeks to maintain it, the political arena and political rights are based not on families but on individuals. John Rawls' theory of choice of political process perhaps best epitomizes this dichotomy. Rawls posits that in order to choose the best political system individuals would be placed behind a "veil of ignorance" where characteristics such as their age, sex or gender would be unknown. Yet, for purposes of this free choice, it is helpful to assume that each is head of a family!

> I shall make a motivational assumption. The parties are thought of as deputies for a kind of everlasting moral agent or institution. They need not take into account its entire life span in perpetuity, but their goodwill stretches over at least two generations. Thus representatives from periods adjacent in time have overlapping interests. For example, we may think of the parties as heads of families, and therefore as having a desire to further the welfare of their nearest descendants. As representatives of families their interests are opposed as the circumstances of justice imply. It is not necessary to think of the parties as heads of families, although I shall generally follow this interpretation.[22]

There is no room, even in this theory, for specific members of a family representing different opinions or different needs. The family is most easily addressed by transforming it into an individual actor, represented by its titular head, who in the Western tradition is automatically a male. The search for equality in a liberal society leads Rawls, ironically and perhaps unconsciously, to celebrate a condition of inequality in spite of himself.

PUBLIC DOMAIN V. PRIVATE DOMAIN

Because the issue of comparable worth deals with the conflict between the values of equality and family, it can be described in terms of another fundamental dichotomy in the Western tradition: the split between public and private realms. The issue of comparable worth stands at the boundary between these two realms. Although the manifest area of concern is the public arena—the workplace—the issue of comparable worth raises as many questions about the family as it does about the workplace. This placement at the boundary is especially interesting because in the Western tradition, women have been seen as occupying only one realm—the private. The notion of "public man" and "private woman," as Jean Bethke Elshtain has put it, has such a long, almost unbroken history in Western religious and political tradition that any change in the relationship between these two spheres, or in the relationship between the two sexes who are seen to occupy these separate spheres, is threatening to society.

In the religious tradition this notion of a clear distinction between the public and private is present in the stories of cosmology. Adam and Eve were given distinct roles and different realms. According to Elshtain, in the Greek tradition it was Aristotle who first delineated the split between the family and society, between private and public, female and male. Just as in the religious tradition, in Greek thought the family was seen as the realm of the private, of the non-political, and of women. The *polis* was the realm of the public, of the political, and of men.

For Aristotle, as for almost all who followed him, the distinctions between these two spheres of life, and the different value placed on them, had serious implications both for the structure of society and for the worth of women. Because the public realm was seen to be of higher value than the private, men, the masters in the public realm, were more significant to society than women who were relegated to the less important arena. Since it was only in the *polis* that the highest good could be attained, women, almost by definition, were inferior to men and had to be subordinate to them. As Elshtain notes, "Because the good at which the household (*oikos*) aimed was a lesser good than the *polis*, the wife-mother achieved only the limited good-

ness of the 'naturally ruled,' a goodness different in kind from that of the naturally ruling." [23]

Women were necessary to the well-being of the *polis* because the services they performed gave men the free time they needed to be full citizens. Yet this work did not give women any moral standing. As with slaves and other non-citizens, Aristotle compares women and men, subjects and rulers, to flute players and flute-makers: "one makes use of what the other makes." [24] Only men, full citizens, could attain "fully realized moral goodness and reason," [25] because only they were allowed to participate in public life. "Women *share* in goodness and rationality in the limited sense appropriate to their confinement in a lesser association, the household." [26]

Susan Moller Okin sees the implications of this public/private split throughout the history of Western political thought: "The only place in political philosophy where women are already included on the same terms as men is Plato's guardian class in the *Republic*. There the abolition of the private sphere of life, the control of reproduction, and the socialization of child-rearing and all domestic functions, result in the male and female guardians being both similarly educated and similarly employed." [27] However, in the works of almost all the other major Western political philosophers, including Hobbes, Locke, and Machiavelli, "the existence of a distinct sphere of private, family life, separated off from the realm of public life, leads to the exaggeration of women's biological differences from men, to the perception of women as primarily suited to fulfill special 'female' functions within the home, and consequently to the justification of the monopoly by men of the whole outside world." [28]

This separation of the spheres has implications not only for women and men but for society as a whole. According to Okin, "the sphere of public life is in many important respects premised on the existence of the private sphere of a family. . . ." [29] In other words, the public sphere is based on having citizens who have the time and freedom to perform the tasks that are necessary for the maintenance of the polity. Men have this ability because others, namely women (and formerly, slaves), are taking care of the time-consuming jobs that maintain the private sphere. If women ceased doing these chores, then men would no longer have the same time available for their work in the public arena. Conversely, by doing these "female" jobs, women become so bogged down that they do not have the time to participate in the public arena. The demands on her "define woman's function and life style, and exclude her from equal participation and status in the world of economic and public life." [30] Women, like slaves in the ancient world, and the underclass today, are less able to exercise all the rights of citizenship.

The notion of separate spheres became further entrenched during the industrial revolution. With the development of the factory, much work that had once been done inside the home began to be performed outside of it. Women who remained at home taking care of the house and children became more isolated than ever from public life. Work also began to be defined as paid labor. Since women were not paid for their labor in the home, it was even further devalued. Nancy Chodorow claims that this further bifurcation of the public and private realms hindered women in the private as well as the public arena:

> [The] extension and formalization of the public-domestic split brought with it increasing sexual inequality. As production left the home and women ceased to participate in primary productive activity, they lost power both in the public world and in their families. Women's work in the home and the maternal role are devalued because they are outside of the sphere of monetary exchange and unmeasurable in monetary terms, and because love, though supposedly valued, is valued only within a devalued and powerless realm, a realm separate from and not equal to profits and achievement.[31]

In his analysis of the industrialization of Europe, Frederick Engels used terminology that has become popular today. He referred to the work of the public and the private arenas as material production and human reproduction.

Many contemporary feminists argue that it is the separation of public and private realms that is largely responsible for women's social subordination to men, and, thus, for women's receiving lower wages than men. Since women don't really belong in the public arena, it is argued, it is not necessary to give them the same rewards as men in the workplace. Lucinda Finley, for example, claims that "the notion that the world of remunerative work and the world of home—or the realms of production and reproduction—are separate, has fostered economic and social subordination of women."[32] Yet the acceptance of these two spheres is deeply ingrained in both the secular and the religious traditions of the Western world. Sources as diverse as the Bible, Plato and Aristotle, Marx and Engels, all seem to confirm the existence of two distinct categories in daily life: the public and the private.

Okin adds the stark reality that to include women in the public arena would require a rearrangement of both the public and the private spheres. If women are integrated into public life, it can no longer be assumed that they alone are responsible in the private sphere:

> It is by no means a simple matter to integrate the female half of the human race into a tradition of political theory which has been based, almost without exception, upon the belief that women must be defined exclusively by their role within the family, and which has thus defined them, and intra-

familial relationships, as outside the scope of the political. There is no way in which we can include women, formerly minor characters, as major ones within the political drama without challenging basic and age-old assumptions about the family, its traditional sex roles, and its relation to the wider world of political society.[33]

EQUALITY V. ALTRUISM

There is another reason that the public/private split leads toward lowered wages for women. As Okin notes, the public and private spheres are not only separated, but they each operate on different moral and organizational principles. Where the liberal political tradition assumes that the public arena operates with self-interested individuals, the private sphere, the home and family, is thought to operate on the basis of altruism. "Theorists who have assumed a high degree of egoism to determine relations between individuals in the sphere of the market, have assumed almost total altruism to govern intrafamilial relationships."[34] It is women, operating in the private realm, who are seen to epitomize this selflessness. When women enter the public arena they, and their male co-workers, are presented with a dilemma. If they are viewed as women, they must be selfless, and therefore unable to demand higher wages. If women do not behave altruistically, they are often accused of not behaving as women.

The question of women's wages, then, is far more complicated than economic or legal writings suggest. It is a conflict not only about women's place in society but about what kind of society we desire to have. The values of family and equality could both be held in society as long as they were differentiated between the genders. Society would not have to choose between two goods if men upheld the value of equality by their presence in the public arena and women maintained the value of the family and altruism by their presence in the private arena.

However, once women enter the public arena, this division of labor—and division of values—does not work because the relationship between the public and private is changed. With women's entry into the work force, society must now confront a conflict between these two values which are both held dear. By requesting equal treatment in the work world women are asking to be treated in the same way men are treated. This reform seems to diminish the value of altruism and of family. Yet if women are not treated equally in the workplace, the importance of the value of equality is shown to be suspect. Is it any wonder that women's equality is not an easy issue, or that many people are angry with those who are demanding it?

Women's entry into the public arena raises difficult questions for soci-

ety. The dilemma of women's wages and women's worth cannot be resolved without facing these underlying conflicts about values. Until we find a way to continue to maintain the value of equality and the value of the family without having to offer each gender only one, women's wages will not reach parity with men's.

RELIGION AND POLITICS

Because the comparable worth debate rests on a conflict of values, it is necessary to understand the role that religion plays in its unfolding and in its resolution. In the United States the religious tradition often parallels the secular order. It cannot be assumed that only the secular tradition, and contemporary secular thought, is having an impact on the comparable worth debate. The influence of Western religious thought on such questions as women's place and women's worth is often critical to understanding the origins of values and philosophies. The different relationships between the religious and secular voices on both sides of the policy question are an integral part of the discourse.

Students of the subject assert that religion is an important area to study in order to understand society. Classic scholars of society, including Durkheim, Marx, and Weber, acknowledged the critical influence of religion on social life. Weber in particular tried to assess the influence of ideas on the material world. He saw ideas as the "switchmen"[35] that may change the course of public policy. The relationship between religion and politics is demonstrated not by the numerical strength of various groups or structures but by the exchange and influence of ideas.

Both the discovery and the evaluation of the relationship between religion and politics are complex and always controversial. Discerning the particular effect of religion on any public policy debate is never easy. Scholars disagree about whether it is religion which undergirds public policy, or whether it is changes in the political arena which lead to developments in religious movements. Because both the religious and the political traditions are integral segments of American culture today, it is often difficult to separate one from the other.

It is wisest to conclude that both spheres influence each other.[36] Kent Greenawalt notes that political decisions are made by people who are themselves affected by a large variety of factors, including religious elements. Although it can be difficult to separate a religious from a non-religious impact, it does not follow that religious influences should therefore be discounted. Religious backgrounds and preferences are part of what all people bring with them to their decision making.[37]

Robert Wuthnow notes that the split between conservative and liberal religious positions has replaced denominational divisions as the most salient category in describing American religion. His recent study demonstrated

> what many had already suspected was a deep division in American religion: a division between self-styled religious "conservatives" and self-styled religious "liberals," both of whom acknowledged a considerable degree of tension with the other side. Added to the misgivings, stereotypes, and unpleasant contacts characterizing each side's relations with the other were deep differences in theological, moral, social, and political orientation. True to their labels, religious conservatives were committed to doctrinally orthodox views of the Bible and of God, to tough positions on abortion and pornography and to politically conservative views on government spending and defense. Religious liberals took quite different stands on all these issues. Furthermore, the study showed that the public was almost evenly divided between these two camps. . . .[38]

This study confirms Wuthnow's claim. Although there are many different groups who offer their opinions on the subject, the debate is most easily seen in terms of political and religious conservatives and liberals. In order to highlight the value conflict most clearly the groups reviewed in the following four chapters represent the most conservative and the most liberal religious and political views.

These chapters illustrate the interaction of the political and religious spheres on the comparable worth discussion. They show that the impact of the religious voices on this policy has been unappreciated. The complexity of the issues and their direct relevance to the fundamental values on which American society is based precipitates a discourse that is rooted in the deepest philosophical, legal, and religious principles on which the community rests.

3

The Free Market Conservatives

The major case against comparable worth is made by those who see it as a disruption of the work of the free market. These opponents claim that the market itself is the most neutral, non-discriminatory way in which to determine wages. By a complicated process of supply and demand, the market sets the appropriate price both for products and for wages. Free market advocates are fond of noting Adam Smith's claim about the place of values in the economy. Water, Smith pointed out, is far more useful and necessary than diamonds. Yet diamonds command a higher price in the marketplace. One should not assume, Smith argues, that diamonds are intrinsically more valuable. Rather, their price is based on the fact that the demand for them exceeds the supply. In a parallel fashion, free market conservatives argue that women's lower wages are not a result of discrimination nor are they a comment on the social value of women's work. They are simply the consequence of the workings of supply and demand. One cannot conclude that women are less valued in society because of the mechanisms of the marketplace.

And so opponents of comparable worth begin by pointing to the difficulty of determining discrimination in wages set in the workplace. They seek to show that most of the differences in wages between women and men can be explained by measurable and non-discriminatory factors. What small amount of the difference in wages that cannot be accounted for by such factors, they say, is unlikely to be the result of discrimination. Women's free choice or other as yet unmeasured variables might account for these num-

bers. According to a 1986 study published by the Brookings Institute, analyses based on statistics

> can show that earnings or wage differentials are not fully explained by any number of measurable characteristics of men or women or the jobs they hold. But they cannot rule out the possibility that the discrepancy is caused by unmeasured variables other than discrimination and other than those included in the surveys on which these studies are based. In particular, they cannot rule out the hypothesis that wage or earnings differences are the result of voluntary behavior.[1]

Comparable worth critics also worry about the use of job evaluation techniques for the purpose of setting wages. They assert that since wages are not based on the intrinsic worth of a job, but rather on what the market will bear, any technique that claims to set value will be inherently more discriminatory than the market itself. Any attempts to assess the worth of jobs will themselves be dependent on the judgment of fallible human beings. While job evaluations may be helpful for determining gross discrepancies of pay within a firm, they are inadequate, and possibly harmful, tools for judging appropriate wages over large job categories. The market, not evaluation techniques, is the ultimate tool for setting the dollar value of different work.

Free market advocates are concerned in general about the effects of tampering with the market. They worry that any incursion into the workings of supply and demand can lead down the slippery slope to socialism at best and totalitarianism at worst. Members of this group often quote the judge in the case of *Lemons v. the City and County of Denver*. Comparable worth is "pregnant [sic] with the possibility of disrupting the entire economic system of the United States of America."[2]

Finally, free market conservatives emphasize the differences between women and men and the role that women's free choice plays in determining women's wages. Where advocates of comparable worth assume discrimination, opponents claim that women prefer, and freely select, jobs that are more suited to their roles as wives and mothers, even though these jobs command lower wages. Free market supporters see women's free choice as the single most important determinant of women's wages. They assume that women are fundamentally distinct from men and that this condition affects their respective job choices. If women and men were alike, then women's free choice—postulated to be a key factor in the wage gap according to free market conservatives—would lead them to the same employment as men. Many comparable worth opponents devote considerable attention to proving these differences between the genders; others merely assume them.

WAGE SETTING: RELEVANT FACTORS V. DISCRIMINATION

For free market conservatives, the discrepancy in wages between women and men can be explained by a number of factors that relate to the way in which wages are set. The pay gap between men and women is not proof of discrimination against women as a group. Instead, both genders' wages are determined by the same non-discriminatory factors which include such variables as the training or education required for a job, the skill necessary to perform it, the number of years one has worked and the consistency of one's work history. If women are weaker than men in those factors that command higher wages in the work world, women will be paid less. Men presenting the same credentials would be equally poorly paid. That is how the market operates, say its advocates.

Robert E. Williams and Lorence L. Kessler, in a book published by the National Foundation for the Study of Equal Employment Policy, state that "most observers agree that there are identifiable reasons, unrelated to any employment discrimination, that explain a substantial portion of the earnings differential between men and women."[3] Women and men differ in all of these factors and free market conservatives believe that if these discrepancies are identified, they can account for most of the pay gap. For example, although government statistics identify full-time workers as those who work 35 hours or more per week, in fact men tend to work more hours than women.[4] Men also tend to have more continuous work experience than women. Since it is women, not men, who usually take time off from work for childbearing and rearing, women's work patterns show more discontinuity than men's. Opponents of comparable worth consider this a non-discriminatory factor since men who demonstrate the same pattern of discontinuity earn similarly depressed wages. At least in part because of these discontinuities, women actually work fewer years than men. Opponents of comparable worth also point to women's lower education levels compared to men's as partial explanation of the wage gap.

Finally, they note that since many women have entered the labor force recently, there is a disproportionate number of inexperienced female wage earners. Male workers, on the other hand, are more evenly distributed across all age and experience classifications. The wage differential between all women's and all men's wages reflects this distribution, they say. Beginning jobs show little difference in salaries between women and men. Thus, opponents of comparable worth claim that as more women enter and stay in the ranks of the work force this skewed pattern will end, and the statistics will reflect a smaller gap between the wages of women and men.[5]

Free market conservatives assume it is the differences in women's and

men's lives, especially the distinctions in childbearing and child rearing, that account for the largest segment of the pay gap between women and men. This group claims that women tend to seek employment opportunities that are more adapted to family responsibilities. They assert that women tend to take jobs with fewer responsibilities,[6] or jobs that are closer to their homes,[7] or jobs that they can leave and come back to after taking time off for child rearing.[8] None of these choices, although they lead women to lower paying jobs, can be seen as discriminatory against women. Williams and Kessler state:

> Women as a group, to a greater extent than men, have traditionally assumed the primary role for child-raising responsibilities. If, as a result of these responsibilities, individual women have taken certain kinds of jobs more often than individual men because the hours and other requirements have been seen as compatible with child-raising responsibilities, should the presence of these women in predominantly female occupations be regarded as a result of employment discrimination? . . . And if the large numbers of women in a few occupations that seem to be most compatible with such patterns and expectations results in an oversupply that drives down the market price of labor in those occupations, is this a problem to be remedied by employment discrimination law?[9]

Michael Levin similarly argues that it is women's childbearing and child rearing that explains the wage gap. Because of these typically female concerns, women are simply attracted to lower paying jobs or do not have the qualifications necessary for higher paying positions: "It is perhaps unfair that it takes spinsterhood to free a woman for work as much as marriage frees a man, but that is irrelevant to whether marriage does in fact depress female wages, and this nondiscriminatory factor indeed explains much, perhaps all, of the wage gap."[10] The market merely reflects, and does not cause, the differences between women and men and thus, between women's and men's wages.

WAGE SETTING: JOB EVALUATION TECHNIQUES

Free market conservatives are quick to point out that they agree with supporters of comparable worth that there should be no discrimination against women in setting wages. The market must recognize supply, demand, and merit—not gender. They disagree, however, about how wages should be set: "Nondiscrimination in pay practices is an objective shared by employers, employees, and society generally. The central argument continues to be over the proper role of the government and whether comparable worth is an appropriate method to enforce the laws against discrimination."[11] Specifically, they wonder whether there is any fair way of setting wages outside the mechanism of the market. They assert that there is no agreed upon, scien-

tifically proven method of wage setting. Thus they ask, "if job worth cannot be determined by scientific, objective means, who will make the determinations of job worth that are inherent in any system of comparable worth?"[12]

Free market conservatives point to the difficulties with job evaluation methods and claim that "until comparable worth has been associated with some measurement device, the concept cannot be applied in any comprehensive or systematic manner."[13] They note not only the disagreements about various techniques but the large number of divergent interpretations of statistics. Where some experts construe data to prove discrimination against women, others find that the same data offer no evidence of discrimination. For example, Harry V. Roberts, an expert witness in a case involving the Harris Bank, found that "the shortfall in female earnings is fully explained when the data have been adjusted for three biases. In other words, the adjusted data are more consistent with an assumption of nondiscrimination than with an assumption of discrimination."[14]

Free market advocates note the complexities inherent in job evaluation techniques. It is very difficult, and almost inevitably subjective, they say, to compare such different qualities as skill, responsibility, or physical labor. Advocates of comparable worth generally favor a job evaluation technique that works from the bottom up—one that sets appropriate salaries rather than explaining the different salaries that already exist. They note that their method differs from the "policy capturing approach" which "selects and weights [factors] so as to replicate the firm's existing pay structure."[15] Most comparable worth supporters favor the "factor point method" for setting wages:

> It begins by identifying a set of compensable factors, which are elements considered to be legitimate bases for pay differentials among jobs. Then scales are devised for measuring the extent to which the various factors are associated with jobs. Next, to take into account that some factors are more important than others, the factors are weighted. Finally, each job is scored on the various scales; the weightings are applied; and each job receives a total score.[16]

Opponents of comparable worth claim that this factor point analysis is not only extremely difficult to implement but that it is also subject to the particular prejudices of the evaluator. They note that agreement between evaluators is highly unlikely:

> The major difficulty with job evaluations . . . is their subjectiveness; they are open both to variation in judgment and to manipulation. Assessing the degree of skill, effort, and other factors required by a job is, in the final analysis after observation is complete, a matter of judgment, and the judgments of job evaluation experts can and do differ. Admission of job evaluation testimony presents problems for courts not unlike those raised by

psychiatric testimony in sanity trials, because of the subjective, nonverifiable nature of the judgments that must be made in both situations.[17]

Critics point to the variation in scores of the same jobs given by different evaluators in different states: "Vermont values its photographers twice as highly as Iowa, while Minnesota's photographers are worth 25% more than Iowa's."[18]

Free market conservatives also question whether any evaluation of a job's worth can take place outside of the context of supply and demand. They claim that factor point analysis focuses on the demand side of the supply and demand formula while ignoring the supply side. They cite such hypothetical cases as the Spanish-English translator in Miami compared to the translator of the same language in Montreal.[19] While it is undoubtedly true that the requirements, skills and education are equal, if not identical, for both of these people, one will command a higher wage than the other. Because it is much easier to find a Spanish speaking person in Miami, the Floridian's talents will not be rewarded as much as the Canadian's. If the language in question, however, were French instead of Spanish, the two translators' salary expectations would be reversed. Comparable worth critics insist on the need to link any job evaluation programs to the mechanics of the market.

THE "WORTH" OF A JOB: THE FREE MARKET V. TOTALITARIANISM

Similarly, free market conservatives point out that the "worth" of any job is based on the laws of supply and demand and that wages reflect only the value of the job to the particular employer, not its social merits. Wages, they claim, have never reflected the worth of a job to society, merely its value to the particular firm. They agree that many jobs seem to be paid less than their importance to society should merit. They assert that school teachers or nurses do not have an inferior social value to lawyers or doctors just because their wages are usually lower. These discrepancies are not commentaries on social worth, they insist, but merely the workings of supply and demand.

Free market conservatives believe that the case of *Lemons v. the City and County of Denver* noted in chapter 1 highlights the problem of comparable worth. The nurses hired by the city and county complained that they were earning less money than the gardeners and sought to prove that nursing required more skill, education, and responsibility than gardening. They argued, therefore, that their work should be "worth" more to the city and county. To the conservatives, the judge properly ruled that the nurses' wages were based on the market within that location. Since nurses at private hospitals were paid the same wages as nurses at public institutions, the nurses lost their lawsuit. The laws of supply and demand dictated that the city could

hire nurses at the wage they were being paid for private employment, while it could not hire gardeners at a lower wage than they were receiving outside public employment. Opponents of comparable worth reiterate that the "value" of any job is simply the rate that is reflected in the market.

If salaries were to be set by the true value of the job to society, free market conservatives fear that America would be on the road to socialism, a slippery slope that many opponents of comparable worth believe leads almost inevitably to a totalitarian state. Williams and Kessler, in their 1984 study for the National Foundation for the Study of Equal Employment Policy, state the matter succinctly:

> Fundamental to the concept of comparable worth is acceptance of the proposition that some entity will make a determination of the worth of each job. Today such determinations are made by employers individually or through collective bargaining, governed primarily by market forces. Under comparable worth, they would be made by third parties or would be subject to third party approval and would be governed primarily by assessments of job content. To be enforceable, the determinations would necessarily have to meet basic standards of legal certainty. They would have to be determined by procedures incorporating rules of evidence and standards of proof and affording due process to the parties involved.[20]

Michael Levin and George Gilder proceed even further in their cries of alarm. Levin sees comparable worth as the "feminist road to socialism," as the title of his 1984 *Commentary* article puts it.[21] Gilder writes of the totalitarian implications of the concept:

> In place of a relatively free job market, comparable worth would require a federal bureaucracy to determine the appropriate pay for each job and each set of credentials and qualifications and to enforce the law throughout millions of businesses in the inevitable flux of economic change. Utterly subjective despite a show of scientific pettifoggery and precision, comparable worth evaluations would be open to endless litigation and challenge, and thus to arbitrary power.[22]

Gilder notes that "it is unlikely that many feminists have any idea of the totalitarian implications of their ideas," because most feminists suffer from a "complete incomprehension of the needs of a prosperous economy."[23]

At the very least, opponents claim that comparable worth would be a disaster for many American businessmen and, by extension, for American business itself. Many companies would become uncompetitive since, as Michael Levin puts it, even "voluntary adoption of Comparable Worth pay scales would be economic suicide. If a firm simply raised the salaries of its females while letting the salaries of its males rest at the general level dictated by the market, it would incur costs incurred by none of its competi-

tors. If it tried to correct matters by lowering the salaries of its male employees, these male employees would promptly disappear or haul in their union." [24]

An even more frightening prospect, as far as opponents are concerned, is that American business itself would lose its competitive edge in foreign markets if enough American companies had to pay undue expenses in order to implement comparable worth policies: "Recent experience in steel, automobile manufacturing and other industries once dominated by U.S. firms has made employers and economists painfully aware that, in today's global economy, when the wage component of production costs of American products rises too high in comparison with that of foreign-made goods, U.S. workers lose jobs to overseas competitors and the overall U.S. economy suffers." [25]

Since free market advocates in general see the role of American business as "business," in the words of Milton Friedman, any measure that impairs a company's capability to increase revenue ultimately hinders the American economy, and by extension, the American political system. For Friedman, as for many free market advocates, "there is one and only one social responsibility of business—to increase its profits so long as it stays within the rules of the game, which is to say, engages in open and free competition without deception or fraud." [26]

Free market conservatives often perceive the American political system resting on an intricate and mutually beneficial relationship between business and government. As Charles Lindblom states: "Public affairs in market-oriented systems are in the hands of two groups of leaders, government and business, who must collaborate." [27] Moreover, "to make the system work government leadership must often defer to business leadership." [28] Lindblom sees this "duality of leadership" as "reminiscent of the medieval dualism between church and state," and notes that "the relations between business and government are no less intricate than in the medieval duality." [29] Any tampering with this delicate relationship invites disaster, and comparable worth policies would upset the relationship by giving government too much power over business. Some women's wages might improve, but only at the expense of the deterioration of the already fragile American economy and political system.

FREE CHOICE: WOMEN, MARRIAGE, AND FAMILY

The concept of the free market rests critically on the assumption of human freedom, especially freedom of choice. Opponents of comparable worth assume that it is women's free choice—specifically their choice to marry and become mothers—that is the crucial factor that accounts for the divergence

in wages between women and men. Ironically, they agree with advocates of the policy that the gap between women's and men's wages increases when women become mothers. They assume, however, that since women are free either to marry or not, or to become mothers or not, this increased gap is reflective of a non-discriminatory factor.

Free market conservatives often cite statistics that indicate that the gender pay gap is not stationary but rather varies with the ages of the workers. Williams and Kessler note that in 1977 "for employees between 20 and 24 years of age, women's earnings are 77.7 percent of the earnings of men; for workers between 25 and 34 years old, the ratio is 68.8 percent; and for those between 35 and 44 years old, the ratio is 56.2 percent."[30] The wage gap increases as women begin to have children and does not diminish even when women return to work. The 1990 statistics show the same pattern in women's wages according to their ages. In 1990, 16-to-24-year-old women earned 90 percent of the wages of men the same age. Women aged 25-34 earned 79 percent as much as men. Women above the age of 34, however, earned less than 70 percent of the male wage. Only after age 65 does the trend reverse. These women earn almost 75 percent of the male wage.[31]

This consistent pattern in the wage gap seems to indicate that it is not women as a group whose wages are depressed. Rather, it is women with children whose wages suffer. If women were not mothers, their salaries would be much closer to men's. Free market conservatives conclude that there is no evidence of discrimination against women as a gender. Rather, the freely chosen conditions of women's lives lead them to lower wages.

Free market conservatives claim that women, either biologically, psychologically, or sociologically, prefer different occupations than men. In order to prove their point, they offer explanations about the nature of men and women, the place of marriage in society, and the role of women in childbearing and child rearing.

According to most opponents of comparable worth, women are more interested than men in establishing families and in caring for children. For this group, female biology necessitates women's relationship with children and therefore explains most of the gap between women's and men's wages. Because of the biological underpinning of these differences it is impossible to change the fundamental relationships between the two sexes or the basic nature of society which rests on the relationship between them. Women naturally are more caring, more concerned with children, and less interested in the kind of competitive world in which higher salaries are found. As Michael Levin explains, women are innately less competitive than men.[32] Therefore, it is not surprising that women's wages are lower than men's.

Most free market conservatives assume that it is women, not men, who desire marriage. Advocates of comparable worth claim that marriage benefits men at the expense of women but for George Gilder and most opponents of comparable worth, it is the reverse. Although they believe that marriage is a necessity for civilization, they think it is accomplished only through taming men's barbarian instincts. Men must be lured into a stable relationship with one person and it is women who do the luring from a position of free choice and a rational assessment of their self-interest. Midge Decter agrees with Gilder: "Marriage and children are not things imposed on women by men but quite the other way around. . . . Marriage is not a psychic relationship but a transaction in which a man forgoes the operations of his blind boyhood lust, and agrees to undertake the support and protection of a family, and receives in exchange the ease and comforts of home." [33] Marriage is seen as an institution that first benefits women, and only later, men.

> The truth is . . . that marriage is an institution maintained and protected by women, for the sake of and at the behest of women, and in accordance with their deepest wishes. Men have, to be sure, for the most part willingly and in some measure perhaps even eagerly, supported them in this. For marriage is not without its very great benefit to men. Nevertheless, the true balance of the situation is that marriage is something asked by women and agreed to by men.[34]

As evidence for this position, Decter claims that while "most men fear getting married . . . most women do not." [35]

For Decter, as for many opponents of comparable worth, a woman's desire for marriage is innate:

> A woman wants to be married for the simplest and most self-evident of reasons. She requires both in her nature and by virtue of what are her immediate practical needs (if indeed the two can even be separated) the assurance that a single man has undertaken to love, cherish and support her. As a sexual being, her true freedom and self-realization lie in a sustained and ever more easy, ever more emotionally intimate commitment to one man—to be acceptable for who and what she simply, individually is. . . . For this she needs a husband—one man—who will agree to keep her safe while she brings forth her gifts and who by accepting these gifts will not only provide the measure of their value, and so of hers, but will help her to her own sense of having contributed fully to the human estate.[36]

Decter disagrees with those advocates of comparable worth who claim that childbearing and child rearing, even more than marriage, diminish women's status in the public arena. For Decter, pregnancy and childbirth are symbolic not of women's impotence but rather of their power: ". . . far

from rendering her a passive agent of nature, pregnancy impels a woman to the belief, however short-lived, that she is a significant actor. If in addition she should be an American woman, and young, and a member of the enlightened middle class, her belief in the unique significance of her condition is apt to overpower her to the point very nearly of pathology." [37] The availability of birth control means that women can freely choose whether or not to become mothers. And so they must also admit that pregnancy and motherhood are desired positions, not burdens imposed on them. For Decter, "birth control has transposed motherhood from a descriptive category to a normative one." [38]

Decter's assessment of modern woman's control over her life is thus very different from the view offered by those she terms "liberationists." She believes that while liberationists ostensibly claim the desire to be freed from some of the burdens of childbearing and child rearing, they really are asking for fundamental changes in society, and, indeed, offering a view of life that Decter asserts is immoral. She offers an explanation for her position:

> The demands of Women's Liberation to reorder the workings of career, to renegotiate the terms of sex, and to redefine the basis of marriage might conceivably be taken as a sort of pressure for social melioration that so many of the movement's sympathizers, and some few members of the movement itself, profess them to be. But the demand no longer to be mothers . . . is a demand that goes beyond the basis of a program for altering existing institutions or even attitudes, and reaches to the heart of what life itself imposes on mortal beings.

> For women to claim that they are victims when they are so clearly not is merely an expression of their terror in the face of the harshness and burdens of a new and as yet not fully claimed freedom.[39]

Decter is not the only free market conservative who criticizes feminists for not appropriately valuing motherhood. Michael Levin notes that although mothers are not paid for their work, this does not mean that it is unimportant. To the contrary, it is only feminists who devalue motherhood. Mothers are not compensated in dollars for their work since "these activities cannot register as high-priced commodities because they lack exchange value. . . . Mother love falls outside the GNP not because society undervalues it—only feminists undervalue mother love—but because mother love cannot figure in exchange." [40] Levin thinks that "the manifold activities of mothers sustain society," [41] and that wages have nothing to do with this.

George Gilder similarly criticizes those who devalue motherhood:

> Women in the home are not 'wasting' their human resources. The role of the mother is the paramount support of civilized human society. It is es-

sential to the socialization both of men and of children. The maternal love and nurture of small children is an asset that can be replaced, if at all, only at vastly greater cost. Such attention is crucial to raising children into healthy and productive citizens. Moreover, the link of men through marriage to the support of particular children is crucial to male motivation and productivity.[42]

WORK AND FAMILY

Most free market conservatives perceive an intrinsic connection between women's wages in the workplace and their roles at home as wives and mothers. In contrast to most supporters of comparable worth, however, critics assume that women's domestic position not only explains their lower wages in the workplace but justifies them as well.

Opponents of comparable worth offer many reasons to explain the direct connection between women's traditional household role and the wage gap. For example, women's child rearing is often associated with those measurable factors that account for lower salaries. Such factors as hours worked, experience, and training are all inversely correlated with women's work as mothers. As Levin notes, "marriage interacts with other factors relevant to wages."[43]

Women's domestic roles not only account for most of the measurable differences in wages. Equally important, these domestic constraints are indicative of the intrinsic distinctions between the sexes. It is these gender contrasts that in turn account for another significant part of the wage differential between women and men.

Many opponents assume that women "have their own nurturant and cooperative drives which deflect energy away from the sort of competition favored by the economic marketplace."[44] According to Michael Levin, this female concern with nurturance itself may have a biological basis since "a woman can reproduce only a few dozen times at most to a man's thousands."[45] Levin also admits that "the care of young children puts a premium on patience and above all empathy—and . . . a complete absorption in the child to the exclusion of extrafamilial pursuits."[46]

Many conservatives assert that women have a lower "career commitment"[47] than men. George Gilder claims that women simply do not produce to their maximum capability on a job because their families are more important to them. In contrast to married men, who see their job in the family as wage earner, married women see their jobs as care giver rather than breadwinner:

Married men with the most earnings capacity also exploited it most effec-

tively, working longer hours and more resourcefully the more education and credentials they possessed. By contrast, the more earnings capacity commanded by married women the less they used it. In other words, the more education and credentials possessed by a married woman the less likely she is to work full time all year at a highly demanding and remunerative job. While the earnings capacity utilization rates of married men rose from 84 to 94 percent from the bottom to the top tenth of earnings capacity, the earnings capacity utilization of married women dropped nearly one-third, from 35 percent to 24 percent, or to a level about one-quarter of their husbands.[48]

Ironically, free market conservatives also frequently turn to arguments about need rather than merit as a wage-setting mechanism. They are likely to refer to what they assume to be women's (read: married women's) diminished needs for funds. Because married women are usually not the only wage earner in a family they are less compelled to work as hard as men. Michael Finn refers to a study of physicians that indicated that women physicians see 38 percent fewer patients per hour than male physicians: "This may be because they try to do a more thorough job or because they prefer to work at a less hectic pace or both. Why might this be so? One explanation offered by Langwell is that male physicians are more likely to be the sole (or major) source of income in their families." [49]

Midge Decter agrees that at least part of the reason that married women earn less than married men is that their needs are different. She asserts that married women have a freedom to be less involved with their careers. Married men do not have this choice. Married women "are free to earn less money if doing so provides them with an opportunity to do something more interesting or satisfying to them. They are free to leave a job whose conditions are not to their liking. They are free, that is, to continue to behave like dependents." [50] Of course, for Decter, "such a relation to work prevents their being economically 'equal' to their husbands—and this, regardless of how much money either of them makes." [51]

Free market conservatives assert that woman's role in the family is based either on a biological determinism, on a woman's free choice, or on some combination of these two sources. They do not see women's work determined by social or cultural forces. They agree that there is a split between the public and private arenas that hinders women's wage earning potential in the public arena but they see this dualism as either freely chosen or as inevitable. For example, Michael Levin claims that "the main trouble with the feminist diagnosis of the economic division of labor is its disregard of biology. The sexual division of labor has been a permanent feature of soci-

ety because it expresses innate psychological differences between the sexes. This division has been a permanent feature of society."[52]

Opponents and advocates of comparable worth agree that woman's role in the household indeed accounts in large measure for her more limited wage earning ability in the public arena. But they part company when it comes to identifying the appropriate role for women in the home. It is not surprising that they also disagree about the place of housework. Midge Decter writes at some length about this question. Although acknowledging that a married woman exercises much of the housekeeping responsibilities, Decter claims that "to an extent unprecedented, probably, in the history of women, the particular details of her choice are up to her."[53] While "Women's Liberation has seen fit to characterize the professions in which the majority of professional women engage as housework in disguise," Decter prefers to see the reverse: "housework has become a profession in disguise."[54] More important, it is not the demands or even the assumption of housework that limit women's role in the workplace.

> It is not the work or the time or even the care required for the fulfillment of those obligations that interferes with her commitment . . . it is rather the possibility they betoken: at any moment, by her own volition, she might be doing otherwise. Her husband, working by day and demanding the full range of her attentions by night, does not enjoy her costly luxuries of choice. With him career is the only and ultimate medium of self-definition. If he succeeds, he is a success; if he fails, a failure.[55]

Thus, "women cannot relieve themselves of their debt to assume the major responsibility for supervising the running of the household unless they can declare their husbands to be volunteers as well. From this follows the idea that wage-earning is a privilege, something undertaken by men because it pleases them also, and in short, entitling them to nothing."[56] Once again, it is women's free choice, not the constraints of patriarchal pressures, that accounts for women's different place in the work arena.

MALE AND FEMALE

In contrast to comparable worth supporters—who often differ with one another about the nature of women, or whether there even is an intrinsic female nature—most free market conservatives agree about feminine nature. The bulk of this group assumes and many explicitly assert that women want, and are suited for, marriage and motherhood. However, although they find it relatively easy to explain the nature of women, many free market conservatives encounter great difficulty attempting to identify the nature of men.

George Gilder offers a contradictory picture of the male that changes from strength and independence to weakness and dependence on the female, according to the topic at hand. In a recent book, *Men and Marriage*, Gilder reiterates his claims for the necessity of subduing men's sexual instincts in order for society to survive: "The crucial process of civilization is the subordination of male sexual impulses and biology to the long-term horizons of female sexuality." [57]

Yet, strong as these male impulses are, strong enough to destroy all of civilization, it is women who are somehow superior to men. "The prime fact of life is the sexual superiority of women." [58] Women are sexually dominant for two main reasons. First, "it is the woman who conceives, bears, and suckles the child. Those activities that are most deeply sexual are mostly female; they comprise the mother's role, a role that is defined biologically." [59] In contrast, "there is no biological need for the father to be anywhere around when the baby is born and nurtured." [60]

Second, it is not only in relationship to childbearing that women are sexually superior. They also excel in what Gilder terms "erotic relationships": "Males are the sexual outsiders and inferiors. A far smaller portion of their bodies is directly erogenous. A far smaller portion of their lives is devoted to sexual activity. Their rudimentary sexual drive leads only toward copulation. The male body offers no sexual fulfillment comparable to a woman's passage through months of pregnancy to the tumult of childbirth and on into the suckling of her baby." [61] Men are also constrained in their ability to express themselves sexually: ". . . as a physical reality, the male sexual repertory is very limited. Men have only one sex organ and one sex act: erection and ejaculation. Everything else is guided by culture and imagination. Other male roles, other styles of masculine identity, must be learned or created." [62]

According to Gilder, a man must constantly struggle to define his maleness, whereas a woman "can be sure of her essential female nature." [63] Women always know they are female, whereas men must always prove they are masculine:

> Unlike femininity, relaxed masculinity is at bottom empty, a limp nullity. While the female body is full of internal potentiality, the male is internally barren (from the Old French *bar*, meaning man). Manhood at the most basic level can be validated and expressed only in action. A man's body is full only of undefined energies—and all these energies need the guidance of culture. He is therefore deeply dependent on the structure of the society to define his role. In all its specific expressions, manhood is made, not born. [64]

For Gilder, male sexuality has a "tragic quality." [65] "Men must perform.

There is no short cut . . . just the short circuit of impotence. Men can be creatively human only when they are confidently male and overcome their sexual insecurity by action. Nothing comes to them by waiting or 'being.' "[66] Because of this male tragedy, men are ultimately dependent on women: "The man's participation in the chain of nature, his access to social immortality, the very meaning of his potency, of his life energy, are all inexorably contingent on a woman's durable love and on her sexual discipline. Only she can free the man of his exile from the chain of nature; only she can give significance to his most powerful drives." [67]

For Gilder it is the dependence of men on women in the private arena that necessitate men's superiority in the public one. Since men are not naturally superior, they must be made to dominate in the culture if society is to survive: "These deeper female strengths and male weaknesses are more important than any superficial male dominance because they control the ultimate motives and rewards of our existence. . . . Women control not the economy of the marketplace but the economy of eros: the life force in our society and our lives." [68] Thus, for Gilder, women's lower wages are indicative not of female inferiority but of female superiority. It is because of women's dominance in the private arena, the realm of eros and of family, that they are paid less well in the public arena. It is not woman's limitations but rather her power that leads to depressed wages.

Yet Gilder does not rest his case with this assertion. Rather, when he writes about the public sector—the "jobs front," as his chapter is named—claims for men's intrinsic dominance in this arena are prominent:

> [Although] it is true that male physical strength is becoming less important in the age of information and service industries . . . men's distinctive aptitudes are not entirely physical. Male domination in the sedentary intellectual game of chess is virtually as great as the male lead in lifting weights. All but two out of the hundreds of international grand masters named over the years have been men despite millions of female competitors in the Soviet Union.[69]

Further, Gilder notes, "in work requiring similar feats of concentration and abstract reasoning, men now hold the vast majority of all the more exacting high-technology jobs in America, and this pattern seems likely to continue." [70] Gilder's explanation for these differences between the genders is, once again, biological: "The reason for these gender differences in aptitude and performance is the difference in genetic endowment and psychological propensity between the sexes. Just as girls from earliest childhood consistently excel boys in all tests of verbal aptitude, male aptitudes are better adapted to advanced technology, with its abstract and mathematical base." [71]

Other work-oriented skills that lead to higher wages similarly favor men. Modern management trends tend to favor aggressiveness and competition, skills that Gilder sees as predominantly male: "In most job and business rivalries, male aggressiveness and technical aptitudes will remain crucial for the foreseeable future." [72] Michael Levin agrees:

> Men are more competitive than women, which is to say more apt to do whatever is needed to get ahead, whatever 'getting ahead' happens to be under the circumstances. This disposition, called 'dominance aggression' by psychologist John Money, is perhaps the determinative factor in economic sexual differentiation. Men are more willing to put out the energy required to dominate in extrafamilial pursuit—success in the world of work is such a pursuit—tend to go further in such pursuits. . . . For better or worse, money is a symbolic measure of others' estimate of one's worth to them, so that the impulse to compete and dominate will manifest itself as an impulse to seek activities for which remuneration is highest.[73]

Similarly, in the area of manufacturing it is once again male skills that will continue to be needed: "The male mechanical aptitudes that still give men between 95 and 99 percent of all jobs in mechanics, repair, machinery, carpentry, construction, and metal crafts will remain vitally important in the service economy. In addition, these aptitudes are readily convertible into skills in the maintenance of computers and other electronic appliances." [74] Female skills, on the other hand, such as "the assembly-line roles currently performed by women in technical manufacturing firms . . . are likely to continue to move overseas or give way to automation and robotics." [75]

It is clear to free market conservatives that women and men are inherently different. It is also clear to them that women's lower wages in the workplace are explained by these intrinsic distinctions between the sexes. They present less clearly, however, an explanation for why the skills and resources in which women excel are less valued in the workplace than those in which men excel.

RELIGION AND POLITICS

Since much of the case for comparable worth's free market opponents depends on inherent differences between women and men, it is not surprising that this group is sympathetic to theologies that assert a biblical basis for gender distinction. They are in agreement with those religious groups who stress the significance of the family and the importance of women staying home in order to maintain that institution. These religious arguments both confirm and strengthen their position that the market is merely reflecting, not causing, a different role for women.

George Gilder, for example, speaks glowingly of the resurgence of fundamentalist religions:

> In America, no one is required to go to the Liberty Baptist Church or watch the 700 Club. But the movements that these institutions represent and promote provide the best hope for American democracy and peace, capitalist prosperity and progress. Ironically enough, it is the so-called reactionaries who offer the best prospects for continued American leadership in the world economy in the new era of accelerating technological change.[76]

Secular opponents of comparable worth often seem to echo Max Weber's thesis concerning Protestantism and the rise of capitalism.[77] Weber posited an intrinsic connection between the values of Protestantism and those that are necessary to sustain a capitalist system. The acceptance of worldly asceticism, a point of view that encourages hard work in this world while discouraging earthly pleasures, leads people to devote themselves to their occupations. Since any capital gained from this labor cannot be spent frivolously, it is accumulated. Therefore, Weber argued, this religious position encouraged the rise of capitalism.

Many free market proponents hold to this view and worry that the demise of Protestantism would pose grave threats to the capitalist economies. But they see the link coming through the family. For many free market conservatives the family itself is seen to rest on religious principles. Since the family is also often viewed as the necessary base for a capitalist economy, without religious values capitalism would suffer. For Gilder the family is the most crucial ingredient in any society, particularly a capitalist one: "In families, men and women routinely make long term commitments and sacrifices that are inexplicable and indefensible within the compass of secular hedonist values. Modern society, no less than any previous civilization, rests on the accumulated moral and spiritual capital embodied in the rock of ages."[78] Traditional religion is at the very least an aid to a flourishing free society and capitalist economy. Perhaps it is even a necessity.

Free market analysts also concur with many of Emile Durkheim's notions of the place of religion in society. While Weber saw an elective affinity between religion and politics, Durkheim posited an even stronger relationship. Religion and society were nearly identical. Without religion, the common set of beliefs and practices that hold people together, society would disintegrate. Without the glue of religion, people would not be able to live in harmony with one another. Religion is a positive force in social maintenance.

To secular opponents of comparable worth, the relationship between these two spheres enables religion to uphold society by sustaining the pri-

vate arena whose values, in turn, buttress the public one. According to free market advocates, without personal sacrifice there could be no capitalist system. Yet the necessary deprivations in the public arena make the home even more important. Without that bastion, it would be difficult for most people to function in the aggressive world of the market.

Conservatives do not have to take a stance on the role of religion in public life itself, for religion's importance in private life ultimately maintains the public arena. They often echo the claims of the religious right who see their involvement in the issues of women and family, even though often taking place in the political arena, as merely an extension of their concerns with the private sphere. To comparable worth opponents, religion's role can be both private and public without having to cross any church-state boundaries. Secular opponents of comparable worth can praise the importance of religion without needing to call for an increased religious presence in public life.

CONCLUSION

The free market conservatives' antagonism to comparable worth relies on several assumptions about human nature, human freedom, and the market. In many ways, these are identical to the premises on which the American economic and social systems have been based. Free market advocates follow the tradition of Hobbes and Locke, viewing "economic man" in terms of "possessive individualism,"[79] in C. B. Macpherson's phrase. They accept a model of society composed of grasping individual men, each seeking to maximize his own benefits. Without some kind of civil order life would indeed be solitary, poor, nasty, brutish, and short as each person sought his own good.

This society depends on a strong separation between the public and private arenas to maintain itself. There is no room in the marketplace for non-acquisitive traits. Yet these more altruistic traits are important. Affection, love, or even human kindness can still be enjoyed, as long as these qualities remain at home. Michael Levin confirms this notion when he states that mother love is highly valued but falls outside market mechanisms. Free market conservatives want to have their cake and eat it too. They are pleased with a competitive public arena, but they do not want to give up more altruistic human qualities. To have both selfish and altruistic qualities represented in society, they need women to be different from men. Then selfless women can remain in the private arena, while acquisitive men control the public one. Any diminution of the separation between the spheres could severely destabilize the enterprise.

Free market conservatives note the benefits of their system. They assert that capitalism is not only the most productive system but also the most humane. It is only under capitalism that human freedom flourishes and that human needs are best filled. They also assume that it is necessary to sustain American power in the world, for America offers the best political system. During the cold war era they argued that the possibility of a world run by godless communists, with its diminished, if not vanished, freedoms, must be avoided at all costs and that it was American power that stood between us and this dystopia. Free market capitalists continue to worry about any changes in a capitalist order for fear of destabilizing that political system.

They further insist that neither women nor men would be aided if a system of comparable worth were to be instituted. Neither gender would gain socially since society itself might collapse with the natural balance and relationship between the sexes destroyed. Some argue that the entire social structure would revert to barbarism if a man's primitive, uncivilized instincts were no longer tamed by a stable relationship with a woman. They fear that instituting comparable worth policies would lead to such a future.

Free market conservatives predict that even economically neither women nor men would gain. Ellen Paul states, "Comparable worth is a detour—not to say, a dead end—that will not aid women in the long run. . . ."[80] Since women would have to be paid the same wages as men, the capitalist system of supply and demand would lead to the further devaluation of women. If women are simply not as productive as men, there would be no reason to hire them at all once they had attained wage parity. There would be more unemployment among women as a group, even as a certain number of women were paid more than under the current system. Men, of course, would not gain from comparable worth because opponents believe men's wages would be diminished in order for businesses to have sufficient funds to pay the increased wages of the women who would be working. Moreover, if the country's economy suffered in comparison to foreign ones where comparable worth policies were not required, then all workers would suffer from the diminished capital available for wages.

Free market conservatives assume that a strong family is necessary not only for a flourishing society but for a robust economy. They criticize comparable worth advocates, feminists especially, for devaluing the family. Because of this criticism, it is necessary to ask whether the policies that free-market proponents advocate serve to enhance the family's well-being.

There is an inherent contradiction in the approach of this group because in many ways they make it harder, not easier, for women to stay home

to raise children. These difficulties stem, at least in part, from the assumptions that they make about mothers' lives. They assume that all women are, or want to be, mothers. They also think that most mothers are supported by men earning a family wage and therefore can afford to live without a salary. Statistics indicate that these assumptions are not correct. There are more mothers who are dependent on a salary to support their children than there are families living adequately with a single male wage.

Even if mothers of young children did not need to earn money, however, free market advocates' policy recommendations would still suffer from another assumption, namely that motherhood is a lifetime occupation. For most women, the care of dependent children spans a shorter number of years than their potential ability to participate in the public arena.

By stressing that such wage-depressing factors as time away from the marketplace are "non-discriminatory," free market capitalists in fact discourage women from taking time away from work in the public arena to raise their children. Any time period absent from work depresses a woman's wages for the rest of her occupational lifetime. The financial penalty for full time motherhood is severe. According to the positions of these family advocates, women must either never leave the marketplace if they desire wage parity with men or they must assume that they will never have to return to the marketplace. The woman who either needs or chooses to work in the public arena but who also wants to take time off from work to raise children (either by limiting her hours or by limiting her years in the work arena) is harshly penalized by the system advocated by comparable worth opponents.

Free market conservatives claim that the market merely reflects the distinctions between women and men, but does not cause these differences. But another explanation is at least as persuasive: the market encourages increased similarity between the genders since women are progressively penalized in the marketplace once they become mothers. The rational self-interest of women in such an economy propels them to forego motherhood and/or behave as much like men as possible.

Further, free market conservatives balk at the very idea of comparable worth. They scorn the notion that occupations dominated by women should be paid more similarly to those dominated by men. They believe that if women want to earn wages comparable to men's, they should undertake careers that are more similar to men's. This policy, too, encourages greater similarity between the genders. Women succeed in the market the more they become like men. The incentive to maintain a separate female identity is diminished. Comparable-worth opponents pursue a policy that, if followed, would undermine the system they are attempting to uphold.

The free market case also suffers from problems with the concept of human freedom. Either women and men are intrinsically distinct, or women choose different work patterns. If women's biological differences lead them to lower paying occupations than men, then women are not free to choose. They are biologically determined beings with little free will. If, however, women have free will, and choose a certain kind of work, then their choices can change as the incentives of the market lead to new calculations of benefits and costs. If there is human freedom of choice, then the policies proposed by these comparable worth opponents will lead to a weakened family because women are penalized for becoming mothers. Many women are already considering reducing or eliminating motherhood in order to attain economic advancement.

Comparable worth opponents profess to value the family, but it is not clear that their policy positions enhance the well-being of that institution. It seems that this group encourages the family not for its intrinsic value, but because it sees the family as the base for the kind of free market that it desires. The idea of the family enables free market advocates to assert the essential differences between women and men, making their task of upholding the split between public and private spheres easier.

4

The Religious Traditionalists

While secular opponents of comparable worth view the family as critical to the maintenance of the capitalist society they espouse, religious opponents of comparable worth view the family as a value that must be preserved for its own sake. Most of these religious traditionalists fear that instituting comparable worth policies will weaken the family. While the secular group thinks it needs the family in order to sustain the free market, the religious group tends to think that it needs the free market in order to uphold the family. As Rabbi Aaron Levine, professor of economics at Yeshiva University, explains, comparable-worth policies "would exert a negative impact on the institution of marriage and encourage lifestyles antithetical to [religious] values." [1]

Those groups that compose the new religious right form the major base of religiously oriented opposition to comparable worth. According to most analysts, the conservative religious groups have three main social policies that they espouse in common: opposition to abortion, opposition to homosexuality, and opposition to feminism. The religious traditionalists also agree with the free market conservatives in their insistence on the importance of the free market and in their opposition to communism and totalitarianism. Most of these religious groups do not speak directly to the question of comparable worth, but it is clear that they would find the potential of comparable worth to disrupt both the family and the free market abhorrent. Comparable worth advocates, moreover, are seen as feminists who probably also support abortion.

Like the religious left, the religious right is composed of people from different religions as well as from a large number of divergent denominations and distinct groups. Orthodox Judaism, the Catholic hierarchy and Mormonism are among the many strands represented in religious traditionalism. Not all of these groups can be discussed here. This chapter will focus generally on some key figures from two of the most politically active branches of the religious right: the Christian fundamentalist and evangelical traditions. Although both of these groups come to similar conclusions about the family, and are frequently discussed within the one rubric of the religious right, their theologies and political styles are distinct enough to merit separate consideration.

According to most analysts, both the fundamentalist and evangelical strains in American religious history, as well as the pentecostal and charismatic traditions, all stem from the same parentage: the revivalist tradition.[2] All were responses of opposition to the growing theological modernism that they saw as questioning or even countering the basic tenets of the Christian faith. Fundamentalism began to emerge in the late 19th century. It formally differentiated itself from the evangelical movement in 1941, with the formation of the American Council of Christian Churches. In 1942 the National Association of Evangelicals was established in distinction to the first group.

Fundamentalism is based on acceptance of the "fundamentals" of the Christian faith, the most important of which, according to Jerry Falwell, are the following five:

(1) The inspiration and infallibility of Scripture.
(2) The deity of Christ (including His virgin birth).
(3) The substitutionary atonement of Christ's death.
(4) The literal resurrection of Christ from the dead.
(5) The literal return of Christ in the Second Advent.[3]

In the early 20th century these fundamentalist principles were published and widely circulated, resulting in the name of the movement. As can be seen from these principles, the fundamentalist movement distinguished itself from modernism and was opposed to any liberal influence on Christianity. According to Falwell:

> the ultimate issue is whether Christians who have a supernatural religion are going to be overpowered by Christians who have only a humanistic philosophy of life. Fundamentalism is the affirmation of Christian belief and a distinctively Christian lifestyle as opposed to the general secular society. It is the opposite of radical liberal Protestantism, which has attempted both to secularize Christianity and to Christianize secularism at the same time.[4]

In the early 20th century, fundamentalists and evangelicals officially differed in response to questions of separation from the mainline churches and in terms of their methods of evangelizing. Although both groups were opposed to liberal religion, fundamentalists were firmer in their insistence on separating themselves from the liberal churches. They saw any relationship with these churches as apostasy. They were convinced of the impossibility of influencing these churches either by staying within them or by cooperating with them. Evangelicals, on the other hand, while beginning from the same fundamental principles, tried "to cultivate a less militant evangelism."[5] They were not as opposed to cooperation with the mainline churches if that would help the cause of their spreading the Gospel. As Robert Booth Fowler notes: "One fundamentalist characterization of evangelicals as a 'party to compromise, evasion, and capitulation to Satanic forces' was a good example of the rhetoric that separated the two groups."[6]

Evangelicalism has a long and respected history in this country, having been the driving force of the Great Awakenings as well as politically important in both the abolitionist and suffragist movements. The modern evangelical movement "consolidated in the early 1950s around the work of Billy Graham."[7] Graham had begun his ministry as a fundamentalist but gradually strayed from that group. His split with the fundamentalists crystallized in 1957, when, in Falwell's opinion, Graham cooperated in his New York crusade with "notable Liberals, such as Henry O. Van Dusen, president of Union Theological Seminary."[8] According to Jerry Falwell, "the issue of Billy Graham and ecumenical evangelism was the first separatist conflict that divided Fundamentalism and Evangelicalism and solidified the concept of separatism."[9] While fundamentalists refused to cooperate with non-Christian or even non-fundamentalist organizations, the evangelicals were more at ease working with the mainstream organizations.

Despite these differences in tactics, evangelicals and fundamentalists share many of the same theological positions. Especially important is both groups' acceptance of the Bible as having divine authority and as the source for religion and morality. With few exceptions, they see the Bible as inerrant, that is, as "both absolutely true and completely authored by God."[10] Although some of the contemporary radical evangelicals take inerrancy to mean that God inspired, although not necessarily wrote, the Scriptures, this is a minority position.

Fundamentalists and evangelicals also overlap in their assessment of the proper relationship between religion and politics. Given the belief of both groups in Christ's Second Coming, it should not be surprising that the question of the proper relationship between religion and government re-

mains important for these two camps. Both groups are concerned with avoiding the perils of modernity while they are awaiting the millennium.

Although the fundamentalists and evangelicals split over the question of separatism, there has been much historical overlap in their attitudes toward dealing with government. One might assume that the fundamentalists, because of their strict notions of separation and their emphasis on the coming of the kingdom of God, would have more clearly eschewed involvement in politics, but this has not always been the case. Carl McIntire, founder of the fundamentalist American Council of Churches, was very concerned with politics.[11] The early Jerry Falwell, on the other hand, epitomized those fundamentalists who shunned involvement in the political arena when in 1965 he noted, "I would find it impossible to stop preaching the pure saving gospel of Jesus Christ, and begin doing anything else—including fighting Communism, or participating in civil-rights reforms."[12]

Although both fundamentalists and evangelicals were antagonistic to religious modernism, frequently their greatest wrath was spent on each other. Much animosity still prevails despite frequent appeals for reconciliation from one camp to the other. Fundamentalists are quick to see the encroachment of modernity, and apostasy, among those who challenge either their doctrine or style. They accuse not only many evangelicals, but even many who still claim the title fundamentalist, of sliding toward modernism. Jerry Falwell, usually seen by those outside of the religious right as the epitome of that group, has been accused by other fundamentalists of falling into the temptations of modernism. He has been labeled a "pseudo-fundamentalist" by those he in turn refers to as "hyper-fundamentalists."[13] These disagreements, although sometimes quite bitter, do not hinder a broad consensus about the questions that have an impact on comparable worth: the family and women's equality.

MORALISM IN POLITICS

The political agenda of the religious right is inextricably linked to the theological principles just mentioned. Although religious traditionalists are often in accord with the free market conservatives on specific policy issues, their policy positions are explicitly related to their religious world view. Erling Jorstad points out that the religious right offers a "politics of moralism,"[14] based on only one right moral action whose authority comes from scripture: "Moralism . . . embodies a particular world view. It understands that the moral answers to the questions perplexing mankind since earliest times are known, that no new or revised moralistic teachings will be forth-

coming from the Author of morality because all revelation from him is full, complete, and binding."[15]

As Samuel S. Hill and Daniel E. Owen describe it, the new religious and political right is called upon to build "not the *good* society, but the *perfect* society, based on biblical righteousness and holiness." [16] This society will include such features as: "(a) happy nuclear families; (b) clear sex roles; (c) family and church in charge of all important social processes; (d) government which exists to provide defense against enemies and to punish evil; and (e) the nation's recognition of the sovereignty of God."[17]

According to most observers, the concerns of the religious right focus heavily on "violation of sexual norms and the theoretical legitimation of this breakdown." [18] Included on the list is the rise of feminism and "its alleged denial of the hierarchical family order" [19] which, of course, is simply part of the larger picture: the "general breakdown of family life." [20] Religious traditionalists are opposed not only to abortion but also to the Equal Rights Amendment, to women being drafted into the army, and to any movements that might encourage pre- or extra-marital sexual relationships. They favor "articulation of a 'Total Woman' philosophy as an alternative to feminism; training in the ways of hierarchial family life, which entail the obedience of wives to husbands, strict discipline for children, and family-centered roles for the wife and mother." [21]

It is clear from these views that religious traditionalists oppose comparable worth policies because they deal with women in the workplace and because this approach demands equal treatment for women and men. Religious traditionalists are concerned with keeping women in the home as wives and mothers and are opposed to any policy that might in any way encourage women to leave the domestic arena. In the past they have opposed the Equal Rights Amendment and abortion legislation, and have been active in lobbying for a comprehensive family bill that would transform their moral standards into legal edicts.

These specific policy positions stem from one source: what the religious right sees as the correct reading of the Bible. They assume that they are upholding God's word and that it is appropriate to do so since, according to Falwell, this nation "was founded by Godly men upon Godly principles *to be a Christian nation.*" [22]

RELIGION AND POLITICS, PUBLIC AND PRIVATE

As the religious right has become progressively more concerned with America's moral fiber, it has also become increasingly active in political life. Analysts have tried to explain both the surge in membership and the activism of

these churches, an especially interesting phenomenon since many of the groups that now compose the religious right have a history of a more separatist relationship with politics. For much of fundamentalist history believers espoused an attitude of disinterest in, if not disdain for, the government. It was the duty of the religious Christian to wait for the Second Coming, undistracted and untouched by the temptations of modernity.

Robert Wuthnow posits that the growth in special purpose groups rather than religious denominations accounts for changing conceptions about the proper relationship between religion and politics. "The sheer growth in numbers of such organizations has made it possible for religious people to mobilize themselves much more effectively for attaining political objectives." [23] Martin Marty offers four ingredients in order to explain the shift not only toward expanded membership but also toward the enhanced importance and activity of conservative churches. He notes the "worldwide reaction against many of the mixed offerings of modernity. Fundamentalism, as part of it, both ministers to the victims of modernization and exploits them." [24] Marty, like others, compares the resurgence of fundamentalism in America to its resurgence in Iran. Second, Marty sees this resurgence connected to another worldwide trend that he calls tribalism. "In this movement people retreat from modernity by withdrawing into their ethno-religio-cultural-tribal bonds." [25] He refers to countries in the Middle East and Africa as illustrations of this point. Third, Marty refers to the undeniable "values crisis" in America, especially regarding "family life, sexuality, and expression" and notes that "there was an ecological niche or cranny to be filled, a void that had room for a new growth." [26] Finally, Marty notes the "uninhibited" use of techniques of modernity, mass communications, computer technology, and so on as another reason for the fundamentalists' recent success in political life. [27]

The fundamentalists themselves offer their own explanations for their increased interest in politics. Falwell's statement in *Eternity* magazine in 1980 perhaps epitomizes this new approach. Here Falwell offers a view about the relationship between public and private that undergirds his position. He explains his new involvement in politics, in contrast to his earlier criticism of pastors who had been involved in the civil rights movement, by referring to the changes in the American scene:

> Things began to happen. The invasion of humanism into the public school system began to alarm us back in the sixties. Then the Roe vs. Wade Supreme Court decision of 1973 and abortion on demand shook me up. Then adding to that gradual regulation of various things it became very apparent the federal government was going in the wrong direction and if allowed

would be harassing non-public schools, of which I have one of 16,000 right now. So step by step we became convinced we must get involved if we're going to continue what we're doing inside the church building.[28]

In other words, in order to protect the private arena—which is the purview of religion—against the incursions of the government, fundamentalists had to involve themselves in the political process.

Robert Booth Fowler reiterates Falwell's point, which he sees as reflecting the broader-based evangelical position as well. As Fowler observes, "evangelical interest in issues such as family, sexual mores, and women's liberation was enormous. . . . Certainly, devotion to the family was the core value in evangelical writing in the 1960's and the early 1970's. Evangelicals united in insisting the family must remain central in every Christian's life."[29] Ironically, according to Fowler, "the curious fact is that both evangelicals and their critics ordinarily did not see their interest and involvement in these questions as the expression of substantial social commitment."[30] Evangelicals were able to continue to assert a non-involvement in public life by "claiming their concern was to defend the private family and Christian norms against the larger, public, secular world. This view tended to obscure the fact that the issues were inevitably public with great public consequences."[31]

Martin Marty argues that the fundamentalist shift toward engagement in politics can still be seen as reflective of their traditional non-involvement in public life. Marty distinguishes between the political and the public and hypothesizes that while the fundamentalists are now entangled in political life they are still not involved in public theology. Marty not only explains this seeming contradiction in the fundamentalists' historic positions and their present behavior, but also distinguishes their current political involvement from that of the more liberal Christian traditions: "A public theology allows for a positive interpretation of that secular-pluralist order with its religious admixtures, even as it recognizes all the while the way the demonic pervades the orders of existence. The political theology of privatist fundamentalism does not do so. It is born of separatists who do not regard nonfundamentalists with any positive ecumenical feelings."[32]

Both Fowler and Marty reiterate the distinction between public and private that permeates discussions of comparable worth. The fundamentalists and evangelicals view comparable worth as fitting into the private rubric, for to them it is the question of women's place in the home, and the continuation of the patriarchal family that is at stake. Instead of focusing on the issues of the marketplace, they are preoccupied with the home. Religious traditionalists see their involvement in public policy as an extension of their concern for the family, not as an incursion into public life.

MARRIAGE AND FAMILY

As Fowler notes, the family has been the core value on which religious traditionalists writing in the last two to three decades have focused. Therefore, issues such as sexual morality, homosexuality, and abortion have all been high on the agenda of the religious right. Similar to their secular conservative colleagues, but often for different reasons, this group sees the family as the essential building block of society. Because the family is necessary in order to constitute a community it is important that this institution be structured appropriately for its task. The dependent relationship between society and family requires that the family be constructed with relationships that correspond to the interests of society at large. Since the public arena is viewed as a place for individualist men, a patriarchal family wherein the male is the dominant authority is the appropriate model from which to build a suitable public order. In this kind of institution, women learn that they are subservient to men. Religious traditionalists view with alarm any developments which they see as threatening this foundation of society.

This version of the Christian family, of course, has its basis in the Bible. Traditionalists cite texts such as Ephesians 5:21–25 to validate the necessity of wives' subordination to their husbands. "Wives be subject to your husbands," is read as a straightforward command to be followed. Similarly, they cite Genesis 3 to show that women are commanded to desire their husbands, as well as to bear children and that men are commanded to bring forth bread by hard labor. Women and men have been created by God to be distinct, and the family is the reflection and fulfillment of these differences. Job segregation by sex is biblically ordained by the two contrasting punishments that Adam and Eve received after eating from the forbidden fruit.

Some religious traditionalists have noticed the similarity of their biblically based positions to those put forth by the non-religious new right. A recent review of George Gilder's *Men and Marriage* in *Christianity Today*, the leading evangelical magazine, concludes that "while a plain reading of Scripture" should be enough to reach the same conclusions as Gilder that men and women are indeed different, "many Christians will find it helpful to collect the evidence of natural revelation to support the teaching of special revelation."[33] The review offers the biblical verification for Gilder's argument:

> . . . the linchpin of civilization is the mutual sacrifice of the sexes (echoes of Eph. 5:25), each according to its nature, for the preservation and advancement of society. A married woman gives herself up to the care and nurture of young children and the establishment of a stable, comfortable, and loving home. This she does according to her nature (or perhaps according to the divine decree that we read in Gen. 3:16). Likewise, a mar-

ried man gives himself up to 50- and 60-hour weeks, to narrow specialization, to earning his bread by the sweat of his brow (more echoes of Genesis 3) for the sake of a woman's love and the prospect of prosperity.[34]

MALE AND FEMALE

Although women have been recognized as having gifts of preaching equal to men's in at least part of the evangelical tradition, they were never regarded as identical to men. On the contrary, in many cases it was claimed that it was important for women's voices to be heard because they represented a different, sometimes even a higher, morality than men's. Women, as protectors of the family, were often viewed as maintaining virtue in society as well. Some evangelicals, especially feminist-oriented ones, speak of the basic equality of the genders, even while testifying to their fundamental differences. Most religious traditionalists, however, focus on the higher position of males in a hierarchical order. Like their secular counterparts, the free market conservatives, almost all religious opponents of comparable worth agree that women should be wives and mothers. They also believe that women should be submissive to their husbands. They share the view of the secular right that women and men are distinct, and add a biblical justification for that view.

Like their secular counterparts, George Gilder especially, they sometimes are not clear in their writings about whether women are by nature more or less powerful, or more or less capable, than men. Although women are told they must submit to their husbands in order to maintain society or God's plan, it is not clear that this submission is a sign of weakness. Marabel Morgan's popular book of the early 1970s epitomizes this tension. *The Total Woman*, a peculiar mixture of sex manual and fundamentalist religious tract, admonishes women to submit to their husbands' wishes in every aspect of life. However, it also characterizes men as weak creatures who need constant propping up by "their" women: "Your man needs to feel important, loved, and accepted. If you won't accept his idiosyncrasies, who will? A Total Woman caters to her man's special quirks, whether it be in salads, sex, or sports. She makes his home his haven, a place to which he can run. She allows him that priceless luxury of unqualified acceptance."[35]

Morgan's conclusions are based on a religious orientation: "Your husband is what he is. Accept him as that. This principle is as old as life itself. God accepts us as we are. Even though we don't deserve it, He still loves us. . . . Because He accepts us, through His power we can love and accept others, including our husbands."[36] Thus, since "the Bible says that wives should love their husbands,"[37] a woman might as well make the

most of whatever husband she has. "Simply make up your mind to accept him just as he is. By an act of your will, determine that you won't try to change him no matter what. That's supreme love."[38] Morgan also notes that "tolerance is not acceptance. Your tolerance only makes your husband feel incomplete and unworthy. He can sense when he's not being accepted, and is not able to love you fully."[39] Morgan further admonishes, "your husband needs your acceptance most of all during his times of apparent failure. . . ."[40]

Morgan has very distinct views about the genders. She asserts that "psychiatrists tell us that a man's most basic needs, outside of warm sexual love, are approval and admiration."[41] She notes the differences between women and men: "Women need to be loved; men need to be admired." She adds that "we women would do well to remember this one important difference between us and the other half."[42] Morgan repeatedly offers the Bible to substantiate her position: "Love your husband and hold him in reverence, it says in the Bible. That means admire him. *Reverence*, according to the dictionary, means 'To respect, honor, esteem, adore, praise, enjoy, and admire.'"[43]

Morgan, then, while advocating female submission, does not speak of a strong male. Rather, it is the male who is weak and in dire need of the support of his wife. Morgan exhorts women: "You are the one person your husband needs to make him feel special."[44] She offers instructions for those seeking to be total women, indicating that this advice is especially useful for those who do not cherish their husbands: "Starting tonight determine that you will admire your husband."[45] Although Morgan claims that she is "not advocating that you lie to give your husband a superficial ego boost," she does maintain that "he has a deep need for sincere admiration. Look for new parts to compliment as you see him with new eyes."[46]

Given Morgan's dim view of men's inherent capabilities and her seeming faith in the ability of women to manipulate almost any man, it might seem surprising that she would insist that women remain compliant in marriage. Yet, according to Morgan, women's submission to their husbands is biblically ordained. It is unimportant whether or not women or men are, by nature, stronger, or even if they are by nature the same, because the Bible must be followed. The "total woman" is obeying biblical injunctions when she adapts to her husband's every desire. "The biblical remedy for marital conflict is stated, 'You wives must submit to your husbands' leadership in the same way you submit to the Lord.' (Eph. 5:22) God planned for woman to be under her husband's rule."[47] In a nutshell: "The fact is that God originally ordained marriage. He gave certain ground rules and if they are ap-

plied, a marriage will work. Otherwise, the marriage cannot be closely knit because of the inherent conflict between your husband's will and yours."[48]

Thus, "man and woman, although equal in status, are different in function. God ordained man to be the head of the family, its president, and his wife to be the executive vice-president."[49] Morgan gives further practical advice from the Bible. Women are told to follow the model of Jesus and "forgive and forget."[50] They are to "speak the truth in love";[51] they are "to forbear one another in love."[52]

SEX AND MARRIAGE

The Total Woman, however, is best remembered not for all of this advice, but rather for Morgan's attitude toward sex. The book created a sensation when it was first published and is still viewed by many as an aberration, rather than as indicative of evangelical or fundamentalist thought. Yet it can also be seen as evidence of the strong concern of these religious groups with questions of sex and sexuality. Religious traditionalists view sexual deviance as at least one and perhaps the most important reason for the breakdown of society. It is therefore not surprising that they have very distinct views about the nature of the proper sexual relationship. Moreover, many in the religious right seem to be trying to make their views on sexual relationships as appealing as possible in order to ensure the marital faithfulness that they see as necessary for maintaining social stability. If marriage and family are the fundamental building blocks of society, and if a sexual relationship can only take place within marriage, then sex becomes a critical consideration if one is interested in upholding society.

For Morgan, and many of those following her, sex in marriage is crucial for several reasons. First, marriage itself is an imperative. And as far as Morgan is concerned, marriage is more apt to flounder without a good sexual relationship: "A Total Woman knows that sex is vital to her marriage."[53] It is important to understand that "a married man shouldn't be wandering around with an unfulfilled libido" for this "is a dangerous state."[54]

Morgan's book is filled with advice not only on how a woman should please a man by being submissive, admiring, and so forth, but how she can maintain her marriage by being a good (perhaps outstanding) sexual partner. Sexual advice is intended to help support a strong marriage whose value is solidly based in the religious tradition.

The religious tradition itself can be used both as a means to the end goal of a good marriage as well as of a good sexual relationship. Ruth Carter Stapleton suggests to a woman who is dissatisfied with her marriage that

she envison her husband as Jesus in order to help her to love him and submit to him:

> Try to spend a little time each day visualizing Jesus coming in the door from work. Then see yourself walking up to him, embracing him. Say to Jesus, "It's good to have you home, Nick."

> If you do this each day, you will condition yourself to respond to Nick as you would respond to Jesus.[55]

While for Morgan sex is important in order to maintain a Christian marriage, for Stapleton religious faith will help to bring about a better sexual relationship.

In similar fashion, Tim and Beverly LaHaye, contemporary evangelical spokespersons on marriage, also claim that belief in Jesus can strengthen not only marriage but sexual pleasure. They offer evidence that a good Christian marriage can lead to an improved sex life. They quote the testimony of one of their followers: "Pastor, I never dreamed when I accepted Christ that He would invade our sex life, but we have never been able to make my wife's bells ring until after we were converted. Now she has a climax most of the time."[56]

Morgan and others go beyond viewing sexual pleasure as an instrumental value, important for the continuation of the marriage. Many evangelicals claim that sexual activity (within marriage) is good in itself. For Morgan, "physically, the climax during intercourse is the greatest pleasure on earth."[57] Moreover, "emotionally, a woman's climax, coupled with the joy she receives giving herself to her husband, completes her. She and her husband both feel satisfied and fulfilled."[58] Of course, Morgan once again relates her position to the Bible: "Spiritually, for sexual intercourse to be the ultimate satisfaction, both partners need a personal relationship with their God. When this is so their union is sacred and beautiful, and mysteriously the two blend perfectly into one."[59] For Morgan, sex is necessary not only for childbearing but also to fulfill God's plan for human beings: "Sex was for a twofold purpose: to express mutual love and to propagate the human race. There they were, man and woman before each other, naked and beautiful. They had no shame. Their human bodies were perfect. No bad parts; they were all good! They fit together perfectly in the exquisite relationship God had planned for them."[60] Morgan concludes that the "Creator of sex intended for His creatures to enjoy it. We need never be ashamed to talk about what God was not ashamed to create."[61] In case the reader does not get the point, Morgan reiterates: "In other words, sex is for the marriage relationship only,

but within those bounds, anything goes. Sex is as clean as eating cottage cheese." [62]

THEOLOGY AND COMPARABLE WORTH

These religious voices assume that marriage is a higher estate than celibacy. They are embellishing the benefit of marriage by combining it with the value of sexual ecstasy. Any policies, including comparable worth, that might be seen as detracting from marriage can be seen as limiting the ability of a person to lead a full religious life. Not only social stability but religious fulfillment is at stake when one tampers with the institution of marriage.

This analysis suggests that the theological positions of the religious traditionalists are likely to lead to women's inequality in the workplace. Their continued assertion that women are different from men encourages divergent treatment in the public arena.

The claim of religious traditionalists that women and men are different can be used to strengthen the free market position. If women are distinct from men, and even biblically directed to bear and raise children, then it would stand to reason that if they entered the marketplace they would choose jobs that were in harmony with their more important vocation. If jobs dominated by women paid less than jobs dominated by men, this could be explained, as the free market's advocates claim, by factors related to free choice. Women are choosing to follow their God-given mandate.

The religious right's emphasis on the family works to reinforce free market capitalism. If the family is the core value that must be maintained, either because it is biblically required or because it is the basis of society, then women's equality in the workplace, even if it were desired, would have to be less important than women's obligation to maintain the family.

RELIGION AND POLITICS: ELECTIVE AFFINITY

The similarities between many of those on the secular right and the religious right have often been noted by the actors themselves. Although there are differences between the positions of the religious and the secular right, within the context of this particular policy issue the points of agreement between the two are more significant than the differences. The religious underpinning offered to assert women's uniqueness and the necessity of the family are useful to both religious and non-religious opponents of comparable worth.

There are other similarities between the positions of the free market conservatives and the religious traditionalists. Indeed, as noted in the last

chapter, many have followed Max Weber and claimed that there is an "elective affinity" between religious and political views. For example, a person who is conservative religiously is likely to be conservative politically, and vice versa. For Weber, this affinity could be explained by a number of factors, especially the force of ideas. In his classic example, he posited that the "Protestant ethic" was not only compatible with, but even encouraged, the rise of capitalism. Tocqueville offered the same idea in more psychological terms: "If the human mind be left to follow its own bent, it will regulate the temporal and spiritual institutions of society in a uniform manner and man will endeavor . . . to harmonize earth with heaven." [63]

A comparison of the writings of the secular conservatives and religious traditionalists could lead to a conclusion of elective affinity because of several historical overlaps between them. George M. Marsden discusses two factors that demonstrate remarkable similarities between the religious and secular right. First Marsden notes that the movements that today are part of the religious right themselves developed at the same time that the entrepreneurial spirit was growing in America: "As was already true in nineteenth-century American revivalism, fundamentalism built its strongest centers on a free-enterprise principle. Effective evangelists, working independently of major denominations, built empires around evangelistic associations, Bible institutes, summer conference grounds, and affiliated ministries that could mobilize support for various causes."[64]

Today one would note the mass communications networks of the televangelists. In this light Marsden sees the entrepreneurial spirit as part and parcel of the historical inheritance of the religious right. Their thinking is essentially in harmony with the entrepreneurial, free market philosophy of the secular right. It should not be surprising that Jerry Falwell has claimed that "the free enterprise system is clearly outlined in the Book of Proverbs in the Bible. Jesus Christ made it clear that the work ethic was a part of his plan for man." [65]

Second, Marsden notes another point about the religious right that is remarkably similar to one made by their secular counterparts—the notion of America as the chosen land, superior to communism. While the secular right would emphasize the lack of economic free choice in a communist society, the religious right emphasizes the godless nature of communism. Both groups agree that it is important for America to maintain its position of strength against communism. The religious right tends to accept, although for different reasons, the secular right's assumption that women's wages are a far less important subject than protecting America from the magnetic attraction of communism. With the end of the cold war, both the religious

and secular right will be struggling with the implications of an unexpected historical development that seems to confirm the correctness of their philosophy but leaves a practical void in their prescriptions for the future.

CONCLUSION

Despite differences, the free market conservatives and the religious traditionalists are in remarkable agreement about the importance of the values that are at stake in the comparable worth debate. Both accept that women are distinct from men; both assert that the family is an institution that must be maintained and protected.

Both of these groups are historically comfortable with each other. The free market conservatives concur that religion is an important factor in maintaining society. Neither group would agree with Marx that religion is counterproductive to the social good, perhaps because they are anxious to maintain the status quo. Both view religion in positive terms.

There is also at least some measure of "elective affinity" between the two groups. Both not only agree on certain values related to the comparable worth debate but share specific historical similarities as well. The spirit of free enterprise permeates both camps, as does the conviction of America's moral superiority.

The religious right and the secular right, then, form a coherent political alliance on the subject of comparable worth. Although they do not concur on all issues, the religious right offers a religious underpinning to the position on comparable worth articulated by its secular allies.

5

The Social Egalitarians

Advocates of comparable worth base their case on completely different concerns and evidence than do its opponents. Most advocates of comparable worth contend that women are penalized in the marketplace not only because of specific discrimination but also because women's upbringing does not emphasize factors such as education or job training that would result in rewards in the work world. Many advocates of comparable worth also stress that women's role in the family, as well as the societal assumption that women are somehow more responsible than men for maintaining the family, also hinders their ability to gain higher wages in the marketplace.

Feminist ethicists, both secular and theological, have written extensively on the questions of women's equality and the role of the family. Indeed, so extensive are these writings that there are numerous ways of organizing their arguments for purposes of discussion. Feminist authors are often divided by analysts into liberal, radical, and socialist camps. Marxist feminists are sometimes discussed as a separate category.

In this chapter I divide non-religious feminist theorists into three groups: liberal feminists, communitarian feminists, and socialist feminists. Liberal feminist ethicists are so classified because they share most of the basic tenets of liberal theory. They accept the liberal view of human nature and politics, including the belief that because it is the mind that makes people human, women and men are essentially similar. Furthermore, they see legal solutions as the answer to social problems. The communitarian femi-

nists criticize liberalism for its emphasis on individualism at the expense of community. They view women and men as distinct, but are not certain whether these differences are socially or biologically based. As exemplified most clearly by Carol Gilligan, they see women offering a "different voice," speaking for an ethic of responsibility, rather than for what they view as harsher notions of justice.

Socialist feminists share the Marxist view of society as divided into two classes, the oppressors and the oppressed. They add to this classification the radical feminist concept of women as the fundamental oppressed class. They think that Marx's emphasis on economic class alone is not suitable for discussions of women's oppression. They see women influenced, like all people, by the combination and the interpretation of social and economic forces. They acknowledge biological differences between women and men, but assert that any inherent distinctions have been interpreted as detrimental for women by a patriarchal, capitalist society. Socialist feminism focuses most specifically on the conflict between family and equality. This section includes authors who can be categorized as socialist feminists as well as analysts who have been strongly influenced by the theoretical formulations of that school.

These three groups, although not inclusive of the entire debate, represent major points of view about those questions that are most important in comparable worth discussions. All three secular feminist groups agree that women are not treated as well as men in contemporary society. They offer different explanations, however, of the causes of the problem and different solutions for it. They also disagree about the similarity or distinctiveness of women and men, and about the role of religion in society.

LIBERAL FEMINISM AND COMPARABLE WORTH

Liberal feminists accept the concepts of liberalism and advocate the application of the liberal ideal of equality to women in the same measure as to men. They favor principles of comparable worth as an extension of the principle of equality. As Alison Jaggar notes: "Liberal feminists are perhaps most familiar to North Americans. They describe oppression as resulting from the unequal treatment of women and men within our social institutions; such unequal treatment results in unfairness to individuals. Changes in the legal and political structures are important liberal mechanisms for redressing injustices."[1]

Liberal feminist theory, however, is complicated when questions of equality confront the fact of biological differences between women and men. Problems often arise in treating women and men alike since they are not biologically identical. Liberal theory is based on the importance not of the

body but rather of the mind. It views people as rational agents. It is the capacity for reason that differentiates humans from other creatures.

For liberal theorists, differences in bodily characteristics are seen as irrelevant. Once it has been established that women are rational beings, gender distinctions are as unimportant to role in society as differences in height, weight, or hair color. Liberal theory ignores biological differences. Jaggar speaks of the "somatophobia" inherent in the liberal tradition. The term, coined by E. V. Spelman, refers to the "hostility toward the body that is displayed throughout the Western philosophical tradition and which liberalism expresses by identifying the human essence with the 'mental' capacity for reason."[2] Thus, "one aspect of liberal somatophobia is its theoretical disregard for the significance of the body."[3]

Liberal feminist theory opposes unequal pay for women because it "violates, in one way or another, all of liberalism's political values, the values of equality, liberty, and justice."[4] Sex discrimination is unjust "because it deprives women of equal rights to pursue their own self-interest."[5] Yet for most liberal feminists, discrimination is not inevitably rooted within the legal system. These feminists assume that laws can be changed, or perhaps better enforced, in order to ensure the equality to which women are entitled.

Like most other feminists, this group notes the unfairness of job segregation by sex as an instance of discrimination against women. "Informal discrimination is manifested not only in assumptions that women are not suited to certain sorts of work; it can also be expressed through assumptions that women are particularly well-suited for other sorts of work."[6] Indeed, job segregation has implications well beyond the world of work:

> Women's relegation to certain kinds of work degrades them not only while they are performing that work. According to liberal feminism, the conditions of women's work also diminish their liberty and autonomy in the rest of their lives. Women are paid so little that they figure disproportionately among the poor and most contemporary liberals recognize that poverty makes it difficult or impossible for individuals to exercise their formal or legal rights. . . . However one expresses the point, liberal feminists complain that poverty makes most women unequal to most men.[7]

Jaggar refers to John Stuart Mill who noted over 100 years ago that "the *power* of earning is essential to the dignity of a woman, if she has not independent property," and to Betty Friedan, writing a century later, who agreed that "for women to have full identity and freedom, they must have economic independence."[8]

It is not surprising that liberal feminists have been at the forefront of the struggle for comparable worth. By working within the legal system, and trying to acquire "role equity" (in the terms of Gelb and Palley) for women,

this group has been active in research and litigation. Most pro-comparable worth analysts recognize the accomplishments of this group in the progress toward women's equality in the public arena. Even when assuming that liberal philosophy cannot fully solve the problems of women's inequality in the work world, most acknowledge the important advances for women that have been accomplished using the theory and techniques of liberalism. Mary Shanley, a critic of traditional liberal theory, expresses the debt that women owe to that theory: "In the nineteenth century traditional liberal concepts of individual rights, natural freedom, and consent or contract were powerful tools in the hands of feminist reformers and provided an important part of the ideological basis of attaining women's rights. For example, individualistic and contractual ideas, particularly the notion that consent is at the root of all human obligations, were crucial to early divorce law reform." [9] In more recent times, the same liberal principles have been used in such areas as the Equal Pay Act of 1963 and the enforcement of equal employment opportunity under Title VII of the Civil Rights Act of 1964.

Shanley and others point not only to the important victories for women's equality that were based on liberal principles but to the critical role of the liberal tradition in promoting such values as freedom, liberty, and equality. "In arguing for these measures feminists again insisted that public policy measures based on assumptions about natural talents or proclivities of either sex were at odds with notions of natural freedom, equality, and right of self-determination." [10] In brief, "despite liberalism's ultimate shortcomings, the notions of individual freedom and self-determination are important in establishing equal opportunities for men and women to develop whatever talents and to pursue whatever interests they may have." [11] Although for Shanley and her cohorts liberal theory must be amended, it cannot ultimately be discarded. Liberal theory is the most common basis used for claims for equal rights for women, especially for those outside of the religious debate and it has provided much of the energy and the rationale for comparable worth policies.

LIBERAL FEMINISM AND RELIGION

Because of its emphasis on individualism and individual rights and freedom, liberal feminism—like classical liberalism—does not have much to say about religion or religion's role in public policy making. Individuals certainly have the right to join any religious groups that they desire, but the assumption of liberalism is that the individual precedes the group.

This group of feminists shares some concepts with free market con-

servatives, for both groups are heavily influenced by the classic liberal tradition. Both groups accept a strong differentiation between the public and private arenas, and both see religion functioning in the private sphere. In contrast to free market conservatives, however, liberal feminists are more worried about setting clear boundaries between church and state. While conservatives accept that religious influence on the private sphere ultimately has an impact on the public sector, liberals fear any such relationship between the two arenas.

COMMUNITARIAN FEMINISM AND COMPARABLE WORTH

Carol Gilligan has come to exemplify the communitarian feminist criticism of liberal theory although many others, both in contemporary and earlier times, have offered similar ideas about women's and men's morality. Her book *In A Different Voice* speaks of the differences between women and men, and the distinct moral voice in which most women (as well as some men) speak. Where liberal feminist theory views women and men as alike, communitarian feminists emphasize women's and men's distinctions. Gilligan never specifies whether these differences between the genders stem from biology, from the particular mode of child rearing prevalent in contemporary Western society (where mothers hold most of the child rearing responsibilities), or from other reasons altogether. According to Gilligan, while men are motivated by concepts of individualism and concern with rights and justice, for women "the moral problem arises from conflicting responsibilities rather than from competing rights and requires for its resolution a mode of thinking that is contextual and narrative rather than formal and abstract." [12]

Feminists, of course, are not the only theorists who have criticized liberal theory for its concept of the "unencumbered self," [13] born free of any attachments to other human beings. Communitarian feminists, however, see the female perspective as an antidote to this aspect of liberalism.

Gilligan notes that "attachment and separation anchor the cycle of human life" [14] and cites studies that indicate that women and men respond differently to these polarities and therefore speak in distinct moral voices. For example, she notices in studies of male and female violence that women and men see danger lurking in entirely different situations. Gilligan hypothesizes that "men and women may experience attachment and separation in different ways and that each sex perceives a danger which the other does not see—men in connection, women in separation." [15]

Gilligan and the communitarian feminists are more ready to accept gender distinctions than some feminist psychoanalysts who acknowledge the psychological problems inherent for women in emphasizing connection at

the expense of separation and autonomy, and who encourage both genders to incorporate the two poles of the separation-connection dichotomy.[16] For the communitarian feminists a good society that values the dual elements of relationship and individual autonomy will need to include both genders in the public discourse because each speaks in a different voice.

Other contemporary authors reiterate Gilligan's viewpoint about gender distinctions. Belenky, Clinchy, Goldberger, and Tarule, for example, write about "women's ways of knowing."[17] They distinguish and compare women's paths to knowledge and truth with men's. Lucinda M. Finley, a legal theorist, also complains that liberal theory is based on only the male perspective, especially the white Protestant male perspective, and that it has ignored any real differences between people: "A fundamental, but too often unquestioned, assumption of our cultural and political tradition is the ideal of homogeneity. When the historical content of the homogeneous ideal is examined, it becomes apparent that it is hardly an objective, inclusive ideal."[18] Finley notes that the concept masked the prominence of the white male: "The defenders of the American ideal of homogeneous equality wrote in sweeping terms about the commonalities among American citizens, yet their descriptions bore a striking resemblance to the world of the white, anglo-saxon protestant male. . . . The American melting pot has been a cauldron into which we have put black, brown, red, yellow, and white men and women, in the hope that we will come up with white men."[19]

Nel Noddings develops an entire ethical theory based on the value of relationships which she finds most prominent in women's experiences of mothering and caring. Noddings claims that "we love not because we are required to love but because our natural relatedness gives natural birth to love. It is this love, this natural caring, that makes the ethical possible."[20] Like Gilligan, Noddings opposes the theories of Lawrence Kohlberg and others who place most women in a category of ethical development inferior to men: "Today we are asked to believe that women's "lack of experience in the world" keeps them at an inferior stage in moral development. I am suggesting, to the contrary, that a powerful and coherent ethic and, indeed, a different sort of world may be built on the natural caring so familiar to women."[21]

Authors such as Gilligan, Finley, Shanley, and Noddings are writing in the contemporary arena, yet their claim that women's voice is different from men's echoes arguments of some earlier feminists. For example, the suffragists often maintained that society would be protected by giving women the vote. Assuming, like Gilligan, that women were either superior to, or at least morally different from men, they thought that the nation's moral fiber

would be strengthened if women participated in the public arena. Many early feminists desired the vote for women not only to enhance the lot of women but also to improve society.

Communitarian feminists are especially interested in changing the perception that women's work is less valuable than men's. In stark contrast to free market conservatives who assert that if women want to earn wages similar to men's they should follow career patterns that are more like men's, this group argues that women's work, like women's moral voice, is not inferior to men's but simply different. It is only when society will be able to recognize these distinctions between women and men, and accept both genders as equal, that it will have reached a point of maturity. As Mary Shanley notes, "increasingly, feminist writers are insisting that 'women's work' has an importance and value of its own, not simply an instrumental value in sustaining life so that people can get on with the 'real' tasks of human existence."[22]

COMMUNITARIAN FEMINISM AND RELIGION

Communitarian feminists, like their liberal sisters, rarely speak directly to the question of the role of religion in society. Ironically, the communitarian view of the function of feminism in a gender-integrated society is remarkably similar to the view of many sociologists of religion about the function of religion in society. Many scholars of religion, such as Tocqueville or Durkheim, saw religion playing an integrative role for society. This school of feminists sees the female voice serving the integrative function. For communitarian feminists, then, it can be said that feminism is a functional replacement of religion.

A comparison of the work of a contemporary sociologist of religion who argues in favor of the role of religion in social maintenance with the work of some communitarian feminists is illustrative of the point. Robert Bellah and his co-authors distinguish between the languages of the biblical and republican traditions, on the one hand, and individualism on the other. They speak of the loss to American society of the language of these earlier traditions and argue that Americans have been trained to use only the "'first language' of American individualism in contrast to alternative 'second languages,' which most of us also have."[23] Describing the people who have been interviewed for *Habits of the Heart*, they note that "when each of them uses the moral discourse they share, what we call the first language of individualism, they have difficulty articulating the richness of their commitments. In the language they use, their lives sound more isolated and arbitrary than, as we have observed them, they actually are."[24] Bellah and his co-authors

propose that the biblical and republican traditions of American history must be revived in order to give Americans the feelings of interconnectedness that are necessary for society to be maintained.

Mary Shanley, expressing the communitarian feminist position, speaks of the individualistic strand of liberalism in a very similar fashion. Almost echoing Bellah's own words about language, she notes that

> while liberal ideals have been efficacious in overturning restrictions on women as individuals, liberal theory does not provide the language or concepts to help us understand the various kinds of human interdependence which are part of the life of both families and polities, nor to articulate a feminist vision of "the good life." Feminists are thus in the awkward positions of having to use rhetoric in dealing with the state that does not adequately describe their goals and that may undercut their efforts at establishing new modes of life.[25]

For Shanley, neither religion nor republicanism is the antidote to overgrown individualism. Feminist theories and practices, not religious concepts, are the solution to this problem. A good society needs "a common affirmation of the importance of nurturant activity to a full and rich human life."[26] According to Shanley: "The basis for adequate public policies must be the recognition that nurturant activity (which includes the care of the sick and aged, as well as caring for children) should be as much a part of a full adult life as productive work. These are tasks not only gratifying to individuals but centrally important to the common life of the polity."[27]

The attitude of many in this group toward Freud and his theories also points toward the substitution of feminism for religion. Although often critical of Freud's alleged misogyny, the more psychologically oriented communitarian feminists often accept Freud's notion of the fundamental unimportance of religion. For Freud, religion is the result of childhood wishes that cannot be fulfilled. As he states in *The Future of an Illusion:*

> [Religious ideas] are illusions, fulfillments of the oldest, strongest and most urgent wishes of mankind. The secret of their strength lies in the strength of those wishes. As we already know, the terrifying impression of helplessness in childhood aroused the need for protection—for protection through love—which was provided by the father and the recognition that this helplessness lasts throughout life made it necessary to cling to the existence of a father, but this time a more powerful one. Thus the benevolent rule of a divine Providence allays our fear of the dangers of life; the establishment of a moral world-order ensures the fulfillment of the demands of justice, which have so often remained unfulfilled in human civilization; and the prolongation of earthly existence in a future life provides the local and temporal framework in which these wish fulfillments shall take place.[28]

For communitarian feminists religion is indeed illusion. Fortunately, feminism, and female relationships, are real.

Communitarian feminists offer subtle clues that convey their substitution of feminism for religion. For example, Carol Gilligan contrasts her concept of the female moral voice with the view of male individualism by citing the response given by Freud to a question about religion raised by Romain Rolland. Rolland wrote to Freud in response to his reading *The Future of an Illusion*. Although he found Freud's analysis of religion fair, he complained that Freud had not analyzed "religious feelings." For Rolland, the religious sensibility was based on an "oceanic feeling," the "sensation of the eternal (which may very well not be eternal, but simply without perceptible limits, and in that way oceanic)." [29] Freud responded to Rolland by shifting the topic. He explained that this so-called oceanic feeling stemmed not from a perception of the "eternal" but rather from the infant's sense of connection to the world around it: "With the ego's boundaries with the universe blurred or incorrectly drawn, the infant experienced an indissoluble bond with his surroundings." [30] For Freud, "the oceanic sensation [was] largely a regression to a childlike state in which the subject had no conception of self as differentiated from individuals or from the environment, and in which an ecstatic feeling of well-being was experienced." [31] This feeling did not relate to religion, but to the development of the ego.

While Freud substituted a framework of individual development for a religious concept in order to explain the "oceanic feeling," Gilligan ignores the fact that Rolland's original question related to religion. Like Freud, she does not seem to see a place for religion in contemporary life. Also like Freud, she explains the feeling of connection to others and to the universe itself as stemming from the infant's earliest perceptions. Unlike Freud, however, she believes the feeling of connection is to be valued, not to be outgrown. The early connection with the mother especially is critical for the development of moral theory. This relationship, rather than religion, is what is necessary for a good society.

Nel Noddings is even more direct in her substitution of feminism for the Western religions as a basis for ethical living. She specifically contrasts her theory with Christianity: "While much of what will be developed in the ethic of caring may be found, also, in Christian ethics, there will be major and irreconcilable differences. Human love, human caring, will be quite enough on which to found an ethic." [32] Noddings insists on the ability of natural caring to serve as an adequate base for an ethical theory and sees no need for a religion to impose principles. Her feminist theory alone is all that is necessary:

> It seems to me quite natural that men, many of whom are separated from the intimacy of caring, should create Gods and seek security and love in worship. But what ethical need have women for God? I do not mean to suggest that women can brush aside an actually existing God but, if there is such a God, the human role in Its maintenance must be trivial. . . . What I mean to suggest is that women have no need of a conceptualized God, one wrought in the image of man. All the love and goodness commanded by such a God can be generated from the love and goodness found in the warmest and best human relations.[33]

For communitarian feminists there is no need for religion in society.

SOCIALIST FEMINISTS

The work of the socialist feminists is dominant among those who view the family as the most important detriment to women's equality in the workplace. Like the communitarian critics of liberalism, socialist feminists view the liberal tradition as too focused on the individual and not concerned enough with the community. Socialist feminists combine Marxist and radical feminist ideas and interpret contemporary American society in terms of two separate but interdependent power structures: patriarchy and capitalism. They see a "mutually reinforcing dialectical relationship between capitalist class structure and hierarchical sexual structuring"[34]—in a phrase, capitalist patriarchy. In other words, capitalism reinforces an underlying system of oppression based on gender. The sexual division of labor in both the family and the workplace connects these two bases of oppression.

Because of their acceptance of Marxist economic interpretation this group in many ways offers the most specific contrast to the theories of free market capitalists such as Gilder, Levin, or Decter. Despite their fundamental disagreement about economics, however, both free market advocates and socialist feminists agree that the family is the linchpin on which contemporary American society rests and that women's role in the family is the major reason for women's lower wages in the work world. Where these two groups differ is in their assessment of the reasons for this social structure and their solutions to the conflict between family and equality.

For Zillah Eisenstein, a socialist feminist theorist, it is the "reciprocal relationship between family and society, production and reproduction, [which] defines the life of women."[35] Thus, "the study of women's oppression . . . must deal with both sexual and economic material conditions. . . ."[36] Eisenstein criticizes radical feminism for insufficient awareness of economic forces and for seeing "patriarchy . . . rooted in biology rather than in economics or history."[37] In contrast, socialist feminism tries to account for both biological and economic means of oppression.

For Eisenstein, sexual relationships, just as economic relationships, must be seen within a context. Unlike many of the free market conservatives, Eisenstein disagrees that men are intrinsically more economically able, or less sexually able, than women. For Eisenstein, men, as women, are products of social forces: "A man as a biological being, were he to exist outside of patriarchal relations, would be a hollow shell. In patriarchal history, it is his biology that identifies him with the relations of power. . . . A man's sexual power is not within his individual being alone." [38] For socialist feminists, it is the interpretation of biological differences between the sexes, not the differences per se, that are important: "Men have chosen to interpret and politically use the fact that women are the reproducers of humanity. From this fact of reproduction and men's political control of it, the relations of reproduction have arisen in a particular formulation of woman's oppression. A patriarchal culture is carried over from one historical period to another to protect the sexual hierarchy of society." [39]

PRODUCTION AND REPRODUCTION

One manifestation of the link between capitalism and patriarchy is the patriarchal family. Socialist feminists see this institution as the cause of women's oppression in both the home and the workplace. This group asserts that it is by defining women as mothers and separating the female responsibility for reproduction from the male responsibility for production that the nuclear family and patriarchy are sustained. One means of diminishing men's power is to deny the identification of women and motherhood. Women must somehow limit their role in childbearing and/or child rearing if they are to become less oppressed. In other words, only if men and women share responsibility for child rearing in the home can they share equal status and compensation in the workplace.

Most feminists accept these views. They do not accept the inevitability of a split between the (male) public and (female) private or between (male) production and (female) reproduction and agree with socialist feminist theories that question the view of women as the only child rearers as well as childbearers. Indeed, it is probably on the issue of child rearing that socialist feminist theory has had its greatest impact on social egalitarianism.

Many note that while childbearing is a biological function, child rearing is inherently social. Susan Moller Okin asserts that "what has been alleged to be women's nature has been used throughout history and into the present to justify keeping the female sex in a position of political, social and economic inequality." [40] For Zillah Eisenstein, "the political definition of woman as both childbearer and rearer is used to maintain a system of male

privilege that sustains the economic-class arrangements of society." [41] Males want to keep this definition of woman as mother intact and "to keep the choice limited for woman so that her role as mother remains primary." [42]

For some radical feminists not only the definition, but the reality, of woman as mother should be eliminated. Shulamith Firestone, for example, envisions a future where women will be "freed" from childbearing and where reproduction will occur in scientific, rather than corporeal, settings. [43] Socialist feminists, however, do not see the necessity of eliminating the function of childbearing. Instead, they want to separate its rigid connection to child rearing and to change the meaning and implications of childbearing for women and society: "[It is] the relations of production and reproduction, not an abstracted notion of biology, [that] define the relationship woman has to herself and society as a reproductive being. . . . It is not reproduction itself that is the problem but the relations which define and reinforce it." [44]

Mary O'Brien in *The Politics of Reproduction* offers a social and philosophical analysis of childbearing that reiterates this view. O'Brien questions why childbearing, alone among biological functions, has been singled out as a "necessity" rather than as a subject for analysis:

> What does it mean to be trapped in a natural function? Clearly, reproduction has been regarded as quite different from other natural functions which, on the surface, seem to be equally imbued with necessity; eating, sexuality and dying, for example, share with birth the status of biological necessities. Yet it has never been suggested that these topics can be understood only in terms of natural science. They have all become the subject matters of rather impressive bodies of philosophical thought. [45]

She comments that Marxism is based on the notion that people have to eat; Freudian analysis is based on sexuality. Many religions rest on the necessity to explain human finitude.

O'Brien notes that the biological function of childbearing has changed significantly with the advent of improved contraception: "The freedom for women to choose parenthood is a historical development as significant as the discovery of physiological paternity. Both create a transformation in human consciousness of human relations with the natural world which must, as it were, be re-negotiated or, to use the language of dialectical analysis, be mediated." [46] Childbearing is less time consuming for women than in previous generations because the number of children any woman has to bear can be limited. Hence, there is even less reason to limit the definition of woman to the biological function.

Socialist feminists agree with free market conservatives that the fam-

ily is an important base that helps to sustain the social, economic, and political systems. Since they do not seek to uphold what they consider to be an unjust political and economic system, however, they are not anxious to strengthen the role of the patriarchal family. Rather, they view that institution as the source of oppression for children as well as for women. Socialist feminist theory asserts the necessity to change the family if women's lot is to be improved.

For socialist feminists the family is central to theoretical as well as practical concerns. The mutual dependence of capitalism and patriarchy is both most noticeable in the nuclear family and institutionalized in the family. The institution of the family epitomizes the interconnections between the two power systems. If one wants to change (or overthrow) the capitalist system, one must change (or overthrow) the family.

Socialist feminists emphasize the connection between family and work. Although "our language treats the family and the economy as separate systems," [47] one must recognize that "the sexual hierarchical division of labor cuts through these two." [48] For this group, public and private are inextricably intertwined. In order to change the workplace, one must alter the family structure. For socialist feminists, then, the family as currently constituted is socially constructed just as is the notion of woman as mother:

> The family is a series of relations which define women's activities both internal and external to it. Because the family is a structure of relationships which connect individuals to the economy, the family is a social, economic, political, and cultural unit of society. It is historical in its formation, not a simple biological unit. Like women's roles, the family is not natural; it reflects particular relations of the society, particular needs to be filled. [49]

Because the family is a social construction, the family can be changed to encourage a more egalitarian society. As Susan Moller Okin notes: "The hierarchical nature of the family made it an exemplary socializing agent for the hierarchical world of king and subjects. . . . It would seem that a family structure that is as democratic and egalitarian as possible would best serve the function of preparing future citizens for a life of political participation and equality." [50] If women and men were to become more equal partners at home, "this will surely affect the potential of the family as a socializing agency for the wider political community." [51]

WOMEN AND CAPITALISM

For socialist feminists, the current construction of the public-private split with its relegation of women to the home is necessary for the maintenance of the capitalist system. Women at home help to maintain society because

they offer both economic and emotional support in their function as house-wives. According to Zillah Eisenstein: "The family supports capitalism by providing a way for calm to be maintained amidst the disruption that is very much a part of capitalism. The family supports capitalism economically by providing a productive labor force and supplying a market for massive con-sumption. The family also performs an ideological role by cultivation of the belief in individualism, freedom, and equality basic to the belief structure of society." [52] Nancy Chodorow notices that "women resuscitate adult work-ers, both physically and emotionally, and rear children who have particular psychological capacities which capitalist workers and consumers require." [53]

Women's work helps to maintain capitalism in other ways as well. Women's underpaid and/or free labor helps to sustain the capitalist economy. Many authors have noted the importance of women's free work in the home, namely housework, in this economy. Women's free labor also includes work in the marketplace that is undertaken to maintain the home. Batya Wein-baum and Amy Bridges discuss the work of "consumption": "Consumption is the work of acquiring goods and services. This work is the economic as-pect of women's work outside the paid labor force." [54] They note that as society has grown more industrialized, many items that were once produced in the home are now available only in the marketplace. Thus women, rather than producing certain goods, are consumers of them. As women's labor has changed from production in the home to consumption of goods produced outside it, that work is now also being done for free, just as home produc-tion was in an earlier era: "Capital [has demonstrated] this ability to increase its own profit by rearranging the labor process and working conditions of shopping and service centers. Those employed there find their work increas-ingly reduced to detail labor; those who shop for services do the walking, the figuring, the comparing, and sometimes even the services themselves (as when auto drivers fill their own gas tanks)." [55] Women, as well as some men, are frequently undertaking without pay work that was formerly paid, while the capitalists are reaping the profit.

Women's underpaid labor also includes their work in the labor force. Socialist feminists are convinced that it is because women are defined as mothers, and devalued as such, that their work is paid less than men's in the free market. It is the "sexual definition of woman as mother [that] either keeps her in the home doing unpaid labor or enables her to be hired at a lower wage because of her defined sexual inferiority." [56] Women's place in the home is ultimately responsible for their poorer position in the workplace.

WOMEN AND WORK

Feminist advocates of comparable worth agree with free market capitalists that motherhood depresses women's wages. The feminists, however, assume that this statistical relationship is an indication not of natural differences between the genders but of women's oppression.

Social egalitarians, including socialist feminists, point to the many changes in women's lives and participation in the work force in the past twenty years that belie the definition of woman as mother and the wisdom of trying to maintain the patriarchal family. They note that despite the patriarchal definition of woman as mother, most women participate in the paid work force: "The characterization of the separate spheres has become less a description of everyday life than one of a persistent ideology," [57] according to Lucinda Finley. Eisenstein asks, "How can one protect the traditional patriarchal family when it no longer exists for a majority of individuals?" [58]

They note the statistics. In 1984, 70 percent of women between the ages of 25 and 54 were in the work force. By 1990 this figure had increased to 74 percent. In 1962 most women between 25 and 54 were full-time homemakers. In 1990 only 21 percent of women of this age were full-time homemakers. Perhaps even more significantly, the percentage of mothers with children under six years who were in the work force has also risen substantially, from 11.9 percent in 1960 to 51.8 percent in 1984. By 1990, over 65 percent of these mothers were in the labor force. [59] These feminists claim that they are not only seeking social improvement, they are also observing and acknowledging changes that have already occurred.

Socialist feminists often claim that it is the denial of these realities of women's lives that is at least partially responsible for the continuation of women's lower status and lower wages in the workplace. Because all women are seen as mothers, whether or not they are, they are not seen as workers, even though most of them are.

Socialist feminists give many reasons why the patriarchal family is the root cause of women's subordinate position in the workplace. Perhaps most obvious, the time commitments necessary for the labor involved in each realm make it difficult to succeed in both. Different skills and psychological attitudes are dominant—almost necessary—in each arena. Women's work in the home discourages the kind of talents and/or personality necessary for success in the marketplace. Lucinda Finley notes that: "the values necessary for success in the home world, such as nurturing, responsiveness to others' needs, and mutual dependence, have been viewed as unnecessary, even incompatible with the work world. Since the work world is assigned economic

importance, the traditionally 'female' tasks and qualities of the home world have come to be generally devalued in our society." [60] Jessie Bernard enumerates the reasons for this incompatibility:

> The reproductive and child-care functions of women . . . may interfere with their labor-force participation and hence influence the sexual division of labor. Homemaking responsibilities assigned to women add to the difficulties of pursuing a career, not only in terms of time and energy, but also in terms of the effect housekeeping as an occupation has on mental abilities. And even more subtle, though no less relevant, is the inherent conflict between the supportive function expected of most women and the demand for aggression found in the most prestigious jobs, those at the top. [61]

Bernard refers to the work of Alice Rossi who identified the incompatibility of many of the social expectations for women with success in the work world. "A childhood model of the quiet, 'good' sweet girl will not produce any women scientists or scholars, doctors or engineers. It may produce the competent meticulous laboratory assistant . . . but not the creative scientists." [62]

Bernard attempts to calculate the losses to the economic system caused by women not working in the economic arena: "The talents of women, according to the optimum utilization of resources policy, may be viewed as a resource to be exploited for the benefit of the economy as a whole, a reservoir to supply services our society needs. . . . " [63] Thus, for example: "if a young woman enters the labor force at age 20, marriage will 'cost' the economy about ten years of lifetime labor-force participation; the woman who never marries will spend about 45 years in the labor force; the woman who marries but remains childless, about 35. One child 'costs' the economy ten more years, for the expected work life of women with one child is 25 years. A second child 'costs' an additional three years. . . . " [64]

She points out that children seriously affect women's professional accomplishments. Although the achievement differential between married and unmarried women is significant, the differential between mothers and non-mothers is even greater: "The advent of children precipitates a marked decline in the professional contribution. Only 41 percent of mothers with one child, and 39 percent of those with two, reach a good or high level of achievement. If there are more than two children, only 17 percent achieve at the good or high level." [65]

SOCIALIST FEMINISM AND RELIGION

Socialist feminists share some assumptions with the religious right, some with the religious left, and some with their secular counterparts on the right. Like the religious right, they see the role of the family as primary in social

maintenance and social stability. Like the secular right, they analyze society in economic terms and discuss the question of the free market. Like the religious left (see chapter 6), they view the subordinate role of women in society as detrimental to women's, men's, and society's well-being.

However, socialist feminists are unlike these other groups in fundamental ways. Unlike the religious right, they wish to change society and family. Unlike the secular right, they view the free market as both reflecting and exacerbating discrimination against women. Unlike the religious left, they see social change as coming from the inevitable clash of class conflicts, rather than from changing notions of God and theology.

For Marxist-oriented feminists, including socialist feminists, religion is not only unnecessary for the process of social change, it is detrimental to it. Change emerges as a consequence of the inevitable tensions between the dominant and subordinate classes. Women's subordination by the male capitalist class will cause the patriarchal capitalist society to deteriorate. Oppression in the home and in the workplace will inevitably lead to changes in the patriarchal family and, thus, in society as we now know it.

Marxist-oriented analysts believe that the needs of advanced capitalism and of patriarchy are already in conflict with one another, and will increasingly be in tension. This tension will ultimately lead to the overthrow of the currently constituted system: "the accommodation of the conflict between women as wage workers, mothers and domestics is not as successful as it may appear. As more women enter the labor force, they expect the ideology of equal opportunity to apply to them; but when they see their limited options within the labor force, the conflict between the ideology of equal opportunity and women's real second class status within the labor force becomes highlighted."[66] Moreover, women "become more conscious of the work they do as childbearers and rearers as they have less time in which to do it. . . . The pressures of the home are exacerbated by the added pressure of the workplace."[67] As capitalism develops and more women are caught in the bind between work and family, the pressures on the system will increase as well, since "the conflict that exists has developed out of woman's dual role in the labor force and her life at home—the ideology of liberal individualism and the reality of sexual dependence."[68]

Religion is, for them, "the opium of the people," and a means of hiding from, and thus continuing, the real causes of their suffering. Just as for the other secular feminist groups discussed, for socialist feminists, comparable worth and similar policies leading toward women's equality will emerge in society not because of, but in spite of, religion. For socialist feminists, society will change, and women's place in society will change, because of a

dialectical process and a class conflict. Religion is unnecessary at best, and oppressive at worst.

This group accepts Marx's negativism toward the place of religion in society: "The abolition of religion as the *illusory* happiness of men, is a demand for their *real* happiness. The call to abandon their illusions about their condition is a *call to abandon a condition which requires illusions*. The criticism of religion is, therefore, *the embryonic criticism of this vale of tears* of which religion is the *halo*." [69]

Ironically, socialist feminists tend to view the religious right, rather than the religious left, as indicative of religion's role in society. This is probably because they share with the religious right the concept of the primacy of the family as society's fundamental building block. When they point to the positions of religious traditionalists toward the family and toward women's equality, they confirm their theoretical view of religion as oppressive.

CONCLUSION

Liberal, communitarian, and socialist feminists all agree on the importance of treating women and men equally in the work world. Each group offers different analyses and distinct suggestions for accomplishing this goal. Yet none of them resolves the conflict between family and equality.

Each group's analyses are both clarified and limited by reference to the larger traditions by which they are identified. Liberal feminists work within a legalist framework, congruent with the liberal tradition. They both benefit from the ability to speak to values deeply imbedded in American life and suffer from the limits of the rational, individualistic, legalistic approach. Communitarian feminists seek to overcome what they see as the deficits of liberalism and speak of the necessity for an ethic of responsibility. They do not, however, adequately account for the importance of rights that is so prominent in the liberal tradition. Socialist feminists stress the connection between family and work and see the intricate relationship between these two realms. However, their theory has not taken account of women who might want to be defined as mothers. Each group also sees the relationship between politics and religion, between its public policy goals and the place of religion in reaching these goals, in terms of its larger philosophy.

A brief assessment of these different positions makes their contributions and limits to the comparable worth debate clearer. It also tests the potential for a religious voice to either sustain or undermine the positions of these secular groups.

Liberal theory's successes can be seen to stem directly from its theory.

In this approach the world of work and the world of the family are not viewed as intrinsically connected because the separation of the public and private arenas is accepted. Liberal feminists have been able to focus their attention on the world of work alone, and to accomplish goals in that arena without becoming bogged down demanding changes in the larger social arena. The values of equality and family can both be accommodated by keeping the public and private spheres distinct. Of the feminist groups discussed, they deal most directly with the question of equal pay for women and men.

The liberal tradition, including liberal feminism, sees human beings in terms of their rational capacities, rather than their physical characteristics. This concept offers a clear basis for equality between women and men. Liberal feminism has excelled in dealing with cases where women can be shown to be receiving less than equal treatment in the public arena. It has been most deficient in dealing with cases that relate to differences between the sexes. Because comparable worth, by definition, refers to situations where work must first be proven to be comparable, even though it is not exactly alike, liberal theory's limits become apparent.

The liberal tradition sees religion playing little, if any, role in the public arena. Liberal theory has no need for a religious basis for equality because women and men are equal on the basis of their rational capacities. Right and wrong, including appropriate policies, can also be discerned without theological concerns because of liberalism's emphasis on rational thought. Religion is acceptable in the private, not the public, arena. Liberal theory, and better laws, are what is necessary for a better society.

The communitarian critics of liberalism deal less directly than the liberal feminists with the world of work. They point to liberal theory's failings and see its definition of the human being limited by what they consider to be a male model. They stress the importance of relationships in contrast to individualism. They criticize liberal theory for not accommodating differences between the genders. They note the liberals' inability to deal with the biological characteristics of women and men. Communitarian feminists assert that once women's special capacities are more appreciated, their lot in the public arena, as well as in the home, will be enhanced.

However, they offer an inadequate basis for their demand for equality between the genders. They criticize liberal theory's emphasis on the mind at the expense of the body, but once they begin, even indirectly, to account for the body, the basis for equality falters. Once women and men are not seen as identical, a new reason for equality between the sexes must be proposed. Once women and men are no longer completely interchangeable

there must be some factor presented that can be viewed as the basis for equal treatment. This theory seems more able to account for the value of family than that of equality.

The communitarian critics of liberalism are similar to their liberal colleagues in seeing the limited role of religion in public policy. Although they stress the importance of relationships in holding a society together, they see feminism itself, rather than any religious input, as serving this function. They accept Freud's negative approach to religion. Although they do not specifically define religion as neurotic, they view it as unnecessary.

Socialist feminists criticize both liberal and communitarian feminists for accepting the split between the public and private realms. They view the patriarchal family as the major impediment to women's equality and seek significant social change. Yet there are several problems in their analyses that limit their ability to bring about that change.

This group emphasizes the intricate interconnections between work and family, between public and private, and seeks to break the barriers between these two arenas, but its suggestions for social change emphasize the need to alter the private more than the public sphere. While liberal feminists speak of the need to change the world of work, socialist feminists emphasize the necessity of changing the family, perhaps inadvertently decreasing the importance of transforming the workplace. Although this theory posits that the only way to change the public arena is to alter the private one, especially the concept of woman as mother, it assumes that once the private arena has been ameliorated, change in the public arena will inevitably follow. Specific suggestions for the workplace in order to insure, or at least encourage, women's equal treatment are not as prominent as they are with some other feminist groups. If one assumes that the workplace cannot be improved without shifts in the family, and if one accepts the Marxist notions about the inevitability of change, the incentives for concrete suggestions for changing the workplace are diminished.

Although socialist feminists emphasize the need to alter the patriarchal family, they offer few recommendations for how this objective is to be reached. Suggestions for sharing child care between two parents, or for increasing public support for child care, are not only limited in their scope but would actually necessitate significant changes in the public as well as the private arena. As long as the workplace remains as it is, the financial risk of leaving paid labor for any substantial amount of time would be the same for men as it is now for women. The problem of poverty might become less feminized, but it would not be diminished.

Despite their desire to reduce the public/private split, socialist femi-

nists rarely acknowledge or focus on the real difficulty of doing so now that most paid labor is undertaken outside of the home. If women are to be seen as workers as well as mothers, the importance of the public, rather than the parental, persona is emphasized. As Mary O'Brien notes: "The integration on equal terms into the productive process is a necessary but not sufficient condition of liberation. Liberation also depends on the reintegration of men on equal terms into the reproductive process. . . . Only then can men and women abandon a long preoccupation with sleeping together in favour of being awake together." [70]

Socialist feminists provide no specific reason for women's equality because to them gender is a socially constructed quality, rather than an intrinsic one. Their arguments are based on Marxist principles of class. Women's oppression will cease once the categories of oppressor and oppressed are eliminated. Socialist feminists discuss notions of the similarities between women and men by emphasizing the social, rather than biological, definitions of childbearing and rearing. Like liberal feminists, they do not account for the possibility of essential differences between women and men.

Socialist feminists remain antagonistic to the role of religion in public policy making. Because they do not accept a differentiation between the public and private arenas, they are not able, as liberal feminists are, to accept a role for religion in the private sphere. They see religion's role even in the private arena as having an adverse impact on public life. Because religion helps to mask peoples' feelings of oppression, it hinders, although it cannot prevent, the changes socialist feminists believe are necessary for society's improvement.

All three of these major feminist groups offer important suggestions for furthering women's equality in the workplace. Many feminists, socialists especially, confirm the fears raised by comparable worth opponents who stress the inevitability of role change for women if women's wages are increased. Other feminists simply do not address these fears. And none of these secular groups has looked to the positions expressed by religious advocates of comparable worth to help them make their case for women's equality.

6

The Feminist Theologians

Feminist theologians differ markedly from the more secular proponents of comparable worth who see religion as irrelevant to women's well-being or even detrimental to it. Instead, they view religion not only as "a contributing factor, [but] undoubtedly the single most important shaper and enforcer of the image and role of women in culture and society."[1] As Mary Daly notes, religious images, including envisioning God as "an old man with a beard," continue to have "a powerful grip . . . upon the imagination even after they have been consciously rejected as primitive and inadequate."[2] These images "can and do have the effect of paralyzing the human will to change evil conditions and can inspire callousness and insensitivity."[3]

According to feminist theologians, it is important to acknowledge that "it has been religion that has been the ideological reflection of this sexual domination and subjugation. And it has been religion, as a social institution, that has been its cultural sanctioner."[4] Feminist theologians believe that if one wants to change the position of women in the workplace, one must alter, or at least reinterpret, the religious traditions that have either caused, or reinforced, the unequal position of women in society. If one seeks equality for women, the patriarchal religious legacy must be overcome. Since religion remains an important cultural determinant, it is important to replace the patriarchal religious traditions with more egalitarian ones.

Feminist theologians can be discussed more clearly by identifying three broad groups that on occasion overlap both in their memberships and in their

positions. I have divided feminist theologians primarily according to their theological perspectives. Biblical feminists, especially evangelical feminists, emphasize that religious truths are expressed in biblical texts. Reformist feminists are not as wedded to biblical texts as the first group but still see religious meaning within the traditional teachings. Radical feminists move outside the Jewish and Christian traditions to find religious truth.

Although there are similarities between the three categories of secular feminism discussed in the previous chapter and the three categories of religious feminism discussed here, these two groups are not exactly parallel. This chapter is not organized around these three groups of theologians. Rather, it discusses the underlying theological questions related to comparable worth while noting the positions of the three feminist religious groups on each of these topics.

Evangelical feminists argue for the intrinsic equality of women in the religious tradition. Tradition must merely be properly understood for this equality to emerge from the texts themselves. These feminists grapple with the alleged conflict between equality and family but assert that this conflict, too, can be resolved through the proper understanding of the texts. Evangelicals are not the only theologians to use biblical texts, but their heavy reliance on them is distinctive.

Reformist Christian and Jewish feminist theologians also refer to the biblical tradition but use texts as resources as much as authority. Feminist liberation theologians, perhaps the most widely known group of religious reformist scholars, frequently assert solidarity both with socialist feminists and with other liberation theologians. They tend to see a model of liberation as the intrinsic message of religious texts and seek to change society through overturning the relations of domination and submission. They are less concerned than their evangelical sisters with preserving the family. Instead, they view enforced heterosexuality, mandated by the institution of the family, as one more indication of women's oppression.

Finally, post-Christian (or post-Jewish) or radical feminists so define themselves because they disagree that the traditional religious texts are in any way compatible with the goal of equality for women. They assert that the Jewish and Christian traditions are essentially patriarchal and that they must be surpassed by those who truly desire women's equality. This group accepts many of the criticisms of liberalism offered by communitarian feminists. They agree that women offer a different moral voice. Yet they usually see this voice as a superior, rather than merely an alternative, position. The radical feminists are often characterized, in Mary Daly's term, as the "exodus community":

> [T]he sisterhood of man cannot happen without a real exodus. We have to go out from the land of our fathers into an unknown place. . . .

> We cannot really belong to institutional religion as it exists. It isn't good enough to have our energies drained and co-opted. Singing sexist hymns, praying to a male god breaks our spirit, makes us less than human. The crushing weight of this tradition, of this power structure, tells us that *we do not even exist.*[5]

Radical feminist theologians are also not concerned with preserving the family because they see it as an essentially unequal relationship between women and men. They agree with reformist theologians that enforced heterosexuality is an expression of male dominance and patriarchal culture and therefore must end.

The one issue on which all of these theologians agree, however, is that religion is fundamental in life and that equality for all people, women and men alike, must be at the core of religion and society. As Carol Christ and Judith Plaskow assert, "the fundamental commitment that feminists in religion share to end male ascendancy in society and religion is more important than their differences."[6] For feminist theologians, the goal of equality for women, including equality in the workplace, can only be achieved by dealing first with religion. Their immediate aim is to correct the damage done by patriarchal religions, especially by changing the image of God as male. Feminist theologians are acutely aware of the charges made by Simone de Beauvoir against the church for its role in maintaining women's inequality, and of the tendency for non-religious feminists to continue to see religion in this oppressive role. They seek to change the image of religion as a conservative and oppressive force.

EQUALITY UNDER A MALE/FEMALE GOD

Feminist theologians assert that imaging God as male is not only theologically incorrect but has widespread ramifications for society. If God is male, then women can never see themselves as being created in God's image and can never partake of the essence of God. Neither men nor women are able to envision women as godlike. If God is male, women are less than men; they are both theologically and socially unequal. As Mary Daly notes, if God is male, then "the male is God."[7]

Feminist theologians point out that the image of a male God has a powerful impact on the entire infrastructure of society. They note the hierarchical orientation that places God at the top of a pyramid, with men underneath but in close proximity to the divinity. Women and children come

below men, thus further away from God. Other creatures follow women and children, with the realm of nature itself at the bottom of the pyramid.[8]

This vision firmly identifies men as the dominant creatures, associated with divine qualities, and places women further from God, but closer to nature. According to many feminist theologians, this patriarchal structure both perpetuates and explains the dualism inherent in the images of female and male. If men are God-like, then they are more rational than women and deserve to be more powerful politically. If women are closer to nature, they are submissive, as well as more emotional.

Feminist theologians seek to overturn this image of God as male and to alter the social conditions that they see as resulting from this image. To counter the theological and social problems presented by the image of God as male, feminist theologians offer a wide variety of means for changing the image of God. Some merely want to correct the perception of the image of God as male; others seek to change the concept of God altogether.

Feminist biblical scholars assert that biblical texts have been misinterpreted by males unduly influenced by the patriarchal tradition. For example Phyllis Trible claims that "we need no longer accept the traditional exegesis of Genesis 2-3. Rather than legitimating the patriarchal culture from which it comes, the myth places that culture under judgment. And thus it functions to liberate, not to enslave."[9] Trible claims that the biblical creation story demonstrates a pattern of less to more important creation. In her view woman, being created after man (in the Genesis 3 version), must be seen as not less, but more, important than man.

Virginia Mollenkott's work is representative of those scholars who see the Christian and Jewish traditions offering an image of God as including both male and female. Like Phyllis Trible, she speculates that if the tradition were appropriately interpreted, sometimes even just correctly translated, the image of God as both female and male would clearly emerge. In her book *The Divine Feminine: The Biblical Imagery of God as Female*, she offers numerous female images of God which she has uncovered in the Bible.[10] She discusses the Godhead as a woman in the process of giving birth. God is also described in terms of other maternal activities, including a nursing mother. Christ as female pelican, God as mother bear, God as female homemaker, God as mother eagle and as mother hen are among the many female images that she uncovers. For Mollenkott, "a patriarchal interpretative grid has simply made it impossible for most people through the ages to be able to perceive the many images of God as female. . . ."[11] She quotes Leonard Swider who thinks that "an underlying widespread Christian deprecatory

attitude toward women . . . blinded most Christian theologians and commentators to the strong feminism of Jesus in the Gospels." [12] Mollenkott, Swider, and others are convinced that if people would only read the texts properly the biblical image of God as both male and female would clearly emerge.

Reformist theologians also seek to reinterpret the traditions in order to accommodate women equally within the religious framework. Christian feminist liberation theologians, for example, emphasize the role of Jesus as liberator. Rosemary Ruether asserts that patriarchal domination has masked this essential core of Christianity. It is not Jesus' masculinity that is relevant; it is his opposition to relations of domination and subjection.[13] Beverly Wildung Harrison also agrees that the essence of Jesus is his liberating activity: "Jesus was *not* crucified for urging that we sacrifice ourselves for God. He was killed because he insisted on encouraging the acting out of the conditions of God's reign and on getting 'the way' of communitarian living under way." [14] These women see the tradition as having been corrupted; it can be purified. As Harrison states: "In spite of the rage of dominant theological groups, many of us have learned that in, with, and under these dominant theologies, there is within Christian tradition a marginal, but nevertheless more authentic and empowering message. Women's use of marginal traditions of Christianity is as appropriate as women's use of *all* marginated historical tradition." [15]

Post-Christian feminists, including Mary Daly, Naomi Goldenberg, Carol Christ and Starhawk disagree that there is a marginal but "more authentic" tradition hidden underneath the patriarchal interpretations of Christianity and/or Judaism. They assert that these religions are sexist at their cores, that no amount of reinterpretation can change such intrinsic parts of the biblical stories as Jesus' masculinity, the story of the virgin birth of Jesus, or creation of the universe *ex nihilo*. They note the long history of women's repression in these religions and think that the Jewish and Christian traditions must finally be discarded if one really wants to overcome sexism. They assert that rearrangements and reinterpretations of these traditions will be inadequate because the traditions themselves are sexist. They often note that they are the*a*logians, studying a concept of God as essentially female, rather than the*o*logians, studying a male God.

Carol Christ, in an essay on why women need the Goddess, summarizes the debilitating effects of seeing God as male and offers three reasons why women need to overcome the male image of God. "The simplest and most basic meaning of the symbol of Goddess is the acknowledgment of the legitimacy of female power as a beneficent and independent power." [16] The second reason "is the affirmation of the female body and the life cycle ex-

pressed in it." [17] Finally: "a third implication of the Goddess symbol for women is the positive valuation of will in Goddess-centered ritual, especially in Goddess-centered ritual magic and spellcasting in womanspirit and feminist witchcraft circles. . . . Here the Goddess is a center of focus of power and energy; she is the personification of the energy that flows between beings in the natural and human worlds." [18]

Starhawk, a proponent of witchcraft, similarly sees the Goddess as the manifestation of the life force. "The Goddess is manifest in the self—but also in every other human self, and the biological world. We cannot honor and serve the Goddess in ourselves unless we honor and serve her in others." [19] Witchcraft is based on an understanding of an intricate relationship between the individual and the community. "In witchcraft, the coven [the community of thirteen] structure fosters the dynamic balance between the individual self and the interrelated community that is necessary for true personal responsibility to develop." [20] Moreover, unlike the traditional Western religions, witchcraft is based on a view of the Goddess (or God) as immanent, residing within the world, rather than as transcendent, only interacting with humans from outside the known world: "The major difference between patriarchal religions and the evolving Goddess religions—perhaps even more central than the image of the divine as female—is the worldview that includes regarding divinity as immanent: in the world, not outside the world, as manifest in nature and in human beings, human needs and desires." [21]

Mary Daly, perhaps the foremost feminist theologian, also refuses to see God as male and has set the groundwork for all feminist theologians who now speak of the deleterious effects of this gender-based image. She sees God not only as above any sexual manifestation but also as different from any anthropomorphic image. In order to emphasize her point, she avoids what she considers to be the static connotation of using a noun as the descriptive language for God. God is envisioned as be-ing.

Whatever their disagreements about the nature of God and/or the viability of religion, all of these feminist theologians agree that an appropriate concept of God is essential to the goal of equality for women and men in society. They see their reinterpretations or changes in traditional religion as leading toward furthering the goal of women's equality. For this group, then, equality is the core value around which most of their discussions revolve.

Yet their disagreements with each other about theological questions ultimately weaken the political impact of their agreement about the necessity of equality for women. If one agrees with theologians that religious beliefs, and especially the concept of God, are the critical underpinnings of society, then disagreement about these matters is significant. Especially

because feminist theologians are attempting to change the image of God that is most ingrained in Western tradition these disagreements limit their ability to influence the greater audience of non-theologians.

MALE AND FEMALE

Like the social egalitarians, feminist theologians focus on equality as the key value that must be institutionalized in order to enhance women's place in society. Yet even as they agree about the importance of equality as a primary value and about the essential worth of women, feminist theologians disagree about the nature of the feminine.

For purposes of influencing public policy on an issue as complicated as comparable worth, a fundamental commitment to women's equality is not enough. Given the nature of the debate and the legal system, advocates must be able to define equality and to assert the relevant likeness between categories of comparison. They can show the fundamental similarity between jobs, as many comparable worth proponents seek to do, or between women and men, as the liberal tradition does by asserting the importance of rationality. If one claims fundamental distinctions between women and men, and one wants to support comparable worth policies within the American political process, one must find a means of showing that there are similarities between the genders that overpower the differences.

In this regard, comparable worth advocates have a more difficult case to make than their adversaries. Most comparable worth opponents assume that women and men are different. They do not need to find a basis for parity in the marketplace. Equal or fair treatment, especially equal opportunity, is adequate for a society based on conservative principles. For most opponents, the marketplace simply reflects differences, not inequalities, between women and men. Furthermore, right wing theologians offer a biblical base for women's and men's differences that serves to underpin the notions of job segregation by sex and lower wages for women.

Comparable worth proponents must offer reasons for treating women and men as fundamentally equal. Feminist theologians have, perhaps, the most difficult task, for it is they who address the religious texts and traditions that are used to assert women's and men's differences and justify women's lower wages in the marketplace.

Feminist theologians must somehow counter the theological claims of the religious right that women's and men's essential natures appropriately result in different treatment, and therefore different wages, in the workplace. For this group, a concept of the nature of male and female is of critical importance in order to be able to define equality between the sexes.

For feminist theologians the first step toward equality between the sexes is to image God as both female and male. Even if this kind of imaging is done, however, questions still remain about the nature of male and female. If God is seen as male, one must have an idea of what being male involves. Similarly, if God is to be understood in female terms, one must determine the nature of being female. Feminist theologians, in stating that God has both female and male attributes, seem to be assuming that females and males are different from one another. Exactly what the distinctions between the genders are, however, and whether they are intrinsic to the genders or socially determined is a matter of disagreement.

Feminist theologians differ markedly in their views about what constitutes the nature of male and female. Like virtually all feminist ethicists, they are more concerned with discussing women than with discussing men. They attempt to avoid abstract concepts and view women's experience as the first building block of a feminist ethic. Yet this principle does not necessarily foster agreement. Women, including feminist women, disagree on the definition or the essence of women's experience.

As Carol Christ and Judith Plaskow note in their introduction to *Womanspirit Rising*, there are at least two basic views of women's experience: "Two poles emerge within the feminist understanding of experience. These poles may be called (1) women's *feminist* experience and (2) women's *traditional* experience, which includes, but is not limited to, women's body experience."[22] Of course, as these authors note, "these experiences are not incompatible, and, indeed, many women have experiences in both categories."[23] Yet in contemporary discussion of comparable worth the value of women's bodily experiences, implying that women and men are different, is in conflict with the value of equality, which implies that women and men are the same.

Valerie Saiving, in one of the first articles on feminist theology, claims that it is not possible to know whether women and men are in fact distinct in their essence, or whether it is the social differentiations accorded them in every known society that account for differences. Whatever the reason for distinct female and male roles and social responses, Saiving is concerned that theology has spoken of the male model as the universal one. She asserts that by universalizing what is a gender-specific model, theology has either excluded women or made their lives more difficult. For Saiving, such fundamental theological concepts as sin and love would have to be rewritten in order to take account of female conditions. While the concept of sin as the attempt to magnify the "power, righteousness, or knowledge"[24] of the self may be appropriate for men, it is inappropriate for women: "The temptations of woman *as woman* are not the same as the temptations of man *as*

man, and the specifically feminine forms of sin—'feminine' not because they are confined to women or because women are incapable of sinning in other ways but because they are outgrowths of the basic feminine character structure—have a quality which can never be encompassed by such terms as 'pride' and 'will-to power.'"[25] Instead women, especially mothers, learn "that a woman can give too much of herself, so that nothing remains of her own uniqueness; she can become merely an emptiness, almost a zero, without value to herself, to her fellow men, or, perhaps, even to God."[26]

While Saiving refuses to conclude whether the differences between the genders are intrinsic or socially constructed, most feminist evangelical theologians, like the religious traditionalists, assume that women and men are inherently different. In contrast to their more conservative co-religionists, however, they assert that since both genders are equally God's creations they must be treated equally.

Feminist liberation theologians, however, tend to agree with socialist feminists that women and men are more similar than different and assume that it is social constraints, rather than inborn characteristics, which give rise to the distinctions between the genders. Although they note the obvious biological differentiation between men and women, they see these differences as less important than those brought about by social expectations. Because women and men tend to lead very different lives in response to these constraints, these theologians discuss the importance of building an ethic from women's experience, rather than from male experience alone.

Post-Christian feminists are more in agreement with feminist evangelicals about inherent distinctions between women and men. Unlike the evangelicals, however, some, like Mary Daly, claim an intrinsic superiority for the female. Beverly Harrison refers to "reverse Thomism"[27] to describe Daly's assumption of an intrinsic female nature, superior to the intrinsically male one. For Daly, males are naturally domineering, power oriented, destructive beings, living under the "phallic morality," which encompasses the "most unholy trinity" of "rape, genocide, and war."[28] Women are naturally loving, caring, concerned people.

The only reason that not all females appear different from men is that their true human nature has been covered by the deleterious effects of living in patriarchal society: "To the degree that the female self has been possessed by the spirit of patriarchy, she has been slowly expiring. She has become dispirited, that is, depressed, downcast, lacking independent vigor and forcefulness."[29] If women were to separate themselves from this type of society, their true natures would emerge naturally: "As she becomes dispossessed, enspirited, she moves out of range of the passive voices and begins

to hear her own active voice, speaking her self in successive acts of creation. As she creates her self she creates new space: semantic, cognitive, symbolic, psychic, physical spaces. She moves into these spaces and finds room to breathe, to breathe forth further space." [30]

RELIGION AND SEXUALITY

As noted in Chapter Four, views of sexuality are connected not only to questions of gender similarity or difference, but are related to the question of comparable worth policy. Religious traditionalists' emphasis on the differences between the sexes, and their view of the family as the most important building block of society, leads them to assert the importance of the sexual relationship within marriage. Unlike the religious right, the religious left (with the exception of evangelical feminists) does not view sexual experience as acceptable only within heterosexual marriage. Yet like the religious right, it often views sexuality itself, as well as sexual experience, as an important ingredient of spirituality.

Similar to the religious traditionalists, feminist theologians offer specific thoughts about the place of sexuality and sexual experience. Many in both groups emphasize that women's sexuality is deeply imbued with religious meaning. Although their concepts of sexuality, and of the appropriate sexual relationship between women and men are very different from those of Marabel Morgan, their emphasis on the importance of sexuality is similar. Feminist theologians use their notions of sexuality to underscore their view of women and men as equal, rather than to show the appropriateness of female subservience.

Carol Ochs pointed out in her study of the archetypes of patriarchal and matriarchal religions that matriarchies, including Goddess-oriented religions, are noted for their emphasis on female sexuality. In contrast to patriarchal religions where female bodies are frequently viewed as sinful, in these societies, the female body, especially the ability to bear children, is viewed as a source of fascination and mystery. Women are seen as the links with the divine because of their ability to give birth to human life. In Goddess societies, women's sexuality is seen as a source of strength and as an indication of divine power and person.[31] This concept of creation differs significantly from the one described in Genesis where creation comes from outside the woman's body.

It is not surprising, then, that many post-Jewish and post-Christian feminists emphasize female sexuality as intrinsic to female nature. For these analysts, sexuality itself is related to divinity and links women naturally to the divine force. For Carol Christ "Aphrodite is Goddess of transforming

cosmic power, especially as it is known in sexuality."[32] She cites Christine Downing, who speaks of Aphrodite as "cosmic life force, associated especially with the transformative power of sexuality."[33] Starhawk speaks of sex as "the moving energy of the Goddess wherever it is honored and recognized with honesty—in simple erotic passion, in the unfathomable mystery of falling in love, in the committed relationship of marriage, in periods of abstinence and chastity, or in its infinite other appearances which we will leave to the reader's imagination."[34]

Starhawk agrees with Carol Christ that sexuality is connected to the divine: "Sexuality is sacred not just because it is the means of procreation, but because it is a power which infuses life with vitality and pleasure, because it is the numinous means of deep connection with another human being, and with the Goddess."[35]

Audre Lorde also speaks of the power of the female erotic and of the attempts of the male power structure to suppress this power:

> The erotic is a resource within each of us that lies in a deeply female and spiritual plane, firmly rooted in the power of our unexpressed or unrecognized feeling. In order to perpetuate itself, every oppression must corrupt or distort those various sources of power within the culture of the oppressed that can provide energy for change. For women, this has meant a suppression of the erotic as a considered source of power and information within our lives.[36]

Lorde speaks of the erotic not only in sexual terms but "as an assertion of the lifeforce of women; of . . . creative energy."[37] Moreover, "the erotic is the nurturer or nursemaid of all our deepest knowledge."[38] For Lorde, women must reclaim the power of the erotic in order to free themselves from male domination.

For feminist theologians, as for many on the religious right, the question of sexuality itself is intrinsic both to the definition of male and female and to the concept of spirituality. It also influences their view of marriage.

Equality v. Family

Because most feminist theologians do not accept marriage as the only appropriate sexual relationship, it is not surprising that their view of the family differs significantly from that of the religious right. Like the social egalitarians, these theologians emphasize the importance of equality rather than the significance of the family. Moreover, they are concerned about the non-egalitarian relationships of the traditional patriarchal family.

Evangelical feminists differ from most other comparable worth advocates because for them the family remains important. This group asserts that

the problems of the family that stem from the patriarchal tradition will be resolved once the question of equality is properly addressed. For example, they advocate marriages based on models of covenant, rather than on relations of dominance and submission.

Most feminist theologians, however, do not speak about the importance of the family but instead bemoan its problems. Beverly Wildung Harrison, for example, discusses concerns about the family that are common to many in this group. Like many socialist feminists, with whom she claims alliance, she notes the problem of women's typically subordinate role in the family: "The social criticism generated by feminism . . . has led to a fresh analysis of the way in which sex role patterns in the family operate destructively in relation to women's self-esteem. These sex role expectations have subtly conditioned us, men and women alike, to accept inequities of power and differing capacities for self-direction between men and women in the broader society." [39] The conclusion that emerges from this argument is that if one wants equality for women the potentially destructive nature of gender relationships within the family must be studied and any negative tendencies must be eradicated.

As a socialist, Harrison also connects the worlds of work and family, especially as she notes the necessity for an increased parenting role for men if the family is to be made more egalitarian: "For men to accept full and equal responsibility as parents, broad-based changes must occur. Of special importance are changes in the structure and organization of the work men do. . . . The current expectation that men's lives are to be immersed totally in work thwarts and undermines voluntary male change." [40] As a theologian, she especially notes the role of the churches in encouraging men's total identification with their work at the expense of their families:

> Religious organizations need to be reminded that they bear much responsibility for long-standing "modeling" of this morally dubious pattern. It is not an over-statement to say that male clerical parenting has long expressed itself as a form of active child neglect. The time has come for the church to rectify such disastrous practices. Criteria of ministry for married persons should presume that professional competence entails the capacity for responsible parenting so that married clergy with children come to be expected, always, to make child-rearing a personal-professional priority. [41]

Egalitarian marriages would not solve the entire problem of female inequality, for monogamous heterosexual marriage cannot be a universal norm, according to most religious feminists. Rather, there are numerous ways in which human sexuality can be expressed: "The goal of a holistic and integrated sexual ethic is to affirm sexual activity that enhances human dig-

nity, that entails self-and other-regarding respect and genuine communication. Such an ethic must challenge actions that degrade, disempower, and reduce oneself's and others' esteem or that aim at control, objectification, or manipulation of another." [42]

Harrison thinks that "long-term, committed relationships do provide a strong environment for personal growth and child rearing, so there is good reason to insist that social policies support rather than constrain people's option for this sort of family relation." [43] Harrison is not averse to encouraging marriage and family. She simply does not agree that "living one's life in the heterosexual, lifelong family unit places one in a status of special moral merit or that this lifestyle warrants superior theological legitimation." [44] Not all people are most fulfilled within the institutions of marriage and family, and these people's needs must also be considered:

> To cease giving overriding direct and indirect ethical sanction to lifelong heterosexual monogamous marriage would not . . . encourage us to anti-family attitudes or to opposition to lifelong relational commitments between two persons. We need to recognize that marriage is not for everyone. At the same time, we can and should affirm, celebrate, and support all covenantal relationships that deepen our capacity for intimacy, creative work, and joyful community, whether or not they accord with the current legally permissible definitions of marriage. . . . Religiously and morally, we need to differentiate more sharply the legal institution of marriage from the religious relationship of covenant between persons that our religious ethics and theology embrace as normative for human well-being. [45]

Family has limited value to many people and so it cannot be seen as a value that overrides other, more fundamental human concerns.

Radical feminists have an even stronger antagonism to the traditional patriarchal family. Both Goddess thealogians and radical lesbian feminists see this institution as constricting women's sexuality and therefore too limiting of women's freedom. Many refer to Adrienne Rich's article on "Compulsory Heterosexuality and Lesbian Existence." For Rich, the enforcement of heterosexuality is used as "a means of assuring male right of physical, economical, and emotional access." [46] Enforced heterosexuality is a means of oppressing all women, whether or not they are lesbian: "Feminist research and theory that contributes to lesbian invisibility or marginality is actually working against the liberation and empowerment of woman as a group." [47] According to Rich, "the failure to examine heterosexuality as an institution is like failing to admit that the economic system called capitalism or the caste system of racism is maintained by a variety of forces, including both physical violence and false consciousness." [48] Heterosexuality itself, as well as marriage or family, is part of the system of patriarchy.

Feminist theologians also disagree about the value of motherhood. Carol Ochs, for example, has written about the spiritual aspects of motherhood itself. For Ochs, religion is "insight into experience," and, thus, "a religion developed out of partial experience cannot be adequate to the needs of a full humanity."[49] Although Ochs makes clear that these spiritual insights are not limited to mothers, or even to women, she sees them as "formulated through the insights growing out of" the experiences of mothering.[50] Ochs does not want to "endorse" a "particular role in life for women" but rather to open "everyone to new, more natural possibilities for spirituality."[51] Ochs sees motherhood not only as a good in itself but as a means for reaching new spiritual awareness.

For most other non-evangelical feminist theologians, however, motherhood is not spoken of as a particular value. Feminist theologians often de-emphasize the notion of woman as mother because they see it as limiting a woman's full potential. These scholars are well aware of the dualism for women and men inherent in the biblical tradition. Although motherhood was glorified, especially in the figure of Mary in the Christian tradition, it was also used to limit women's possibilities for being anything other than mothers. Moreover, as Mary Daly notes, the image of Mary as the virgin mother itself creates conflict for women since, in the real world (without laboratory assistance), women cannot be both virgins and mothers.

Contemporary scholars offer further evidence of the limitations that Western religion placed on women as mothers. They note that only when women gave up being mothers and wives, and entered into a celibate existence in religious communities, were they allowed to study and to develop their non-biological abilities.

The biblical tradition presents a split between sexuality and motherhood. Many contemporary feminist theologians merely reverse the priorities; sexuality, not motherhood, is the power of women. Ironically, even those feminists who stress the spiritual powers intrinsic to women's sexuality do not emphasize, and in fact often ignore, the frequent consequences of that sexuality—childbearing and motherhood. Although in many of the early Goddess religions woman was seen as mother, more contemporary Goddess followers seem to relate the concept of mother more closely to general characteristics of motherhood such as nurture and caregiving rather than to the specific daily problems of rearing children. As Gayle Kimball has noted, more recent feminist writings have given up the model of motherhood altogether and instead substitute a model of sisterhood.[52]

Emily Culpepper argues that the glorification of motherhood is often used to limit the worth of women who are not mothers. She also sees the

model of childbirth as the prototype of creativity as limiting. Women, just as men, have more than one way of being creative.[53] Of course, even in the more well-known Goddess traditions, the Goddess of procreativity was herself usually not the child rearer. One cannot turn to stories of goddesses for models of women combining motherhood and career!

Although there are vast differences between these radical feminist thealogians and the more conservative evangelical feminist theologians, one can also see areas of agreement between them. Feminist theologians agree that the patriarchal family must be changed and that equality for women is of paramount importance. The areas of disagreements are over the desirability or possibility of achieving equality for women while maintaining a system of marriage and family.

THEOLOGY AND COMPARABLE WORTH

Feminist theologians disagree among themselves on the issue of the family, the nature of maleness and femaleness, and the definition of equality. It is therefore not surprising that they do not, and probably cannot, offer specific solutions for the problems of fulfilling the concept of equality in the workplace. In fact, feminist theologians themselves reflect one of the essential disagreements among non-religious feminists: are women and men alike or not? If women are essentially the same as men, equality means that women and men must be treated similarly. But if women are essentially distinct from men, operationalizing equality must take account of these differences.

If women, by nature, are both childbearers and child rearers, then equality in the workplace must somehow include recognition of these qualities. Awareness of women's sexual nature and the religious implications of the mysteries of women's creativity leads to different workplace accommodations than an assumption of the sameness of women and men. For those post-Christian feminists especially who see women and men as essentially different, comparable worth policies would have to account for these distinctions. For those feminist theologians who see women and men as essentially the same, however, comparable worth policies could be based on a simpler notion of equality. In brief, the feminist theologians and thealogians, while offering religious concepts as the reason for equality between the sexes, in fact recreate, rather than ameliorate, the debate over the values underlying comparable worth.

Once an issue such as comparable worth is in the political and legal arenas, it is usually not the task of the religious voice to formulate political strategy and tactics. It is only when an issue of concern to religious groups is not being debated within the political process that these groups are the

initiators of policy discussion. The influence of religious thinkers is more often used to insure that the principles that they prize are maintained in society. This objective is accomplished most easily by working with others who share the same policy commitments and who are acting within the political system.

The feminist religious voice could gain political importance by filling gaps left by secular arguments. The religious right offers alternative reasons for assuming women's and men's inequality. The religious left has been unable to play the same role with relationship to women's equality for its secular counterpart. Some secular advocates of comparable worth who are critical of classical liberalism have not provided sufficient justification for equality or have left specific questions unanswered. As noted earlier, both communitarian critics of comparable worth and socialist feminists often assume that women and men are different from one another without clearly indicating on what basis they should then be treated equally in the workplace. Feminist theologians could provide this justification. Their task is substantially more difficult than that of the religious right, which need only offer a rationale for difference. Yet it is a challenge that feminist theologians can meet.

Despite their internal debates and limitations, the religious voices offer a basis for women's equality in several different ways. Yet, the influence of feminist theologians on the public policy making process is hindered because secular feminists either ignore or are hostile to religion.

The treatment of biblically oriented feminists starkly illustrates the distance between secular and religious advocates of comparable worth. These feminists' views are compatible with liberal political tradition, yet offer a solution to the comparable worth dilemma. They provide a reason for women's and men's equality even while acknowledging gender distinctions. Women and men are created in God's image, and it is this creation that serves as the justification for equal treatment. Equality is a necessity not because women and men are both rational beings, but because they are both God's creations. This essential equality overrides any differences between the genders. But liberal theory does not perceive the need for a religious justification for equality and so these feminist thinkers are ignored.

This kind of biblical base for equality should be helpful in answering questions left by communitarian feminists who do not see rationality as the overarching reason for gender equality and who claim equality for women and men while still recognizing differences. After all, these feminist biblical exegeses show that women and men can be equal even while different. Yet communitarian feminists see feminism itself replacing the need for religion.

Caring and an ethic of responsibility stem from women's experiences. There is no need to identify a religious source. Like their liberal theorist colleagues whom they criticize, communitarian feminists too see no use for religion. They assume equality without offering any basis for it. Although they could refer to religious arguments for equality, they fail to do so, depriving themselves and their cause of a potentially powerful political alliance.

Liberation theology should be compatible with socialist feminism because both of these theories accept the Marxist concept of class. Feminist liberation theology views women as the oppressed class. It offers a religious component to secular theories of domination and subordination. These theologians claim that relationships of domination are not only wrong from a political perspective but are morally and religiously wrong as well. Christian liberation theologians present Jesus' most important teaching as the imperative for ending domination. This group claims that the very purpose of religion is to liberate the oppressed classes.

Since Marxist theories in general are antagonistic to religion, the theologians' impact is limited. Because the American political process does not acknowledge the significance of class differences, it is difficult to use liberation theology in this context. Liberation theology would have to offer some notions of equality outside of the class system if it were to be fully utilized in the American context. This it does not do.

Finally, radical feminist theologians' work is based on the need to overturn the liberal system in both its religious and political manifestations. They do not see the need to have their theories be compatible with the liberal tradition on which the American polity currently rests. Instead, they encourage a change in the system and assume that by altering religion, they can achieve political change. Their impact on the political process, particularly on a narrow policy issue such as comparable worth, is limited by their position outside rather than inside the system.

RELIGION AND POLITICS

It is ironic that the effect on public policy of feminist theologians is not as great as that of more conservative religious voices. Religious feminist thinkers assume that changes in religious thought and behavior automatically lead to transformations in politics. Since feminist theologians view religion as the most important underpinning of society, to alter religion is to modify society. One might therefore assume that feminist liberation theologians would have a significant impact on public policy. The reality, however, is not that simple.

Unlike some of their detractors who see them as dealing only in the

realm of the spiritual and unconcerned with the realm of everyday life, feminist theologians assert an intrinsic connection between the spiritual and the political, between religion and politics. According to Carol Christ, "the connection between women's spiritual quest and women's social quest have been intuitively recognized by many women whose spiritual experiences have provided them with energy and vision to make changes in their lives and to work to change women's position in culture and society." [54] For feminist theologians, "women's spiritual quest . . . is not an alternative to women's social quest, but rather is one dimension of the larger quest women have embarked upon to create a new world." [55]

Feminist theology tries to avoid what it sees as the false dichotomies of male/female, powerful/powerless, and mind/body. Similarly, it seeks to end the intellectual dichotomy between the spiritual and the political. Since life is not lived in dichotomies, but is interconnected, there is an intrinsic relationship between religion and politics, whether it is recognized or not.

This belief in the interconnection of politics and religion is a source both of weakness and of strength in assessing the impact of feminist theology on public policy. On the one hand, these theologians gain political strength because they are comfortable with the notion of influencing the political arena. They are not concerned with questions of the appropriate role of religion in political life because they do not make sharp distinctions between the public and private spheres. They assume that their work in theology automatically has an impact on public policy since any change in theology, especially changes in concepts of God, will be reflected in public life.

On the other hand, their impact on policy is limited because the notion of the interrelatedness of religion and politics, especially when it rests on the concept of God as more immanent than transcendent, is not congruent with the workings of the American decision making process. Public policy accepts two assumptions that are not fully compatible with the theological/political concepts offered by most feminist theologians: the importance of law and the role of interest groups.

Feminist theologians assert the importance of acknowledging God as non-male. At the same time, many reformist and almost all radical theologians posit the concept of an immanent, rather than (or at least in conjunction with) a transcendent notion of deity. While a wholly transcendent God, they claim, is more concerned with law giving from outside the community, a concept of God as immanent is more related to daily life as it is lived. A God who is immanent, therefore, is not as concerned with authority and obedience. It is not laws that are important but people's relationships with one another. As Starhawk notes, "in such a system, justice is not based on

an external absolute who imposes a set of laws upon chaotic nature, but on recognition of the ordering principles inherent in nature." [56] Yet, as Elizabeth Anscombe has written, in the Western tradition, "the moral concept of moral obligation is not an intuition that is independent of culture and belief, but . . . it derives from a law conception of ethics, and . . . the conception assumes belief in a divine lawgiver." [57] If religion is no longer based on a notion of a transcendent lawgiver, the compatibility between religion and politics as two related systems of social control is diminished. Since American political life still operates on the basis of laws and controls, it is more compatible with another system based on a law-giving model, such as the religious right offers, than with a non-law oriented model, as most feminist theologians propose.

In many ways, feminist spirituality is more compatible with a therapeutic model, as defined by Philip Rieff, than with a political model. Although feminist theology is far more socially oriented than Rieff's therapeutic model—because religion is seen as necessary for both personal and social well-being—it is not encompassed by a series of interdicts that must be obeyed. As Emily Culpepper has noted:

> The primary source, the continuing referent, for thealogical inspiration is one's self, understood as the consciously reflective self in communication with others. Critical self-awareness is the most respected and essentially present-oriented form of pursuing thealogical knowledge. Feminists often mention in this regard the ancient maxim, 'Know Thyself,' and are fond of noting that this tradition, so closely associated with Socrates, was spoken to him by a female oracle at Delphi.[58]

Feminist theology, especially radical theology, while not necessarily incompatible with public policy making, is somewhat out of step with it. Feminist theological concepts give much less importance to the concept of laws themselves than do either more conservative religious conceptions or the American governmental process. Since one of the ways of achieving pay equity is through passing and interpreting laws, their impact on comparable worth policy suffers accordingly.

Feminist theology which emphasizes the interconnectedness of life and eschews dualistic concepts also has difficulty with interest group politics. If religion and politics are separate, then religious groups can be called upon to influence the political process just as any other interest group. This is what religious conservatives do, and perhaps more importantly, what they perceive themselves to be doing. If religion and politics are not clearly separated, however, then an interest group model, based on those outside of the

official government decision making process influencing those elected officials and bureaucrats within it, cannot work in the same way. Since the classic model of American public policy making is the model of pressure group politics, the notion of an inherent connection between religion and politics can be a detriment to political influence.

Finally, although feminist theologians see an inherent interconnection between the political and the spiritual, in most cases they see the spiritual influencing the political. They acknowledge the influence of political and social realities upon religion, as indicated by the claim that the traditions of the Jewish and Christian religions have been covered over with non-religious patriarchal influences. Yet feminist theology consistently asserts that if one wants to change social and political reality one must start by changing religion.

Although differing significantly from socialist feminists who assume that change is inevitable as part of the dialectical process, they are similar in that they, too, assume that political change comes from outside the political system. Rather than dealing directly with that system, as liberal feminists or conservative opponents of comparable worth do, they are more likely to deal with it only indirectly. While socialist feminists assert that overthrowing the patriarchal family is necessary if one seeks women's social and political equality, feminist theologians contend that changing one's concept of God is necessary for social improvement. Neither of these two major groups of comparable worth advocates believes that directly entering the political process in order to change the laws is either necessary or inevitably beneficial. Their incentive to directly enter into the political and legal process is thereby restricted.

CONCLUSION

Feminist theologies are theoretically compatible with different secular feminist philosophies. Yet the impact of feminist theology on the theories of secular advocates of comparable worth is more limited than that of conservative theology on their secular partners. It is clear that secular advocates of comparable worth do not, by and large, see the need for, or even the utility of, religious thought.

Perhaps equally important, the various manifestations of feminist theology merely reinforce the conflicts found in the more secular theories. The wide variety of feminist theories, with all of their disagreements, are found in feminist theology as well. Almost all opponents of comparable worth—both religious and secular—agree on the fundamental issues relevant to the

comparable worth debate. By contrast, advocates of comparable worth provide more complex arguments and much less consensus among themselves. Although there are many pieces of feminist theology which could be helpful in substantiating the various arguments made by secular advocates for comparable worth, these theological positions have not been fully integrated into the comparable worth debate.

7

The Religious Impact
on the Public Policy Debate

This discussion has now analyzed four different perspectives on comparable worth, each of which offers some help toward resolving the dilemma. Unfortunately, no one group has been able to provide a satisfactory answer to the problem of women's wages. Comparable worth speaks not only about the marketplace and about the legal system. It also addresses the place, and the worth, of women in contemporary society. As an issue that stands at the boundary between public and private, it is at the cutting edge of social change. Yet, despite much talk in the media and the press, there have been few meaningful improvements in women's wages. Women still earn significantly less than men, and they are valued less than men.

RESOLVING THE DILEMMA: EQUALITY AND FAMILY

The comparable worth debate demonstrates that both equality and family must be viewed as a primary value, and each must somehow be accommodated within the religious and political arenas. While both opponents and advocates of comparable worth affirm important values, both are lacking in their ability to recognize the significance of the other. The religious voices seem just as unable as their secular counterparts to accept the value of their opponents' preferences. The religious traditionalists speak movingly of the importance of procreation and of child care. However, for the most part they

ignore the limits placed on women in contemporary society. The feminist theologians, on the other hand, speak forcefully of the necessity of viewing women as full human beings, not only as mothers. Yet they often denigrate the family and motherhood as symbols and components of a patriarchal system, rather than seeing procreation and child care as necessary social and religious values.

It is more helpful to realize that both family and equality must be upheld if society is to function. The religious liberals' arguments suffer from their lack of concern for motherhood and procreation. If one's religious values do not account for reproduction, one is not only being unfair to those women who either choose or are forced to become mothers. Even more important, one is limiting the religious influence on the basic human desire to reproduce. A society that does not account for reproduction becomes sterile in both the physical and social spheres.

The religious right, on the other hand, is overly involved with maintaining not only reproduction but the particular form of motherhood and family they view as appropriate. Because they have been preoccupied with upholding the traditional patriarchal family, which in fact is no longer the societal norm, they have, not only restricted women's options but have limited the benefits potentially available to children. Ironically, this pro-family group sometimes seems to have difficulty in adequately expressing the value of family. As we have seen, they often substitute sexual pleasure as a reason for marriage and family, an argument that is rather weak when many now assume that this pleasure is also available outside of marriage.

The religious right, while expressing the notion that all people are God's creations, has shown little concern about the lack of respect for God's female creations in contemporary society. The secular and religious conservatives assert that women's lower wages are merely reflective of the marketplace, and not reflective of the value of women themselves. Yet there is too much evidence to the contrary to be able to accept that assertion as an accurate proposition.

If, like most comparable worth opponents, one views capitalism not only as the best economic system but the one most conducive to human freedom, then it is necessary to understand the social implications of seeing the free market as a value that must be protected. The religious right runs the risk of too closely mimicking their secular counterparts and making the market, rather than God or God's creations, the primary focus of ethical concern.

It is not easy to resolve the conflict between these values in contemporary society. The tension between family and equality has a long history in both the theological and secular traditions. The conflict is by now deeply

imbedded in contemporary social structure. Yet I believe it is necessary to try to ameliorate the tension in both the theological and practical arenas.

J. Philip Wogaman offers the concept of polar values as a way of resolving what seem to be conflicting ideals. Polar opposites are "values which actually belong to each other even though they are apparently contradictory."[1] They are concepts that not only are in direct opposition to one another but are both necessary in order for each to make any sense. For example, male and female are a classic pair of polar opposites. It would be logically absurd to define some people as male and some as female unless there were two genders. If everyone were female, the concept female would not be necessary; everyone would just be a person. In other words, without a concept (and a reality) of male there could be no concept of female. Similarly, Wogaman mentions several other pairs of polar opposites: freedom/responsibility, subsidiarity/universality, optimism/pessimism, individual/social nature of humans.

While it would be difficult to suggest that family and equality are precisely polar opposites, the concept is useful in pointing to the necessity of maintaining both of these values. In many ways they are similar to the contradiction Wogaman notes between the individual and the social nature of people. If there were no families, or, at least, no provisions made for raising children, the social nature part of the pair would dissipate as society ultimately disappeared. It is a truism that if one wants to maintain society, there must be reproduction. Comparable worth opponents refer to this dictum while comparable worth advocates ignore its truth.

At the same time, if one wants a society based on equality, the symbol of individual rights, it is not possible to have only some of the people treated equally. As George Orwell's *Animal Farm* illustrated, it is not logically possible to have some people more equal than others. Comparable worth advocates acknowledge this truism while comparable worth opponents ignore it.

The task for both sides in the debate, then, is not to profess either value even more strongly but rather to reconcile them. The comparable worth dilemma will not be resolved until a model is found that sees family and equality as both necessary even though in healthy tension with each other. Ironically, because the policy recommendations that each camp espouses do not clearly lead to maximizing their professed value, there is a need for both sides to re-evaluate their positions. The internal contradictions in their positions confirm the necessity of reconciling the two values.

VALUES AND POLICY: THE OPPOSING CAMPS

Both sides of the comparable worth debate suffer from their inability to answer the charges of their opposition. Comparable worth advocates do not

respond to the claim that equality for women in the workplace will weaken the family. Comparable worth opponents do not answer the charge that the patriarchal family severely limits the possibility of even the legally required equality for women.

Further, both sides of the debate refer to only selected parts of the available data in order to strengthen their arguments. Comparable worth's opponents, favoring the value of family, ignore information that implies that the free market approach is not necessarily compatible with family enhancement. Free market conservatives assert that women knowingly choose jobs that just happen to command less money in the open market. They see women having priorities in their lives other than paid work, especially priorities related to childbearing and child rearing. They also believe that women want to work less hard than men and to have more personal freedom.

Yet it is doubtful that women freely choose positions in the work world that happen to pay less. Comparable worth advocates counter convincingly that jobs that are heavily female-dominated pay less not because of the free working of the market but because women and women's work are less valued in society. They note that the relative pay of occupations often changes when the occupational category shifts from male-dominated to female-dominated. Clerks, secretaries, and bank tellers, among other categories, were proportionately higher paid when they were men's occupations.

Advocates also seriously question the opponents' claims that women need money less, and therefore prefer jobs that offer benefits other than money. They point to current statistics that show the large numbers of families being supported by single women, a disproportionate number of which are living in poverty. Similarly, they note the small percentage of contemporary American families that actually fit the conservatives' ideal model: a working father and non-working mother at home raising children. In the contemporary arena, working mothers of young children are the norm, not the exception.

On the other side of the debate, advocates of comparable worth ignore information about American women that does not fit into their theoretical constructs and proposed solutions. While this group chides their adversaries for ignoring statistics that show the limited presence of the traditional patriarchal family, they themselves do not take account of the statistics that show the persistence of motherhood. In fact, more American women of childbearing years are now mothers than ever before, even than during the 1950s, the heyday of the feminine mystique. At least 90 percent of American women of childbearing age are mothers.[2] Although the American family is changing, and any one woman is likely to have fewer children than her

female ancestors, greater numbers of women are having children. The growth in smaller families, as well as the increase in single mothers, reflects these changes.[3]

Ironically, both opponents and advocates of comparable worth hinder their own expressed policy preferences by ignoring these realities. Opponents are advocating positions that may be weakening, not strengthening, the American family. There are very few women who can afford to stay home with their children, even if they want to. Some women do not want to stay home. Further, only women who die young can spend their entire adult lives raising a family because child rearing is a time-limited occupation. If the family is valued, ways must be found of protecting that institution while mothers are working in the marketplace. Opponents of comparable worth who refuse to support programs that deal with questions of child care because they fear that such programs would encourage women to work outside the home may be hindering the well-being of those whom they claim to value most.

Ways must be found of changing the workplace so that women who leave it in order to stay home raising their children will not be penalized for the rest of their potential work lives. Not only does the gap between women's and men's wages increase during women's childbearing years, the gap does not diminish even after those years. If women return to work after having raised a family, their wages will never reach parity with those who have not left the marketplace.

Free market conservatives claim that there is no evidence of discrimination against women since those with the most seniority and with the greatest number of years of continuous work are similarly rewarded in the work world, be they male or female. Yet this position in many ways discourages women or men from taking time off work to raise children. If people are going to lose not only the wages from the time they are not working, but also the potential to ever "catch up" if they leave the work world for a few years, the incentives to continue in the marketplace are powerful.

Those who value the family should be looking for ways of changing the work world so that women or men are not forever operating at a disadvantage economically if they choose to raise children.[4] It is difficult to offer specific ways to accomplish this objective. Perhaps some way of giving "seniority credit" for those years away from the public work world could be devised, similar to the way in which some colleges are now giving credit for women's (or men's) work at home, noting that child rearing develops skills and discipline that are valuable in the public arena. This type of program would mean that people who took time off from work would lose their sala-

ries for the years they were not wage earners, but would not be penalized upon their return. Even more radical notions are possible. It might be necessary, for example, to avoid the now standard formulae by which years of service on a job are used as measures for wage increases.

As many have noted, ways must be found for giving not only more money but more value to women's traditional work. If women's labor were more prized, not only would the gap between female- and male-dominated job categories diminish, it would also be easier to make the claim that women (or men) could be rewarded in the marketplace for work done at home.

On the other side of the debate, comparable worth advocates who ignore the persistence of women as mothers do so to the detriment of their preferences for women's equality. If one assumes that most women are, and will continue to be, mothers, ways must be found for making motherhood and wage earning compatible. Women's equality in the work world should not be diminished just because they are mothers. Nor should women need to limit their mothering, either in terms of the number of children they have or their ability to be with their children, in order to earn wages comparable to men's. It is unrealistic either to assume, as liberal feminists do, that women and men need only be treated alike for them to be alike, or to assume, as the socialist feminists do, that changes in the family will solve the problems of the work arena. Advocates of comparable worth, just as their opponents, need to look for substantive ways to change the workplace in order to maximize women's equality while enabling women not to be economically crippled for having children. It is clearly not enough to want women and men to be treated exactly alike, while ignoring the fact of women's motherhood.

If those who value the family should look for means of not penalizing women who raise families once they return to the workplace, then those who advocate pay equity should find methods of not penalizing women who choose motherhood as well as equality. This latter group should also concern itself with such questions as the need for maternity and/or paternity leave and for appropriate child care programs for working parents. But these suggestions alone are inadequate. Ways must be found for reconciling the real conflicts of time and energy of working parents. Part-time work, work sharing, flextime, and computer networking are all ways of ameliorating the problems of this group. Advocates must also ensure that these workplace alternatives offer the same wages (proportionately) as full-time, in-house labor and the same social service benefits. Those who work part time or at home also need health insurance and life insurance.

If these types of changes are not made, the tension between family and equality will intensify. If their current positions remain unchanged, the

opponents of comparable worth could end up weakening the family because they do not take account of the needs of women for equal treatment. The proponents of comparable worth could end up weakening the chances for women's equality because they fail to address the needs of mothers in contemporary society. Both sides would make more productive contributions and have a greater chance of maximizing their own goals if they were to see family and equality as polar values—neither one of which can be ignored if effective policy is to be pursued.

RELIGION AND POLITICS

The relationship between religion and politics is central to the resolution of the comparable worth debate because comparable worth decisions are taking place not only in the business arena but also in the political sphere.

In Western civilization, a discourse has been carried on at least since Biblical days concerning the appropriate relationship between religion and politics. The different dynamics between these two arenas are often the keys to understanding distinctions between Judaism, Christianity, and Islam, between different denominations within Christianity, and even between pre-modernity, modernity, and post-modernity. As George Kelly has noted, both religion and politics are forms of belief and of control. It is not surprising that there is almost constant need to re-evaluate their relationship with one another.[5]

This study of comparable worth indicates that there are at least three different axes around which the relationship between religion and politics now revolves. All three of these axes must be considered if one wishes to understand the contemporary debate, and all three must be addressed if one wishes to influence policy decisions.

The first axis is the particular policy issue. Agreements or disagreements between the secular and religious camps are influenced by the specific ingredients of the discussion at hand. In the case of comparable worth, these include such questions as the similarity between women and men, the appropriate role for women in the public arena, and the view of the family.

The second axis is the concept of the proper relationship between religion and politics that each side espouses. If secular discussants feel that religion has no views or harmful views to offer on a policy question, they will obviously be less receptive to religious input. Conversely, if religious groups assert that they wish to live as far removed as possible from the secular arena, they are unlikely to concern themselves with policy issues. In contrast, if secularists feel that religion can be a positive influence on society, they are likely to listen to the religious voice.

If religious leaders are concerned with policy issues, they are more likely to try to have their voice heard.

The third axis around which the relationship between religion and politics revolves is the compatibility of the theological and political underpinnings of each camp. Since both religion and politics involve themselves with many of the same questions, their theoretical underpinnings must be congruent if they are to be able to work together. As Max Weber noted, there is often an elective affinity between specific types of religious positions and certain kinds of political issues. If people are theologically conservative, it is likely that they will also be politically conservative. In the contemporary arena, new theological thinking has given rise to questions about the compatibility of liberal theology and American public policy making processes.

The interactions along these three axes all tend to reinforce the strength of the alliance of the secular and religious opponents of comparable worth and to weaken the advocates' coalition. However, along the first two axes there is potential for a weakening of the opponents' alliance and a strengthening of the advocates' relationship. The difficulties faced in the work of the religious and secular left in terms of the third axis—the congruence of theology and political process—raise questions about the ability of the religious left, especially feminist theologians, to influence political policy in the current American context. This finding points to serious obstacles in the liberal secular-religious relationship, and offers clues about the growing influence of the religious right on public policy.

AXIS ONE: THE ISSUE

The nature of the comparable worth issue gives the immediate advantage to its opponents. Both secular and religious opponents agree about most of the factors that are related to the complicated questions of women's wages. Both of these groups assert that women and men are distinct. Both secular and religious conservatives believe that society is best served by preserving what they see as the natural differences between the sexes, especially by maintaining the public/private split. Both groups also value the family and fear the weakening or demise of this social phenomenon, especially in its traditional manifestation.

Neither secular nor religious opponents of comparable worth are particularly interested in women's equality in the work world since they assume that women and men are intrinsically different. To them, the very concept of comparable worth is misleading, for women and men are not comparable. Since society's needs are best served by strong families, it is important to keep women at home. The question of women's wages is less important for

opponents of comparable worth than it is for advocates. This in itself is an advantage for opponents; they need barely bother with the question.

Comparable worth opponents enter the political arena with several factors on their side. As noted earlier, they portray the debate about women's wages not in terms of role equity, but rather in terms of role change. They raise fears that women's equality will lead to massive social changes, not least of which is the breakdown of the traditional family. Opponents present themselves as those who are seeking to conserve the best of "old-fashioned values."

Because they are in the position of conserving, the opponents of comparable worth see the argument in less complicated terms. Once it is agreed that women and men are distinct, there is no need for convoluted arguments and discussions about the exact nature of women and men. Also, once the genders are different from one another, the place of women in the family and the importance of preserving the family are clear. Religious traditionalists in particular pride themselves on their ability to make things understood and see their ability to offer simple answers as proof of the essential truth of their positions. It may be that starting out as the conservative side on a particular issue enables a simplification that those who desire change do not have the luxury of offering. After all, the known is almost always easier to see than the unfamiliar.

The secular conservatives are more concerned with economic matters than the religious traditionalists, and approach the issue of comparable worth from a very different angle. Their goal of preserving the free market rests on maintaining the more traditional relationships between public and private, and between women and men. This assumption of the necessity of the family and the public/private split serves to reinforce the position of the religious traditionalists. Although the main concerns of the secular and religious camps are not identical on the issue of comparable worth, at the present time their goals are remarkably parallel.

Finally, there is a congruity not only of interests but also of prioritization. The secular and religious right are converging on this issue at the very point on which each of their philosophies rests. Maintaining the family, and traditional morality, is probably the single most significant political issue for the religious right, just as maintaining the free market is the linchpin for all other goals of the secular right. Comparable worth is where the family and the ostensibly free market intersect.

On the other side of the debate, advocates of comparable worth agree with each other on far fewer issues than their opponents. They also view the subject in more complicated terms. They often talk not only about the economic issues of the marketplace, or about theories of women and fam-

ily, or public and private, but about such difficult to measure concepts as discrimination.

In contrast to comparable worth's opponents, its advocates do not speak about the need to preserve the family. Therefore, they are easily cast as favoring role change which can be depicted as dangerous to the future of society. Although this group's concern is for role equity, because their position requires altering the status quo, it is not difficult for their opponents to label them as enemies of the family.

Both secular and religious advocates of comparable worth disagree about the nature of women and men. Some advocates posit that the genders are essentially alike, and it is for this reason that both should be paid equally. Others claim that women and men are distinct, but assert that lowered wages for women reflect not biological differences but social bias.

In part because of the disagreement about the nature of women and men, advocates of comparable worth also disagree about the family. While some feminists, both religious and secular, emphasize the positive aspects of childbearing, others see this biological function as having forced women to remain outside the public world of work. Some feminists claim that discussions of equalizing women's wages must take account of women's childbearing and child rearing preferences while others think that women's equality in the workplace will come about only when women are no longer viewed as childbearers and rearers.

In contrast to the opponents of comparable worth who see maintaining the family as central to their political agenda, neither the social egalitarians nor the feminist theologians see women's equality in the workplace as the linchpin on which their entire philosophy stands. There are disjunctions in how they approach the issue. The feminist left certainly tends to view women's equality as its single most important issue without whose resolution no other domestic or international problems can be solved. However, there is little consensus in this group about exactly what women's role in the workplace should be. Moreover, feminists are the only component of the left who see women's equality as their single most important concern. Others in both the secular and the religious left tend to put different issues on the front burner. Questions of economic justice, racial inequality, the environment, or past preoccupations such as human rights abroad, the nuclear freeze, or relationships with Central American countries have seemed to be more important to political liberals and radicals than questions of women's equality. The religious and political right is united around maintaining the family and the free market in their present condition; the religious and political left have women's equality on the list, but that list is long.

These differences among the advocates of comparable worth weaken the possibility of alliances among those in the secular or religious camps, and between the two larger groups. The religious proponents of comparable worth in many ways reproduce the disagreements among the secular advocates. Theologians offer no more consensus on such issues as sameness or differences between the genders or on the role of women in child rearing than do their secular colleagues. In contrast to the religious traditionalists, who also have internal theological disagreements, the conflicts among the religious feminists are around the very points on which the comparable worth debate hinges.

Finally, the nature of the debate itself makes the task of the advocates of comparable worth more difficult than that of its opponents. Since the American legal system rests on the assumption of like cases being treated alike, most comparable worth opponents merely have to claim that women and men are not essentially alike in order to show the fairness of different wages for women and men. In order to demand comparable wages, however, advocates must either claim the essential sameness of women and men or must find some reason to assert similar treatment for things (or people) that are in some ways not alike.

Thus, the religious and secular right appear to offer a much stronger working alliance in opposition to comparable worth than do the secular and religious advocates in its favor. Yet this study reveals potential problems in the conservative alliance. At the moment, both groups are able to emphasize their concern with the family. The religious traditionalists offer religious texts about the importance of family and the appropriateness of gender distinctions that justify different pay for women and men. They oppose comparable worth policies because they fear they would weaken the family. The secular opponents, on the other hand, while claiming concern for the family, are more preoccupied with upholding the free market. As Wuthnow notes, the free market is itself a value: "The fact that the market system is frequently associated with the idea of freedom is . . . doubly important. Not only does it link the economy to a virtually unquestioned value; it also undergirds the market's capacity to provide moral worth."[6]

At the moment both the value of family and the value of the free market can be held simultaneously. Yet, as more women enter the marketplace, either by choice or for economic survival for themselves and their children, a conflict between these two values is likely to arise. It is already becoming clear that policy positions that are based on an assumption that women do not have to work, when in fact they do, may actually weaken families. When women work similarly to men, neither gender has adequate time for child

rearing. The free market can glorify motherhood and families easily as long as women are adequately supported by men. But when mothers must support themselves and their children the situation changes. Since the free market approach has been most successful with the separation of the public and private spheres, any changes that break down these boundaries cause potential problems for the approach. Working mothers epitomize the tension between the value of the market and that of the family.

The importance of maintaining the free market may undermine the ability to strengthen the family. Eventually, this contradiction may have to be faced by religious traditionalists. If they come to believe that comparable worth is necessary to support the family, they could switch policy positions while still maintaining their moral and religious framework, and the alliance on the right would be effectively shattered.

AXIS TWO: RECEPTIVITY TO A SECULAR-RELIGIOUS RELATIONSHIP

The secular and religious alliance against comparable worth also benefits from the fact that each of these groups sees religion playing a positive role in American public life, especially when that role is defined as one of expressing a moral position related to the private sphere. In contrast, the advocates' alliance suffers from their mixed attitudes toward religion. Most secularists on the left view religion with suspicion, if not contempt, while many feminist theologians view politics in similarly negative terms. Yet on this axis there are possibilities for strengthening the relationship between the secular and religious proponents of comparable worth.

Neither the religious nor the secular left wants either religion or government involved in questions of personal morality. In contrast to the religious right, both the religious and secular left tend to view personal morality as a question for private individuals, not for the public arena. While the secular left has been suspicious about religion in public life, the religious left has most frequently seen its political role not as the guardian of private morality, but rather as the voice of public morality. In this schema, neither comparable worth nor the place of women or the family in American society is the primary concern of the religious or political left.

Secular advocates of comparable worth need to become more willing to accept a positive role for religion in order to benefit from feminist theology. Otherwise, the only religious voice heard in the public square is one whose policies they strongly oppose. There are areas of agreement where the feminist theologians could strengthen the position of secular comparable worth advocates were the secularists willing to turn to their religious colleagues for assistance. For example, feminist theologians offer many reli-

giously oriented reasons for women's and men's equality that have not been heard in the policy-making conversation. Evangelical feminists look to biblical texts for verification of their position and offer what they consider more accurate readings of Genesis creation stories and Paul's attitudes toward women. Other feminist scholars offer biblical exegeses based on different hermeneutic techniques to reach this conclusion of gender equality.[7] Post-Jewish and post-Christian theologians and thealogians proffer non-biblical religious reasons for women's equality.

The secular left does not use either biblical or non-biblical religious justification. Instead, in the liberal tradition, it looks to reason alone for legitimation of its position. Because social egalitarians ignore feminist theologians, they make their assessments of religion based on what they see of the religious traditionalists. They find religion itself to be repressive and a hindrance to social progress. Rather than viewing the feminist theologians as allies in the public policy making process, social egalitarians either inadvertently or purposefully undermine this potential ally. Ironically, when social egalitarians view with alarm what they claim to be the increased role of religion in public policy making they are referring only to the role of the religious traditionalists, for it is that group that they see representing religion in America.

Yet there are issues on which the secular and religious left work together, despite the lack of regard the secular left has for religion. The civil rights movement best exemplifies the high point of this alliance, but issues such as Nicaragua, the nuclear freeze, and the environment have in the past provided further evidence of the possibility. Just as a study of the relationship between the religious and secular voices on the first axis indicates the potential loosening of the opponents' alliance, a study of the second axis points to the potential for strengthening the advocates' alliance.

This potential is limited, however, by those feminist theologians who are unwilling to participate in a political arena that they view as corrupted by patriarchalism. Ironically a separatist philosophy was formerly associated with conservative Christian groups. For many years scholars assumed that the religious right was more prone to sectarian behavior. In Troeltsch's archetype, sectarians separated themselves from political life because they thought that it was impossible to live a religious life in an inevitably corrupt political setting.[8] Yet the religious right is active in the political debate about comparable worth. They have managed to turn politics upside down and assert that the cause of their involvement is their interest in the private, traditionally religious, arena.

The radical feminist theologians, on the other hand, while asserting

that the personal is political, in many ways are taking a more sectarian path. Because their philosophy and theology are so different from the principles on which the political arena operates, and because they see the public realm as being so hopelessly patriarchal, it is they who sometimes assume that it is impossible to lead a religious life in this secular society.

It is this disparity in the willingness of the different religious camps to interact with the political system that explains much of the disproportion in their political impact. Radical feminists' concern with not being parties to the patriarchate often diminishes their political effectiveness. It may be true, as Audre Lorde forcefully asserts, that one cannot dismantle the master's house using the master's tools.[9] It may be impossible to overthrow patriarchy using patriarchal methods and ideologies.

Yet it is also difficult to see how one could change a democratic political system using different rules, except if one used force, a principle generally foreign to feminists. It is hard to influence the political debate while remaining outside the political process. The effectiveness of separatist tactics is questionable at best. A group's principles may influence public life in the long run, but it is unlikely that non-participation will be effective in ameliorating day to day problems. When espousing separatist tactics feminist theologians diminish their influence on the political process and abandon the working women whose lives would be immeasurably enhanced by pay equity. It is necessary instead to tackle the hard question of how to influence a political system which runs on democratic principles while refusing to accept the underlying patriarchal order. In such a system it may be impossible to dismantle the master's house without using some of the master's tools. The challenge may be to make the proper selections in the tool shed.

Axis Three: Theological-Political Congruence

An analysis of the third axis confirms the strength of the conservatives' alliance and proposes a new dimension of the contemporary relationship between politics and religion. Here the alliance between the religious and secular advocates of comparable worth is limited by fundamental theological impediments.

It may be possible for the religious left to develop better means of communication with its secular partners, to become less separatist and more willing to dirty its hands in the political arena. It is also possible to encourage the secular left to become more receptive to the benefits of a theological underpinning for its position and to acknowledge the work of feminist liberation theologians. It is not possible, however, to ask theologians to change their theology in order to increase their political impact. Ultimately,

that is what would be needed in order to make liberation and radical theology more effective in the American political context.

As removed from political analysis as this may seem, it is the different concepts of God offered by the traditionalist and the liberationist theologians that creates much of the disparity in their political impact. Religious traditionalists are in harmony with the American political system in a way that liberation theologians simply are not. Although there is much room for disagreement between religious fundamentalists and non-religious conservative political activists on many issues, both of these groups accept several basic assumptions. Both accept a split between the public and private, and both accept systems of religion and politics based on law.

In the Western theological tradition, God is lawgiver, as well as enforcer, of a legal and/or moral code. Western political tradition mimics this concept of deity. Certainly the American political system was framed by people who accepted the principle of a transcendent divinity. Although there are obvious differences between biblical religion and the social contract theory of government that forms the basis of the American constitutional system, there are equally obvious similarities.

The Bible assumes that God and God's demands existed prior to creation; in contrast, social contract philosophers assert that people construct their own government. Yet once a government is contracted it becomes, in Durkheim's terms, something that is seen as separate from its creators. Contemporary discourse reflects this position: "To be an American means to be a member of the 'covenanting community' in which the commitment to freedom under law, having transcended the 'natural' bonds of race, religion, and class, itself takes on transcendent importance." [10] The government is based on a system of law that develops a significance independent of its creators and obligates its citizens. The legal system, although open to influence, functions as an institution apart from the citizens, just as a transcendent God is open to supplication and prayer, but is ultimately separate from the creatures who were created.

Religious influence on the political debate has been strongest when it has been able to refer to the morality of God's law in opposition to the immorality of human law. In these cases the transcendent lawgiver is given higher accord than mere mortals. Martin Luther King Jr. met with success at least in part because he invoked the concept of a higher law—a God-given law. This higher law was used to challenge the lesser laws of the American Congress. The abolitionists used similar arguments to help end the institution of slavery.

These successful cases of religious challenges to more conservative

secular policy illustrate the point. Although these examples seem to confirm the ability of the secular and religious left to work together, they also verify the intrinsic incompatibility of more radical theology with American politics. A religious voice is most successful when it speaks in conservative theological terms, no matter how liberal its political position. Martin Luther King and the abolitionists were espousing what came to be seen as liberal political positions. Yet they were not doing so with radical theological concepts. They were promoting a position in terms of a transcendent lawgiver God, a stance which is most compatible with the American political system and culture. In the current political arena President Clinton fits into the same frame: he espouses a liberal political agenda, but is himself a Southern Baptist who speaks the religious language based on a concept of a transcendent deity.

As liberal theology becomes more identified with the concept of an immanent God, its influence on public policy debate is likely to be even further diminished. An immanent God is neither a creator nor a lawmaker. Such a God cannot serve as the ultimate enforcer of either legal or moral codes. Nor can it justify a public/private split. As Wuthnow notes, "With the new immanentism we come to believe that life is ultimately not governed by some creator-God outside the natural world, but by forces within the system of nature itself." [11] This kind of God does not offer an elective affinity with the American political system.

Of course, more radical feminist theologians would assert that they are not seeking an affinity with the American political system; they want to change that system. As noted, they are not interested in having an impact on the system as it now exists, a stance which itself limits their political influence. They might further claim that an immanent God is more in keeping with the kind of political system they envision. They are not looking to recreate a society based on power relationships and laws which have a transcendent nature.

The question of whether an immanent God (or Goddess) can sustain such a polity, or indeed, any political system, remains. Since Western religious tradition is based on a transcendent God, it is not possible to look to Western political history for examples by which to test the capacity for political maintenance of a non-transcendent God. Most historical examples of an immanent God come from Eastern religious traditions. Here the political history is not hopeful. India, for example, remains divided between Hindus who believe in an immanent God and Muslims who pray to a transcendent deity. Sri Lanka struggles against ethnic strife among Sinhalese and Tamils who all share a belief in Buddhism. The Dalai Lama, perhaps the best known contemporary example of a person who accepts a non-transcen-

dent concept of God, is loved and respected. Yet he was unable to preserve the physical boundaries of his nation. Of course there is no proof that in any of these (or other) cases that it is the concept of God which in any way influences the political stability of a regime. Nonetheless, there are no examples to turn to in order to prove the political effectiveness of an immanent God.

Even the Eastern examples are not adequate, however, for the immanent God in these traditions is either Hindu or Buddhist, both long standing religious traditions with well developed concepts of human nature and of the sacred. In contrast, the feminist Goddess is new and little defined. More important, the attributes of an immanent God or Goddess can only be constructed according to one's concept of human nature. After all, by definition such a God resides not outside of human beings, but within. Therefore, such a concept of divinity requires a sophisticated theory of human psychology. Feminist theologians do not provide this.

Rather, they define women in contrast to men and portray women's attributes as opposite male characteristics that they abhor. Where men are war-mongers, women are peace-loving. Where men seek power, women pursue compromise. The assumption then is that a Goddess would reflect the best feminine attributes and would enhance human lives. There would be no need for a lawgiver God, or a judgmental God, because people naturally would behave appropriately toward one another.

If the more radical feminist theologians are correct, and human nature (or at least women's nature) is as peaceful as they describe it, then it would be possible for people to maintain themselves in societies without need of higher laws or transcendent deities. Of course, all polities would have to become this way, since in an interconnected world any war-mongers would undoubtedly attempt to conquer non-warring nations.

One could probably envision a separatist feminist regime living at the grace of a larger non-feminist nation. It is more difficult to imagine such a regime existing independently, however, since it would undoubtedly be destroyed by a polity that accepted, and perhaps even encouraged, violence. The case of the Amish in America is illustrative of a separatist regime living within a larger society. Although this religious community has been able to maintain its own traditions, it is not hard to imagine that if the American government ever ceased to allow the Amish this privilege they would soon be destroyed by the force of the greater political power. It is difficult for a non-violent community to defend itself against violence.

Even in such a peaceful community, however, there might still be a problem with diversity. In a society resting on an immanent God who has no intrinsic attributes, the likely disputes among different religious, ethnic, or social groups could easily deteriorate into discussion of which group was

best exhibiting appropriate God-like behavior. Since the feminist God is so undefined, any conflict among human beings could indicate controversy about God, especially since disagreements could no longer be blamed on a patriarchal structure. Ironically, such a polity might be more conflictual than a non-religious one. A secular society can assert that human beings themselves have the capacity to resolve difficulties without recourse to God. But a society which rested on a concept of an immanent God would run the risk of disagreements escalating into conflicts about the essential nature of God, or human beings.

Feminist theologians and thealogians are at the forefront of the demand to re-image God. They are not alone. Liberal theology shares many of the same views, albeit less strongly. Although the concept of an immanent deity is most apparent in radical thealogians, it echoes throughout the religious left. The diminishing of God's transcendence affects not only feminist issues, but has an impact on other issues about which religious and secular thinkers are concerned. It helps to explain at least some of the loss of liberal religious impact on public policy and sheds new light on why the religious right has been so politically successful in recent years, even when popular majorities are arrayed against them.

CONCLUSION

Pay equity will only be achieved when the values of equality and family are harmonized. In order to achieve this reconciliation, the religious voices must alter their roles in the public policy making process. After all, the secular right has no interest in women's equality. They are content to let the free market do its job and can assume that the family is protected by the capitalist system. Although they are receptive to religious influence they fear the effects of any diminution of the free market. At the same time, the secular left has little incentive to listen to feminist theologians who assert that the only way to achieve political change is to alter the more traditional Western concept of God.

The religious traditionalists, although usually opposed to women's equality, must begin to understand that the only way to protect the values that they hold dear is to institute pay equity. Without more equal wages for women, children and families are in trouble. There is no longer a complete convergence of interests between their religious positions and the needs of the free market conservatives. If they are interested in preserving the family, they must find ways of enabling women to work while avoiding the incentives against motherhood now built in to the present wage system. The work of evangelical feminists is useful in offering theological and practical

models for squaring the circle between allegiance to the Bible and support for women's equality.

The feminist theologians, on the other hand, must make some alterations in their positions if they are to be able to press successfully for women's equality. Perhaps most importantly, they must begin to address the needs of the vast majority of women who are mothers, even mothers who choose to live in heterosexual families. The work of these theologians has been necessary in unmasking the subtle, yet crucial, discrimination against women by patriarchal religious influences, both textually and historically. If their influence is to continue they will have to begin to speak a language that can be more easily understood within the American social and political context.

There is a need for more models from reformist theologians who must explicate how to change not only their religious traditions, but also some political traditions even while staying within them. Those reformists who espouse liberation theology must acknowledge that America is unlikely to accept a model of class conflict based largely on notions of oppressor and oppressed. Not only does such a model go against American political tradition, but it has also not been developed for a two-gendered, multi-cultural society. Although the ultimate message of religion may indeed be human liberation, there are many routes to this goal. Efforts must be made to find one that is in harmony with the current American society and polity. Radical feminist thealogians whose work has been crucial for those seeking to end a system of patriarchy must now give more attention to delineating a more appropriate policy, and to explaining how to reach that goal. Otherwise their influence will be limited.

Understanding the role of religious voices opens new vistas for possible future political victories, explains past successes and defeats, and suggests stumbling blocks to greater success. The comparable worth debate will continue in the courts, corporate headquarters, labor offices, churches, universities, and legislatures of America. Victories will undoubtedly be won by both sides. Beneath the headlines, the briefs, and the charts lie conflicts about values and theological platforms. Ultimately, the shifting focus of the religious voice, secular attitudes toward that voice, and changing religious-secular partnerships will have at least as much, if not more, impact on the future of gender equality and the composition of the American family as developments in the political and legal arenas.

Endnotes

CHAPTER 1: RELIGION, POLITICS, AND WOMEN'S WAGES

[1] Sylvia Ann Hewlett, *A Lesser Life: The Myth of Women's Liberation in America* (New York: Warner Books, 1987), 71–72.

[2] Census Bureau, U.S. Department of Commerce, Current Population Reports, Consumer Income, Series P-60, no. 174. Reprinted in National Committee of Pay Equity, *Newsnotes*, April 1992.

[3] Ibid.

[4] Ibid.

[5] Ibid.

[6] Ibid., 18.

[7] Ibid., 96.

[8] Ibid.

[9] U.S. Bureau of the Census. Reprinted in Sara E. Rix, ed. *The American Woman 1990–91* (New York: W. W. Norton and Co., 1990).

[10] Wendy Kaminer, *A Fearful Freedom: Women's Flight from Equality* (New York: Addison-Wesley Publishing Company, Inc., 1990), 93.

[11] Ibid., 4.

[12] Donald J. Treiman and Heidi Hartmann, eds., *Women, Work and Wages: Equal Pay for Jobs of Equal Value* (Washington, D.C.: National Academy Press, 1981), 28.

[13] Nancy Barrett, "Women and the Economy," in Sara E. Rix, ed., *The American Woman 1987–88: A Report in Depth* (New York: W. W. Norton, 1987), 118.

[14] *Working Women: A Chartbook* (U.S. Department of Labor, Bureau of Labor Statistics, 1991), 15.

[15] Treiman and Hartmann, 25.

[16] *Working Women: A Chartbook*, 17.

[17] Treiman and Hartmann, 28.

[18] Barrett, 126.

[19] Ibid., 127.

[20] Ibid., 128.

[21] Catharine A. MacKinnon, *Feminism Unmodified: Discourses on Life and Law* (Cambridge: Harvard University Press, 1987), 24–25.

[22] Sara M. Evans and Barbara J. Nelson, *Wage Justice: Comparable Worht and the Paradox of Technocratic Reform* (Chicago: The University of Chicago Press, 1989),11.

[23] Ibid.

[24] Peter Westen, "The Empty Idea of Equality," *Harvard Law Review* 95:3 (January 1982).

[25] Polan, "Toward a Theory of Law and Patriarchy," in *The Politics of Law 294*, D. Kairys, ed. 1982 and Rifkin, "Toward a Theory of Law and Patriarchy," 3 Harvard Women's L J 83, 83–85 (1980). Both of these works are cited in Christine Littleton, "Reconstructing Sexual Equality," *California Law Review*, 75:4 (July 1987).

[26] Michael Rubenstein, *Equal Pay for Work of Equal Value: The New Regulations and their Implications* (London: The Macmillan Press Ltd., 1984), 13.

[27] Littleton, 1287.

[28] Ibid., 1292.

[29] Kaminer, 8.

[30] Littleton, 1295.

[31] Kaminer, 8.

[32] E. Robert Livernash, ed. *Comparable Worth: Issues and Alternatives* (Washington, D.C.: Equal Opportunity Advisory Council, 1980), 3.

[33] Treiman and Hartmann, 70.

[34] Quoted in Mary Heen, "A Review of Federal Court Decisions under Title VII of the Civil Rights Act of 1964," in Helen Remick, ed., *Comparable Worth and Wage Discrimination* (Philadelphia: Temple University Press, 1984), 199.

[35] Ibid., 199–200.

[36] Ibid., 213.

[37] Quoted in Heen, 214, from the *Washington Industrial Relations Manual: Wage Administration*, Nov. 1, 1938 and Feb. 1, 1938 cited in Brief of IUE v. Westinghouse Electric Corporation, 631 F2d 1094 (3d Cir. 1980).

[38] Helen Remick, "Major Issues in A Priori Applications," in Remick, 103.

[39] Ibid.

[40] For a detailed account of the struggles in San Jose and Contra Costa County, Calif., see Linda M. Blum, *Between Feminism and Labor: The Significance of the Comparable Worth Movement* (Berkeley: University of California Press, 1991).

[41] Evans and Nelson, 80.

[42] Ibid.

[43] Heen, 217.

[44] Evans and Nelson, 62.

CHAPTER 2: FAMILY VERSUS EQUALITY

[1] Joyce Gelb and Marion Lief Palley, *Women and Public Policies* (Princeton: Princeton University Press, 1982), 7.

[2] Sharon Toffey Shepala and Ann T. Viviano, "Some Psychological Factors Affecting Job Segregation and Wages," in Helen Remick, ed., *Comparable Worth and Wage Discrimination* (Philadelphia: Temple University Press, 1984), 47.

[3] Ibid.

[4] Ibid.

[5] Ibid., 55.

[6] U.S. Department of Labor, Women's Bureau, 1985. Quoted by Nancy Barrett, "Women and the Economy," in Sara E. Rix, ed., *The American Woman 1987–88: A Report in Depth* (New York, W. W. Norton and Company, 1987), 130.

[7] George Gilder, "The Relationship of Women to Wealth and Poverty," in Phyllis Schlafly, ed., *Equal Pay for Unequal Work: A Conference on Comparable Worth* (Washington, D.C.: Eagle Forum Education and Legal Defense Fund, 1984), 91.

[8] Ibid.

[9] Charlotte Perkins Gilman, quoted in Sylvia Ann Hewlett, *A Lesser Life: The Myth of Women's Liberation in America* (New York: Warner Books, 1987), 183, from Dolores Hayden, *The Grand Domestic Revolution: A History of Feminist Designs for American Homes, Neighborhoods and Cities* (Cambridge, Mass: MIT Press, 1981), 189.

[10] Mary Daly, *Beyond God the Father: Toward a Philosophy of Women's Liberation* (Boston: Beacon Press, 1973), 45.

[11] Cited in Elizabeth Clark and Herbert Richardson, eds., *Women and Religion: A Feminist Sourcebook of Christian Thought* (New York: Harper and Row, 1977), 170.

[12] Cited in Ibid., 195.

[13] John Rawls, *A Theory of Justice* (Cambridge: Harvard University Press, 1971), 74.

[14] Michael Walzer, *Spheres of Justice: A Defense of Pluralism and Equality* (New York: Basic Books, 1983), 229.

[15] Ibid.

[16] Ibid.

[17] Ibid.

[18] Ibid.

[19] Ibid., 239.

[20] Jessie Bernard, *Women and the Public Interest: An Essay on Policy and Protest* (Chicago: Aldine Publishing Company, 1971), 27.

[21] Max Weber, "Religious Reflections of the World and Their Directions," in H. H. Gerth and C. Wright Mills, *From Max Weber: Essays in Sociology* (New York: Oxford University Press, 1958), 350.

[22] Rawls, 128.

[23] Jean Bethke Elshtain, ed., *The Family in Political Thought* (Amherst: The University of Massachusetts Press, 1982), 52.

[24] Ibid., 53.

[25] Ibid.

[26] Ibid.

[27] Susan Moller Okin, *Women in Western Political Thought* (Princeton: Princeton University Press, 1979), 274.

[28] Ibid., 274–275.

[29] Ibid., 281.

[30] Ibid.

[31] Nancy Chodorow, "Mothering, Male Dominance, and Capitalism," in Zillah Eisenstein, ed., *Capitalist Patriarchy and the Case for Socialist Feminism* (New York and London: Monthly Review Press, 1984), 89–90.

[32] Lucinda M. Finley, "Transcending Equality Theory: A Way Out of the

Maternity and the Workplace Debate," *Columbia Law Review*, 86:6 (October 1986), 1119.

[33] Ibid., 286.

[34] Ibid., 284.

[35] Weber, 280.

[36] For examples of this debate, see for example Robert Wuthnow, *The Restructuring of American Religion* (Princeton: Princeton University Press, 1988); Mark Silk, *Spiritual Politics: Religion and America Since World War II* (New York: Simon and Schuster, 1988); and Kenneth D. Wald, *Religion and Politics in the United States* (New York: St. Martin's Press, 1987).

[37] Kent Greenawalt, *Religious Convictions and Political Choice* (New York and Oxford: Oxford University Press, 1988).

[38] Wuthnow, 133.

CHAPTER 3: THE FREE MARKET CONSERVATIVES

[1] Henry J. Aaron and Cameran Lougy, *The Comparable Worth Controversy* (Washington, D. C.: The Brookings Institution, 1986), 15.

[2] Cited in remarks of Eleanor Holmes Norton in *Comparable Worth: A Symposium on the Issues and Alternatives* (Washington, D.C.: Equal Employment Advisory Council, 1980), 56.

[3] Robert E. Williams and Lorence L. Kessler, *A Closer Look at Comparable Worth: A Study of the Basic Questions to be Addressed in Approaching Pay Equity* (Washington, D.C.: National Foundation for the Study of Equal Employment Policy, 1984), 17.

[4] Ibid., 18. Michael Levin makes the same point in "The Earnings Gap and Family Choices," in Phyllis Schlafly, ed., *Equal Pay for Unequal Work: A Conference on Comparable Worth* (Washington, D.C.: Eagle Forum Education and Legal Defense Fund, 1984), 126.

[5] Williams and Kessler, 21.

[6] Ibid., 20.

[7] Michael Finn, "The Earnings Gap and Economic Choices," in Schlafly, 105.

[8] Levin in Schlafly, 127.

[9] Williams and Kessler, 20–21.

[10] Michael E. Levin, *Feminism and Freedom* (New Brunswick, N.J.: Transaction Books, 1987), 141.

[11] E. Robert Livernash, ed. *Comparable Worth: Issues and Alternatives*, second edition (Washington, D.C.: Equal Employment Advisory Council, 1984), iii.

[12] Ibid., iv.

[13] Ibid., 9.

[14] Livernash refers to this work in Ibid., 7–8.

[15] Michael Evan Gold, *A Dialogue on Comparable Worth* (Ithaca, N.Y.: ILR Press, 1983), 42.

[16] Ibid., 41.

[17] Walter Fogel, *The Equal Pay Act: Implications for Comparable Worth* (New York: Praeger Publishers, 1984), 70.

[18] Ellen Frankel Paul, *Equity and Gender: The Comparable Worth Debate* (New Brunswick: Transaction Publishers, 1989), 55. Paul cites a study by Richard Burr,

"Rank Injustice," *Policy Review* 73, 73 (1986).

[19] Gold, 43–44.

[20] Williams and Kessler, 37–38.

[21] Michael Levin, "Comparable Worth: The Feminist Road to Socialism," *Commentary*, 13:18 (1984).

[22] George Gilder, *Men and Marriage* (Gretna: Pelican Publishing Company, 1986), 151.

[23] Ibid., 151.

[24] Levin, *Feminism and Freedom*, 136.

[25] Williams and Kessler, 67–68.

[26] Milton Friedman, "The Social Responsibility of Business is to Increase Profits," in Thomas Donaldson and Patricia Werhane, *Ethical Issues in Business: A Philosophical Approach* (Englewood Cliffs, N.J.: Prentice–Hall, Inc., 1983), 294.

[27] Charles Lindblom, "The Privileged Position of Business," in Mark Green, ed., *The Big Business Reader* (New York: The Pilgrim Press, 1983), 196.

[28] Ibid.

[29] Ibid.

[30] Williams and Kessler, 16. These figures are based on 1977 statistics.

[31] *Working Women: A Chartbook* (U.S. Department of Labor, Bureau of Labor Statistics, August 1991), Bulletin 2385, Chart 11 and Table A–11.

[32] Levin, *Feminism and Freedom*, 144.

[33] Midge Decter, *The Liberated Woman and Other Americans* (New York: Coward, McCann and Geoghegan, Inc., 1971), 93–94.

[34] Midge Decter, *The New Chastity and Other Arguments Against Women's Liberation* (New York: Coward, McCann and Geoghegan, Inc., 1972), 124.

[35] Ibid., 129.

[36] Ibid., 124–125.

[37] Ibid., 165.

[38] Ibid., 173.

[39] Ibid., 179.

[40] Levin in Schlafly, 128.

[41] Ibid., 127.

[42] Gilder, *Men and Marriage*, 153.

[43] Levin, *Feminism and Freedom*, 141.

[44] Levin in Schlafly, 132.

[45] Ibid.

[46] Ibid.

[47] Ibid., 105.

[48] Gilder, *Men and Marriage*, 142.

[49] Finn in Schlafly, 113.

[50] Decter, *The New Chastity*, 139.

[51] Ibid.

[52] Levin in Schlafly, 130.

[53] Decter, *The New Chastity*, 45–46.

[54] Ibid., 46.

[55] Ibid., 49.

[56] Ibid., 139.

[57] Gilder, *Men and Marriage*, 5.

[58] Ibid.

[59] Ibid., 6.

[60] Ibid.

[61] Ibid.

[62] Ibid., 8.

[63] Ibid., 9.

[64] Ibid., 9–10.

[65] Ibid., 10.

[66] Ibid.

[67] Ibid., 13.

[68] Ibid., 18.

[69] Ibid., 144.

[70] Ibid.

[71] Ibid., 144–145.

[72] Ibid., 145.

[73] Levin in Schlafly, 131–132.

[74] Gilder, *Men and Marriage*, 145.

[75] Ibid.

[76] Ibid., 113.

[77] Max Weber, *The Protestant Ethic and the Spirit of Capitalism* (New York: Charles Scribner's Sons, 1958).

[78] Ibid.

[79] C. B. Macpherson, *The Political Theory of Possessive Individualism: Hobbes to Locke* (Oxford: Oxford University Press, 1983).

[80] Paul, 129.

Chapter 4: The Religious Traditionalists

[1] Aaron Levine, "Comparable Worth in Society and in Jewish Law," *Tradition: A Journal of Orthodox Thought*, 23:1 (Summer 1987), 29.

[2] George M. Marsden, "Preachers of Paradox: The Religious New Right in Historical Perspective," in Mary Douglas and Steven M. Tipton, eds., *Religion and America: Spirituality in a Secular Age* (Boston: Beacon Press, 1983), 151.

[3] Jerry Falwell, Ed Dobson and Ed Hindson, eds., *The Fundamentalist Phenomenon: The Resurgence of Conservative Christianity* (Garden City, N.Y.: Doubleday and Company, 1981), 7.

[4] Ibid., 6.

[5] Marsden, 154.

[6] Robert Booth Fowler, *A New Engagement: Evangelical Political Thought, 1966–1976* (Grand Rapids, Michigan: William B. Eerdmans Publishing Company, 1982), 13.

[7] Marsden, 155.

[8] Falwell, 146.

[9] Ibid.

[10] Ibid., 3

[11] Marsden, 154.

[12] Ibid., 155.

[13] Falwell, 160.

[14] Erling Jorstad, *The Politics of Moralism: The New Christian Right in American Life* (Minneapolis: Augsberg Publishing House, 1981), 8.

[15] Ibid., 9.

[16] Samuel S. Hill and Dennis E. Owen, *The New Religious Political Right in America* (Nashville: Abingdon, 1982), 18.

[17] Ibid.

[18] Gabriel Fackre, *The Religious Right and Christian Faith* (Grand Rapids, Michigan: William B. Eerdmans Publishing Company, 1982), 7.

[19] Ibid., 8.

[20] Ibid.

[21] Ibid., 10.

[22] Cited in Daniel C. Maguire, *The New Subversives: Anti-Americanism of the Religious Right* (New York: Continuum, 1982), 13.

[23] Robert Wuthnow, *The Restructuring of American Religion* (Princeton: Princeton University Press, 1988), 131.

[24] Martin E. Marty, *Religion and Republic: The American Circumstance* (Boston: Beacon Press, 1987), 299.

[25] Ibid.

[26] Ibid., 300.

[27] Ibid.

[28] Cited in Falwell, 144.

[29] Fowler, 191.

[30] Ibid.

[31] Ibid.

[32] Marty, 295.

[33] *Christianity Today*, 31:4 (Mar. 6, 1987), 36.

[34] Ibid., 35.

[35] Marabel Morgan, *The Total Woman* (Old Tappan, N.J.: F.H. Revell, 1973), 55.

[36] Ibid., 53.

[37] Ibid.

[38] Ibid., 54.

[39] Ibid.

[40] Ibid.

[41] Ibid., 57.

[42] Ibid.

[43] Ibid., 58.

[44] Ibid.

[45] Ibid., 59.

[46] Ibid., 64.

[47] Ibid., 69.

[48] Ibid., 70.

[49] Ibid.

[50] Ibid., 145.

[51] Ibid., 143.

[52] Ibid., 146.

[53] Ibid., 102.
[54] Ibid.
[55] Ruth Carter Stapleton, *The Gift of Inner Healing* (Waco, Tex.: World Books, 1976), 32. Andrea Dworkin notes many of these views in her *Right Wing Women: The Politics of Domesticated Females* (London: The Women's Press, 1983).
[56] Cited in Peter Gardella, *Innocent Ecstasy: How Christianity Gave America an Ethic of Sexual Pleasure* (New York: Oxford University Press, 1985), 150.
[57] Morgan, 102.
[58] Ibid., 103.
[59] Ibid.
[60] Ibid., 104.
[61] Ibid.
[62] Ibid., 111.
[63] Alexis de Tocqueville, *Democracy in America* (New York: Vintage Books, 1958), vol. I, 310.
[64] Marsden, 151.
[65] Quoted in Maguire, 14.

CHAPTER 5: THE SOCIAL EGALITARIANS

[1] Alison M. Jaggar, *Feminist Politics and Human Nature* (Totowa, N.J.: Rowman and Allenheld, 1983), 19.
[2] Ibid., 186.
[3] Ibid.
[4] Ibid., 175–176.
[5] Ibid., 176.
[6] Ibid., 177.
[7] Ibid.
[8] Ibid., 178.
[9] Mary Shanley, "Afterword," in Irene Diamond, ed., *Families, Politics and Public Policy: A Feminist Dialogue on Women and the State* (New York and London: Longman, 1983), 357.
[10] Ibid., 358.
[11] Ibid., 360.
[12] Carol Gilligan, *In A Different Voice: Psychological Theory and Women's Development* (Cambridge: Harvard University Press, 1983), 19.
[13] See especially Michael J. Sandel, *Liberalism and the Limits of Justice* (Cambridgeshire and New York: Cambridge University Press, 1982).
[14] Gilligan, 151.
[15] Ibid., 42.
[16] For examples of this alternative position, see Nancy J. Chodorow, *Feminism and Psychoanalytic Theory* (New Haven: Yale University Press, 1989) and Jessica Benjamin, *The Bonds of Love: Psychoanalysis, Feminism, and The Problem of Domination* (New York: Pantheon Books, 1988).
[17] Mary Field Belenky, Blythe McVicker Clinchy, Nancy Rule Goldberger, and Jill Mattuck Tarule, *Women's Ways of Knowing: The Development of Self, Voice, and Mind* (New York: Basic Books, 1986).
[18] Lucinda M. Finley, "Equality Theory: A Way Out of the Maternity and the

Workplace Debate," *Columbia Law Review*, 86:6 (October 1986), 1153.

[19] Ibid., 1152–1153.

[20] Nell Noddings, *Caring: A Feminine Approach to Ethics and Moral Education* (Berkeley: University of California Press, 1984), 43.

[21] Ibid., 46.

[22] Shanley, 361.

[23] Robert N. Bellah, Richard Madsen, William M. Sullivan, Ann Swidler, and Steven M. Tipton, *Habits of the Heart: Individualism and Commitment in American Life* (Berkeley: University of California Press, 1985), 20.

[24] Ibid., 20–21.

[25] Shanley, 360.

[26] Ibid., 361

[27] Ibid.

[28] Sigmund Freud, "The Future of An Illusion," James Strachey, ed., *Standard Edition of the Complete Psychological Works* (London: The Hogarth Press Ltd., 1927), 21:30.

[29] Letter from Rolland to Freud, 5 December 1927, quoted in David James Fisher, *Romain Rolland and the Politics of Intellectual Engagement* (Berkeley: University of California Press, 1988), 9.

[30] Fisher, 11.

[31] Ibid.

[32] Noddings, 29.

[33] Ibid., 97.

[34] Zillah R. Eisenstein, ed., *Capitalist Patriarchy and the Case for Socialist Feminism* (New York and London: Monthly Review Press, 1979), 5.

[35] Ibid., 15.

[36] Ibid., 15–16.

[37] Ibid., 17.

[38] Ibid., 51.

[39] Ibid., 25.

[40] Susan Moller Okin, *Women in Western Political Thought* (Princeton: Princeton University Press, 1979), 297.

[41] Zillah Eisenstein, "The State, the Patriarchal Family, and Working Mothers," in Irene Diamond, ed., 44.

[42] Ibid.

[43] Shulamith Firestone, *The Dialectic of Sex* (New York: Bantam Books, 1972).

[44] Eisenstein, ed., 50.

[45] Mary O'Brien, *The Politics of Reproduction* (Boston: Routledge and Kegan Paul, 1983), 20.

[46] Ibid., 22.

[47] Eisenstein, ed., 27.

[48] Ibid.

[49] Ibid., 50.

[50] Okin, 287.

[51] Ibid., 10.

[52] Eisenstein, ed., 26.

[53] Nancy Chodorow, "Mothering, Male Dominance, and Capitalism," in

Eisenstein, ed., 100.

[54] Batya Weinbaum and Amy Bridges, "The Other Side of the Paycheck: Monopoly Capital and the Structure of Consumption," in Eisenstein, ed., 194.

[55] Ibid., 196.

[56] Ibid.

[57] Finley, 1120.

[58] Eisenstein in Diamond, ed., 55.

[59] Pre-1990 statistics are found in Jan Rosenberg, "Hard Times for the Women's Movement," *Dissent*, 33:4 (Fall 1986), 401–405. 1990 statistics are from the *Chartbook*, 31.

[60] Finley, 1119.

[61] Jessie Bernard, *Women and the Public Interest: An Essay on Policy and Protest* (Chicago: Aldine Publishing Company, 1971), 63–64.

[62] Ibid., 126.

[63] Ibid., 45.

[64] Ibid., 160.

[65] Ibid., 161.

[66] Eisenstein in Diamond, ed., 50.

[67] Ibid., 51.

[68] Ibid.

[69] Karl Marx, "Contribution to the Critique of Hegel's *Philosophy of Right: Introduction*," in Robert C. Tucker, ed., *The Marx–Engels Reader*, second edition (New York: W. W. Norton, 1978), 54.

[70] O'Brien, 210.

Chapter 6: The Feminist Theologians

[1] Rosemary Radford Ruether, *Religion and Sexism: Images of Women in the Jewish and Christian Traditions* (New York: Simon and Schuster, 1974), 9.

[2] Mary Daly, *The Church and the Second Sex, with the Feminist Postchristian Introduction and New Archaic Afterwords by the Author* (Boston: Beacon Press, 1985), 180.

[3] Ibid., 182.

[4] Ruether, *Religion and Sexism*, 9–10.

[5] Cited in Elizabeth Clark and Herbert Richardson, eds., *Women and Religion: A Feminist Sourcebook of Christian Thought* (New York: Harper and Row, 1977), 270.

[6] Carol P. Christ and Judith Plaskow, eds., *Womanspirit Rising: A Feminist Reader in Religion*, (San Francisco: Harper and Row, 1979), 16.

[7] Mary Daly, *Beyond God the Father: Toward a Philosophy of Women's Liberation* (Boston: Beacon Press, 1973), 19.

[8] Elizabeth Dodson Gray, *Green Paradise Lost* (Wellesley, Massachusetts: Roundtable Press, 1982), 2–7.

[9] Phyllis Trible, "Eve and Adam: Genesis 2–3 Reread," in Christ and Plaskow, 81.

[10] Virginia Ramey Mollenkott, *The Divine Feminine: The Biblical Imagery of God as Female* (New York: Crossroad, 1984).

[11] Ibid., 65.

[12] Ibid.

[13] Rosemary Radford Ruether, *Sexism and God-Talk: Toward a Feminist Theology* (Boston: Beacon Press, 1983).

[14] Beverly Wildung Harrison, *Making the Connections: Essays in Feminist Social Ethics*, Carol S. Robb, ed. (Boston: Beacon Press, 1985), 218.

[15] Ibid., 215.

[16] Carol P. Christ, *Laughter of Aphrodite: Reflections on a Journey to the Goddess* (San Francisco: Harper and Row, 1987), 121.

[17] Ibid., 123.

[18] Ibid., 126–127.

[19] Starhawk, "Ethics and Justice in Goddess Religion," in Barbara Hilkert Andolsen, Christine Gudorf, Mary D. Pellauer, eds., *Women's Consciousness, Women's Conscience: A Reader in Feminist Ethics* (San Francisco: Harper and Row, 1985), 196.

[20] Ibid.

[21] Ibid., 194.

[22] Christ and Plaskow, 8.

[23] Ibid.

[24] Valerie Saiving, "The Human Situation: A Feminine View," in Christ and Plaskow, 26.

[25] Ibid., 37.

[26] Ibid., 37.

[27] Ibid., 21.

[28] Mary Daly, *Beyond God the Father: Toward a Philosophy of Women's Liberation*, 114.

[29] Mary Daly, *Gyn/Ecology: The Metaethics of Radical Feminism* (Boston: Beacon Press, 1978), 340.

[30] Ibid.

[31] Carol Ochs, *Beyond the Sex of God: Toward a New Consciousness Transcending Matriarchy and Patriarchy* (Boston: Beacon Press, 1977).

[32] Christ, 192.

[33] Ibid., 188

[34] Starhawk, 197.

[35] Ibid.

[36] Audre Lorde, "Use of the Erotic: The Erotic as Power," *Sister Outsider* (Freedom, CA: The Crossing Press, 1984), 53.

[37] Ibid., 55.

[38] Ibid., 56.

[39] Harrison, 87.

[40] Ibid., 104.

[41] Ibid., 105.

[42] Ibid., 90.

[43] Ibid., 108.

[44] Ibid.

[45] Ibid., 110.

[46] Adrienne Rich, "Compulsory Heterosexuality and Lesbian Existence," in Alison M. Jaggar, Paula S. Rothenberg, eds., *Feminist Frameworks: Alternative Theoretical Accounts of the Relation Between Women and Men* (New York: McGraw Hill,

1984), 416.

[47] Ibid., 417.

[48] Ibid.

[49] Carol Ochs, *Women and Spirituality* (Totawa, New Jersey: Rowman and Allanheld, 1983), 2.

[50] Ibid., 3.

[51] Ibid. 4.

[52] Gayle Kimball, "From Motherhood to Sisterhood: The Search for Female Religious Imagery in Nineteenth and Twentieth Century Theology," in Rita M. Gross, ed., *Beyond Androcentrism: New Essays on Women and Religion* (Missoula, Montana: The Scholars Press for the American Academy of Religion, 1977).

[53] Emily Erwin Culpepper, "Contemporary Goddess Theology: A Sympathetic Critique," in Clarissa Atkinson, Constance H. Buchanan, Margaret Miles, eds., *Shaping New Vision: Gender and Values in American Culture* (Ann Arbor: University of Michigan Press, 1987).

[54] Carol P. Christ, *Diving Deep and Surfacing*, second edition (Boston: Beacon Press, 1986), 131.

[55] Ibid.

[56] Starhawk, 194.

[57] Elizabeth Anscombe, "Modern Moral Philosophy," *Philosophy* 33: 1–19 (1958), cited in Wayne Proudfoot, *Religious Experience* (Berkeley, CA.: University of California Press, 1985), 220.

[58] Emily Erwin Culpepper, "Philosophia: Feminist Methodology for Constructing a Female Train of Thought," *Journal of Feminist Studies in Religion*, 3:2 (Fall 1987), 52.

Chapter 7: The Religious Impact on the Public Policy Debate

[1] J. Philip Wogaman, *A Christian Method of Moral Judgment* (London: SCM Press Ltd., 1976), 132.

[2] Sylvia Ann Hewlett, *A Lesser Life: The Myth of Women's Liberation in America* (New York: Warner Books, 1986), 15. Hewlett cites the Bureau of Census figures quoted in *American Women: Three Decades of Change* (Washington, D.C.: Bureau of the Census, August 1983), 4–5.

[3] For discussion of alternative futures of the American family, see Frances K. Goldscheider and Linda J. Waite, *New Families, No Families? The Transformation of the American Home* (Berkeley: University of California Press, 1991).

[4] For further discussion of how structural changes affect both the work world and women's decision making about work and family, see the work of Rosabeth Moss Kanter, *Men and Women of the Corporation* (New York: Basic Books, 1977) and Kathleen Gerson, *Hard Choices: How Women Decide about Work, Career, and Motherhood* (Berkeley: University of California Press, 1985).

[5] George Armstrong Kelly, "Faith, Freedom, and Disenchantment: Politics and the American Religious Consciousness," in Mary Douglas and Steven M. Tipton, eds., *Religion and America: Spirituality in a Secular Age* (Boston: Beacon Press, 1983), 208.

[6] Robert Wuthnow, *The Restructuring of American Religion* (Princeton:

Princeton University Press, 1988), 264.

[7] For a general discussion of feminist biblical scholars and their impact on religious studies see Cullen Murphy, "Women and the Bible," *The Atlantic Monthly*, August 1993.

[8] Ernst Troeltsch, *The Social Teaching of the Christian Churches* (Chicago: University of Chicago Press), 1981.

[9] Audre Lorde, "The Master's Tools Will Never Dismantle the Master's House," *Sister Outsider* (Freedom, Calif.: The Crossing Press, 1984).

[10] Whittle Johnson, "Little America—Big America," *Yale Law Review* 58 (December 1968), 10–11. Cited in Sanford Levinson, *Constitutional Faith* (Princeton: Princeton University Press, 1988), 5.

[11] Wuthnow, 293.

Index